Reproduced on the cover
Alan Saret. *Dual Union Ensoulment,* detail. 1969.
Colored pencil on paper,
entire work 25 x 37½″ (62.5 x 93.75 cm).
Collection Mr. and Mrs. Ronald K. Greenberg,
St. Louis, Mo. (Photograph: Al Jung, St. Louis)

Cover design
Karen Salsgiver

A Contemporary Approach
Drawing

Holt, Rinehart and Winston
New York Chicago San Francisco Atlanta
Dallas Montreal Toronto London Sydney

Claudia Betti
Teel Sale
North Texas State University

A Contemporary Approach

Drawing

To our students,
colleagues,
and teachers

Editor Rita Gilbert
Picture Editor Joan Curtis
Developmental Editor Karen Dubno
Project Editor Karen Mugler
Manuscript Editor Laura Foti
Project Assistant Barbara Curialle
Production Manager Nancy Myers
Layout Helena Kolda
Designer Karen Salsgiver

Library of Congress Cataloging in Publication Data

Betti, Claudia W
 Drawing.

 Bibliography: p.
 Includes index.
 1. Drawing—Technique. I. Sale, Teel, joint author.
II. Title.
NC730.B43 741.2 79-26976
ISBN 0-03-045976-1

Composition and camera work by York Graphic Services, Inc., Pennsylvania
Printing and binding by Capital City Press, Vermont
0 1 2 3 4 138 9 8 7 6 5 4 3 2 1

rawing: A Contemporary Approach has as its underlying assumption that drawing is an exciting as well as a necessary artistic activity. We believe that drawing can be taught through a series of related steps and techniques that show students their own powers of observation and execution. This ability to observe and to draw, using a number of methods, remains much the same regardless of a student's area of concentration in art—crafts, painting, sculpture, or the professional fields.

We have structured *Drawing* around a series of 73 "problems," each of which is designed to encourage fluency in drawing, to foster self-confidence, and to instill an understanding of the basic art elements. As students progress in developing these qualities, they become more comfortable with drawing tools and materials and face new concepts more readily.

The word "contemporary" in the book's subtitle has two meanings. First, we have emphasized a method of teaching and learning the art of drawing that is contemporary in outlook. The technique of gesture is used as an introduction to the art process, an essential first step in learning to draw. Because the handling of space is such a major concern in drawing—as in all the visual arts—the formal art elements are approached through a study of spatial relationships.

The other implication of "contemporary" refers to the drawings reproduced and discussed. Virtually all of the 399 illustrations in the text date from the 20th century, and many were created in the late 1970s. Today's students are of their own age, and while it is certainly valuable to study the productions of earlier periods, the new generation of artists will be creating 20th-century art. We have attempted, therefore, to give an indication of the incredible range of possibilities open to the contemporary artist, in medium, style, and expression. The drawings illustrated include both masterworks and student examples from the classrooms at North Texas State University.

Supporting the body of the text are four "practical guides," which deal respectively with materials, keeping a sketchbook, presentation, and methods for breaking artistic blocks. All are intended to enhance the student's ability to draw—and continue drawing, and draw constantly. Practice keeps the student moving along an ambitious path that involves growth in intellectual, emotional, and sensory—as well as artistic—capabilities.

Acknowledgments

Many people have assisted and encouraged us in preparing this text. We are grateful to our colleagues at North Texas State University, especially to Richard Sale, who helped in many ways throughout the project. The staff at Holt, Rinehart and Winston guided us through the painful process of being first-time authors; our appreciation goes to our editor, Rita Gilbert, and to Joan Curtis, Karen Mugler, Karen Dubno, Laura Foti, Barbara

Curialle, Nancy Myers, and Karen Salsgiver. The excellent photographs of student drawings in this book were taken by Pramuan Burusphat. Finally, and above all, we are indebted to the students whom we have taught—and who have taught us.

Denton, Texas C.B.
February 1980 T.S.

Contents

A Contemporary Approach

Drawing

Introduction to Drawing

Part I

Drawing: Some Thoughts and Definitions

Chapter One

The exciting process of creating art may seem complex to the beginning student. The proliferation of styles and trends contributes to this, but practice and an understanding of drawing techniques help to unravel the complexity.

A way through this complexity is to recognize that art has certain classes or divisions. Our focus here is on *drawing,* one of the major areas of artistic activity. Drawings, however, are not of interest to artists only. Illustrators, designers, architects, scientists, and technicians make use of drawings in their professions. Just as there are different uses for drawings, there are many types of drawings.

Subjective and Objective Drawing

In its broadest division drawing can be classified as either *subjective* or *objective.* Subjective drawing emphasizes the artist's emotions. In objective drawing, on the other hand, the information conveyed is more important than the artist's feelings. Claes Oldenburg's eraser-tornado drawing (Fig. 1) is an example of the sub-

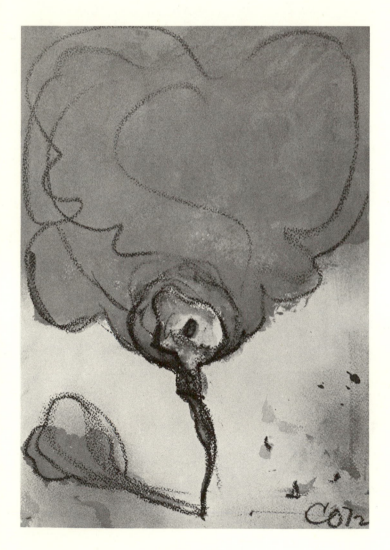

1. Claes Oldenburg.
Typewriter Eraser as Tornado. 1972.
Lithograph, 26½ × 17⅞″ (67 × 45 cm).
Fort Worth Art Museum.

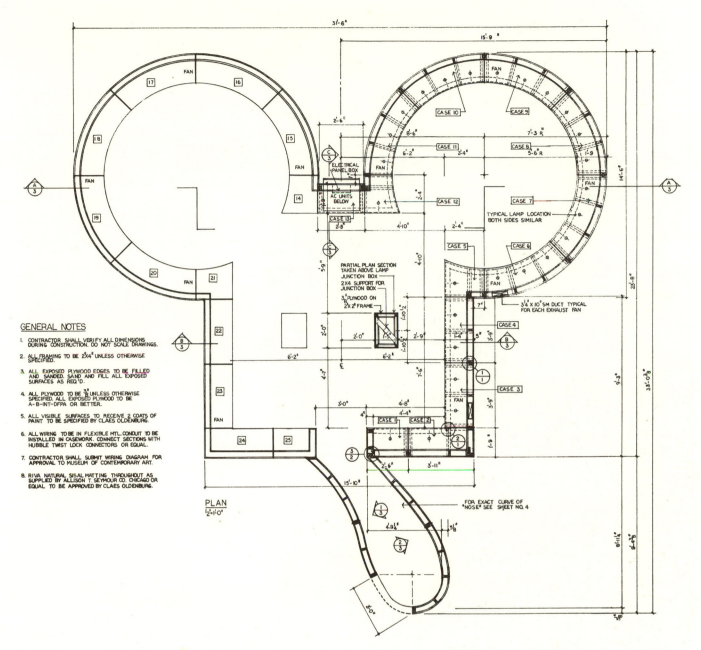

2. Stuart E. Cohen for Claes Oldenburg. Construction plan for revised version of *Mouse Museum.* 1977. Pencil, 20 × 30″ (51 × 76 cm). Museum of Contemporary Art, Chicago.

jective class. Oldenburg makes a highly personal, witty analogy between eraser and tornado. His plan for *Mouse Museum* in Figure 2, on the other hand, is concerned with design information—measurement, scale, and proportion between parts—and thus belongs to the objective class.

The objective category is also called *informational drawing* and includes diagrammatic, architectural, and mechanical drawings. Informational drawings may clarify concepts and ideas that are not actually visible. The biologist's schematic drawing of a molecular structure is an "artist's guess" used for instructional

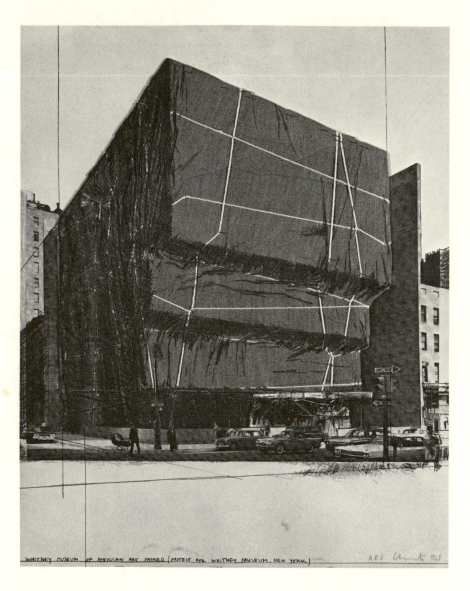

WHITNEY MUSEUM OF AMERICAN ART PACKED (PROJECT FOR WHITNEY MUSEUM, NEW YORK) A88 Christo 1968

3. Christo.
*Whitney Museum of American Art Packed
(Project for Whitney Museum, New York).*
1968. Photolithograph and collage,
28 × 22″ (71 × 56 cm).
Courtesy Landfall Press, Inc., Chicago.

purposes. Art as documentation and information has been created by many serious 20th-century artists. Christo's work shown in Figure 3 is a proposal for one of his projects—packaging a museum. He combines photography, collage, and drawing to present an accurate description of what the museum would look like if it were wrapped. Christo's plans are frequently carried out, and he documents these projects both in drawing and in photography.

Another type of objective drawing is the *schematic,* or *conceptual,* drawing. It is a *mental construct,* not an exact record of visual reality. Comic book characters and stick figures in instruction manuals are familiar examples. We know what they stand for and how to "read" them. We do not think of them as complicated, but they are schematic and conceptual; they are an economical way to give information visually. They are *conventions,* just as the western hero riding into the sunset is a convention. This conventional schematization is easily understood by everyone in our culture.

At this point our two broad categories of subjective and objective begin to overlap. A schematic or conceptual drawing may be objective, like the illustration of stick figures in an instruction manual. It may also be intensely subjective, like a child's drawing in which the proportions of the figure are exaggerated in relation to its environment (Fig. 4). Artists tend to use the schematic approach in a subjective manner, as in Saul Steinberg's drawing *Main Street* (Fig. 5). The humorous intent is heightened by his shorthand style. The emphasis is on idea—on concept—rather than on visual reality. Roy De Forest's drawing (Fig. 6) is an example of the flourishing movement in contemporary art involving schematized drawings. De Forest depicts an imaginary world, similar to a child's vision, complete with base line and scribbles symbolizing water. Again emphasis is not on a visual reality; the apparently direct and simple schematized images carry considerable sophisticated and subjective expression.

4. Child's drawing.

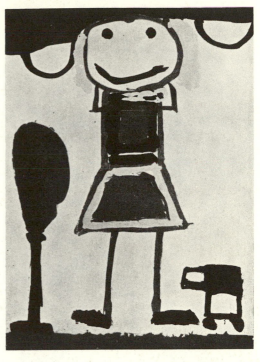

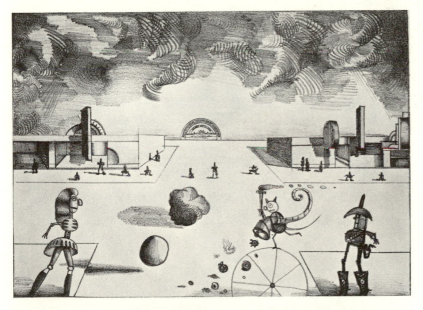

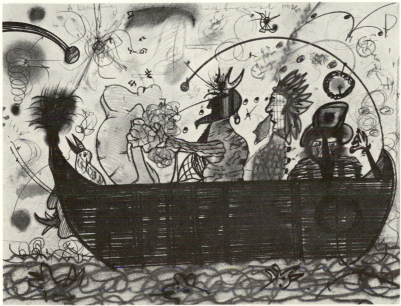

5. Saul Steinberg. *Main Street.* 1972–73.
Lithograph, 15³/₄ × 22″ (40 × 56 cm).
Museum of Modern Art, New York
(gift of Celeste Bartos).

6. Roy De Forest. *Untitled.* 1976.
Pastel and charcoal, 22¹/₂ × 30″ (57 × 76 cm).
Courtesy Allan Frumkin Gallery, New York.

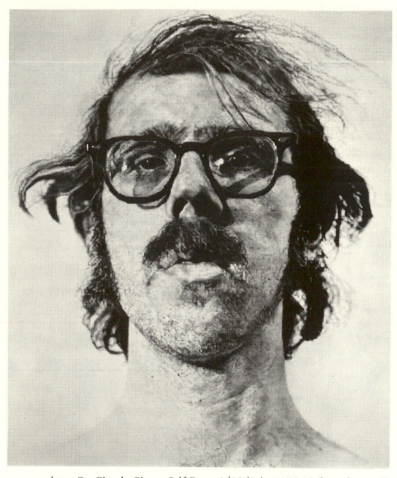

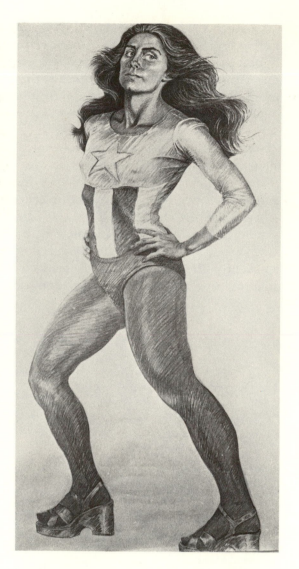

above: 7. Chuck Close. *Self-Portrait/58424.* 1973. Ink and pencil, 5′10½″ × 4′10″ (1.79 × 1.47 m). Courtesy Pace Gallery, New York.

right: 8. Sharon Wybrants. *Self-Portrait as Superwoman (Woman as Culture Hero).* 1975. Pastel, 12 × 5′ (3.66 × 1.52 m). Courtesy the artist.

Pictorial recording is another important category in drawing. The medical illustrator, for example, objectively records an image with almost photographic accuracy. Yet with some artists, imitating certain photographic techniques can lead to highly subjective effects. A number of contemporary artists are concerned with duplicating what the camera sees—both its focus and distortion. This movement is known as *Photorealism.* The work of these artists suggests a bridge between subjective and objective art, for even in the most "photographic" drawing or painting a part of the artist's personal style enters. In the Photorealist self-portrait by Chuck Close (Fig. 7) there is a strong element of subjectivity.

Just as in every other human activity, there is a full range of the subjective element in artistic production. Sharon Wybrants' powerful self-portrait (Fig. 8) is her own very personal, expressionistic view of the world as well as of herself. A drawing may be slightly or highly personal; there are as many degrees of subjectivity as there are artists.

The Audience

Another set of distinctions involves the question: For whom is the drawing intended? Artists make some drawings only for themselves. These drawings may be preparatory to other work, like Jonathan Borofsky's study for a wall drawing (Fig. 9). An artist may wish to solve some problems or "play" with ideas before beginning the final piece. Artists may also draw to sharpen their sense of observation, to experiment with materials, or to increase their knowledge of the subject. These "drawings-for-the-self" are investigations ranging from pictorial accuracy through varying degrees of subjective interpretation.

9. Jonathan Borofsky. *I dreamed a dog was walking a tightrope at 2,445,667 and 2,544,044.* 1978. Ink and pencil, 12 × 13" (30 × 33 cm). Courtesy Paula Cooper Gallery, New York.

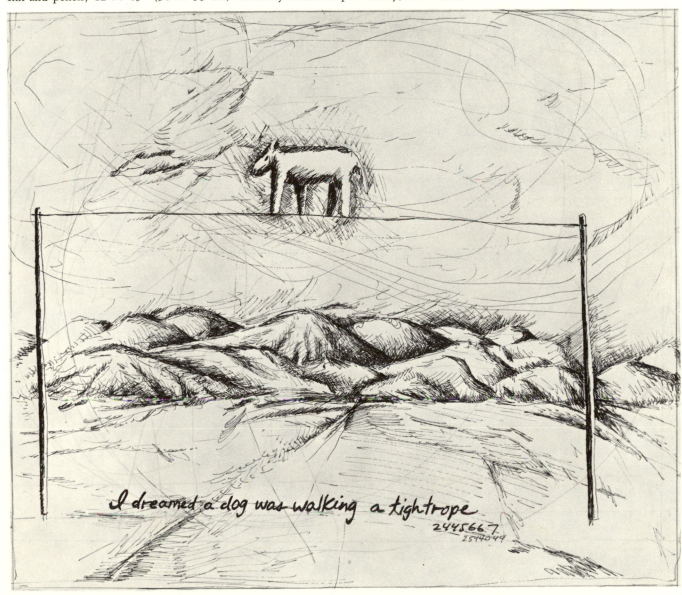

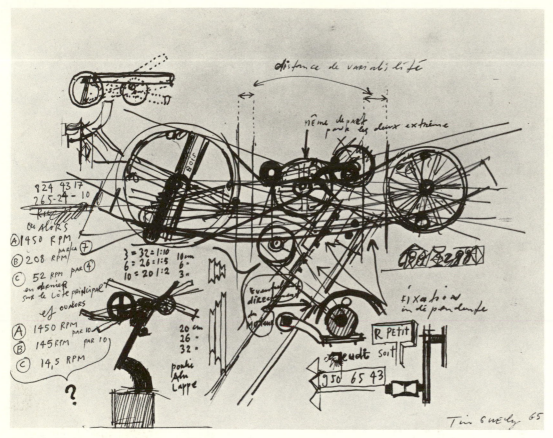

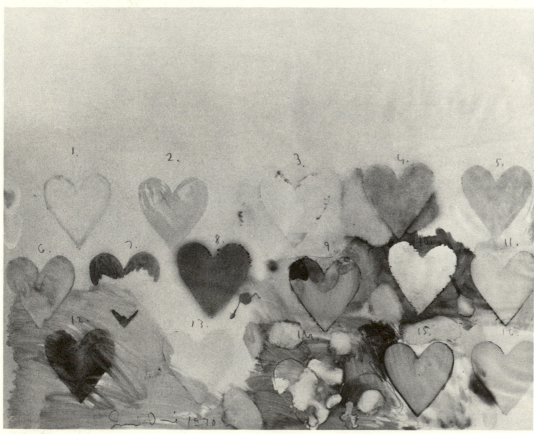

10. Jean Tinguely.
Study of Machine. 1965.
Ink, 12⅝ × 15⅞″
(32 × 40 cm).
Courtesy Iolas Gallery,
New York.

11. Jim Dine.
Large Heart Drawing.
1970. Felt-tip pen
and watercolor,
34 × 44″
(87 × 112 cm).
Fort Worth Art Museum.

Drawings not intended for an audience, however, do not prevent our enjoyment of them. Jean Tinguely's *Study of Machine* (Fig. 10) gives the viewer an insight into the playful mind of the artist. This intimate glimpse is often as satisfying as the look at a "finished" drawing.

Of course, a drawing can also be a final graphic statement intended as an end in itself rather than preparatory to other work. Jim Dine's *Large Heart Drawing* (Fig. 11) is as finished as any of his paintings.

Our enjoyment of an artist's work increases in proportion to our knowledge of the work. The more familiar we are with the style of an artist, the more we are able to relate a new drawing to works remembered. Because his style is so widely recognized, a drawing by Picasso (Fig. 12) cannot be viewed without the memory of many of his other works coming to mind.

12. Pablo Picasso.
29.12.66.III (Mousquetaire et profils).
1966. Pencil and bistre,
21⅝ × 18⅛″ (55 × 46 cm).
Courtesy Editions Cercle d'Art, Paris.

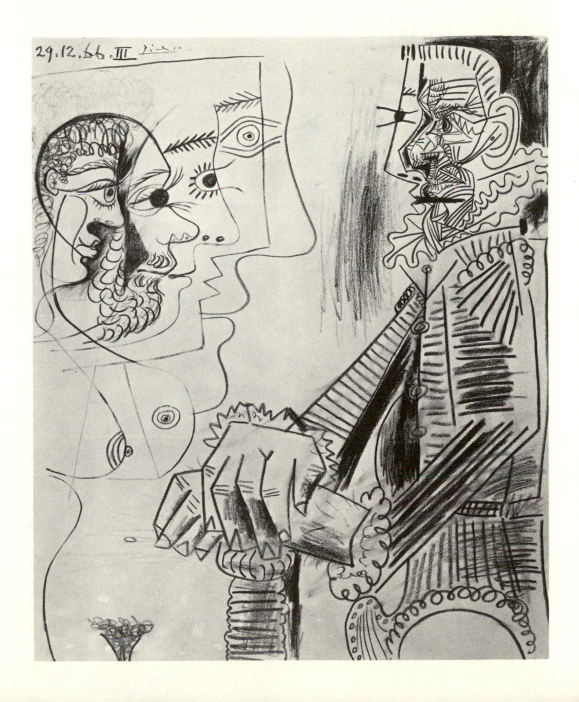

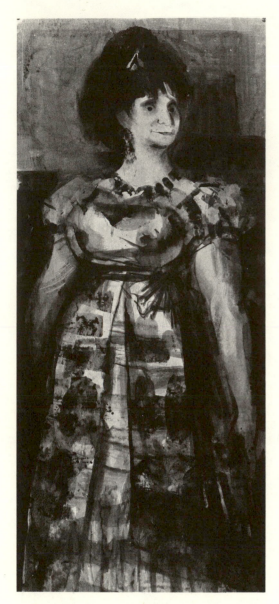

Furthermore, some works are more meaningful when viewed in relation to the works of other, earlier artists—that is, when seen in the perspective of art history. Our understanding of Rico Lebrun's drawing of Maria Luisa (Fig. 13) is increased when we know the source of his image, Goya's *The Family of Charles IV* (Fig. 14). Goya, as court painter to Charles IV, suggested as much as he dared about the character of Charles' queen. Lebrun finishes and makes explicit Goya's earlier statement.

Subject and Treatment

Let us consider another major determinant in an artist's work—the subject to be drawn. Once the subject is chosen, the artist must determine how the subject is to be treated.

Landscape, still life, and figure are broad categories of subject sources. Nature is a constant supplier of imagery, both for the ideas it can offer and for the structural understanding of form it gives. Two widely different approaches to using natural subjects can be seen in the study *The Spiral Jetty* (Fig. 15) by Robert Smithson, in which he proposes changes to an existing landscape, and in *Great Piece of Turf with Tomato and Jar* (Fig. 16) by Lowell Tolstedt, which deals with well-observed structural forms that occur in nature.

above: 13. Rico Lebrun.
Maria Luisa (after Goya). 1958.
Ink wash, 7'2" × 3' (2.2 × .92 m).
Collection Dr. and Mrs. Albert Chase,
Northfork, Calif.

right: 14. Francisco Goya.
The Family of Charles IV, detail. 1800.
Oil on canvas, entire work 9'2" × 11'
(2.79 × 3.35 m). Prado, Madrid.

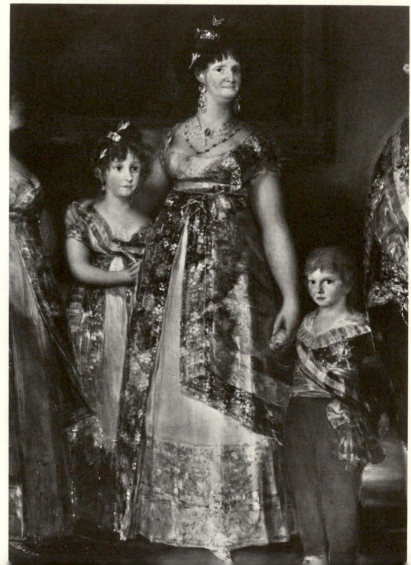

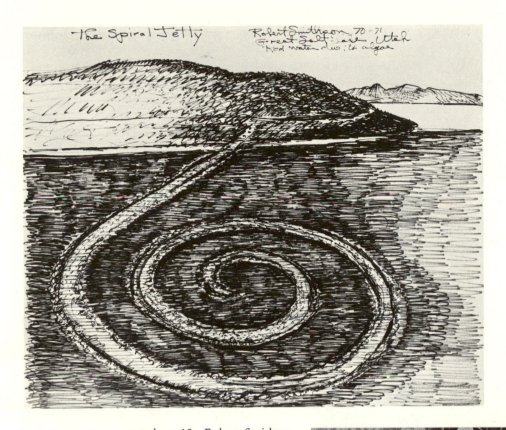

The Spiral Jetty Robert Smithson 70-71
 Great Salt Lake, Utah
 Red water due to algae

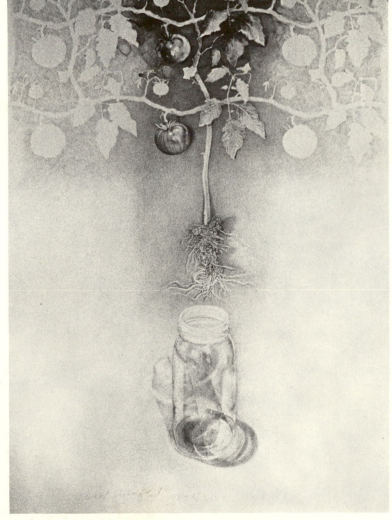

above: 15. Robert Smithson.
The Spiral Jetty. 1970–71.
Black and red ink, 12$^1/_2$ × 15$^1/_2$"
(32 × 39 cm).
Courtesy John Weber Gallery, New York.

right: 16. Lowell Tolstedt.
*Great Piece of Turf with
Tomato and Jar.* 1973.
Pencil and watercolor,
39 × 28$^1/_2$" (99 × 72 cm).
Minnesota Museum of Art, St. Paul.

The artist may choose an exotic subject, as Robin Endsley-Fenn does in the drawing *Mujeres* (Fig. 17), or the artist may find significance in a commonplace subject, as in Irene Siegel's drawing of an unmade bed (Fig. 18). Both the exotic and the commonplace may be equally provocative to the artist.

An object or form can be treated symbolically; it may stand for something more than its literal meaning. An example of this symbolic use of an object is Charles Sheeler's *Self-Portrait*

right: 17. Robin Endsley-Fenn.
Mujeres. 1978.
Gouache, 16 × 20″ (41 × 51 cm).
Courtesy the artist.

below: 18. Irene Siegel.
Unmade Bed, Blue. 1969.
Pencil, 30 × 40″ (76 × 102 cm).
Collection Roberta Dougherty.

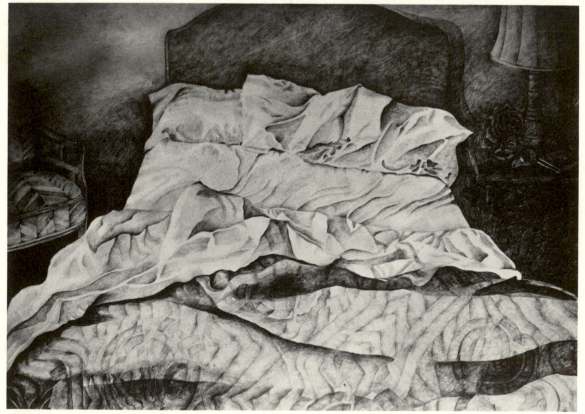

(Fig. 19). We are given a clue to Sheeler's symbolic intent by the title of the drawing. We can only speculate how the telephone, accurately rendered, represents the artist's self, but we do know Sheeler has made a connection between his idea of inner self and the relation of that self to the outer world.

The manner in which an artist may choose to depict a subject can be extremely simple or highly complex. Alexander Calder's *Balancing Act with Tables* (Fig. 20) reduces the subject to

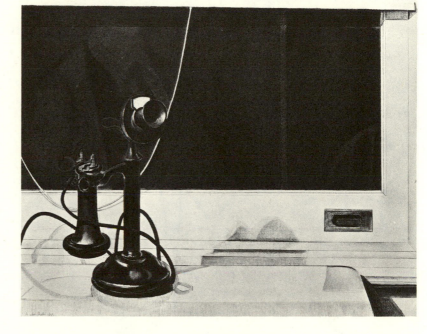

right: 19. Charles Sheeler.
Self-Portrait. 1923.
Conté crayon, gouache, and pencil;
19³/₄ × 25³/₄″ (50 × 65 cm).
Museum of Modern Art, New York
(gift of Abby Aldrich Rockefeller).

below: 20. Alexander Calder.
Balancing Act with Tables. 1931.
Ink, 22³/₄ × 30³/₄″ (58 × 78 cm).
Fort Worth Art Museum.

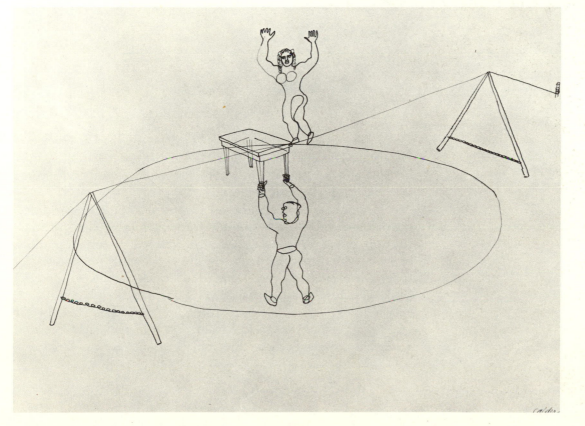

21. Robert Horvitz.
Personal Domain of Freedom and Ecstasy No. 3.
1973. Ink, 20″ (51 cm) square.
Courtesy the artist.

the simplest of lines. Robert Horvitz's drawing *Personal Domain of Freedom and Ecstasy No. 3* (Fig. 21), on the other hand, treats a difficult abstract concept in a complex manner that underscores the ramifications of his subject.

The image can be an object taken from the real world and then altered beyond recognition. In the prints by Roy Lichtenstein (Figs. 22–24) we see the bull abstracted through a number of stages. In this series Lichtenstein is referring to Mondrian's style, a raid on art history. Mondrian's work, however, is an example of purely nonobjective art (Fig. 25). He did not begin with a recognizable image and then abstract it; instead he started with lines, shapes, and colors. The arrangement of these nonobjective geometric images becomes the subject of the work.

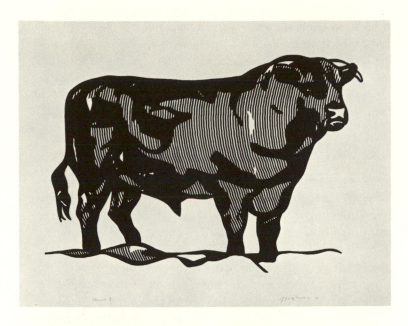

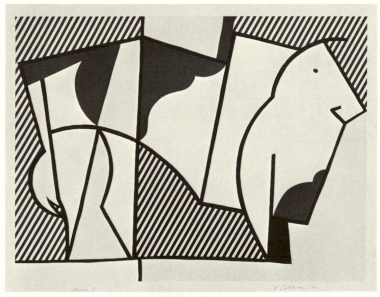

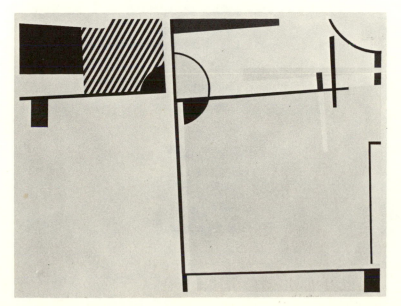

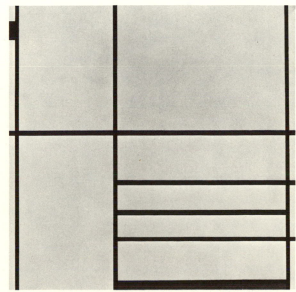

In Richard Diebenkorn's charcoal and ink drawing (Fig. 26) the marks, which seem abstract to the viewer, become the subject. The artist may deal with compositional options of scale and placement of forms on the drawing surface, as in Heinz Mack's *Black Drawing* (Fig. 27). These compositional concerns become the subject of the work.

Reasons for Drawing

The process of drawing develops a sensitivity to materials and a heightened awareness of the visual world. This awareness is both subjective (knowing how you feel about things) and objective (understanding how things actually operate). Perception is molded by subjectivity as well as by the facts of the world. Drawing affords you, the artist, an alternative use of experience. It provides a new format for stating what you know about the world. Through drawing you are trained to make fresh responses. You have a new way of "making meaning." Finally, drawing teaches you to observe, distinguish, and relate.

The therapeutic value of art is well accepted; the intellectual benefits are many. Art is a way of realizing your individuality. The making of art and the making of the self are both part of the same exciting process.

below left: 26. Richard Diebenkorn.
Untitled. 1970.
Charcoal, 25 × 18″ (64 × 46 cm).
Courtesy M. Knoedler & Co., New York.

below right: 27. Heinz Mack.
Black Drawing. 1965.
Oil, crayon rubbing;
5′ × 4′8″ (1.53 × 1.18 m).
Courtesy Galerie Denise René Hans Mayer G.m.b.H., Düsseldorf.

Learning to See: Gesture

Chapter Two

There are two basic approaches to drawing, both involving time. The first is a quick, all-encompassing overview of forms in their wholeness. The second is an intense, slow inspection of the subject—a careful examination of its parts. The two approaches can, of course, be combined, but the first—called *gesture*—is an essential starting point for the drawing student. It opens the door most effectively to unexplored abilities.

The gestural approach to drawing is actually an exercise in seeing. The hand duplicates the movement of the eyes, quickly defining general characteristics of the subject—movement, weight, shape, tension, and so on. Gesture is not unlike the childhood game of finding hidden objects in a picture. Your first glance is a rapid scanning of the picture in its entirety; then you begin searching out the hidden parts.

Gesture is indispensable for establishing unity between drawing and seeing. It is a necessary preliminary step to gaining concentration. We can recognize friends at a glance and from experience we do not need to look at them further for identification. We perform an eye-scan unless there is something unusual to make us look intently—unusual clothes, a new hair style, or the like. For most daily activities, too, a quick, noninvolved way of looking is serviceable. For example, when we cross the street, a glance at the light, to see if it is green or red, is enough. We may add the precaution of looking in both directions to check on cars; then we proceed.

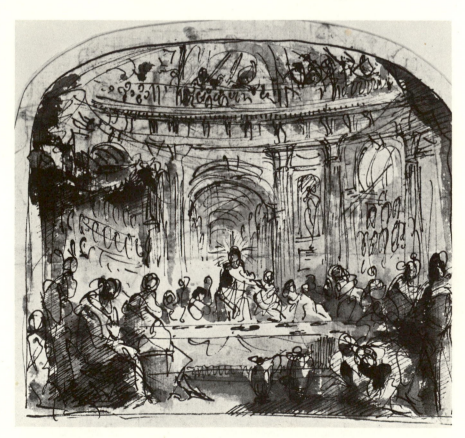

28. Gaetano Gandolfi.
The Marriage Feast at Cana.
Late 18th century.
Pen and brush with ink and wash,
9¾ × 8⅛″ (25 × 21 cm).
Collection Janos Scholz, New York.

This casual way of screening information is not enough to make art, however. Even if the glance at the subject is quick, our minds should register innumerable facts almost immediately. In the subject to be drawn, we should see the color, the texture, the lights and darks, the spaces between objects—the measurable distances of their height, width, and depth—the materials from which they are made, the properties of each material, and many more things as well. Through gesture you will learn to translate this information into drawings.

Artists throughout the ages have used the gestural approach to enliven their work. Gaetano Gandolfi used gesture to establish his composition (Fig. 28). He quickly translated three-dimensional forms onto the two-dimensional surface of his paper, establishing scale and proportion early. The drawing thus becomes a blueprint for further development. Salvator Rosa, in the ink wash drawing illustrated in Figure 29, used a gestural approach to introduce lights and darks at an early stage. Rosa's placement of these lights and darks economically establishes a dramatic feeling in the work.

Rico Lebrun's *Woman Leaning on a Staff* (Fig. 30) is more developed than the two preceding drawings, but the gestural approach is sustained. The drawing remains flexible—capable of being corrected and further developed. Through gesture Lebrun reveals the underlying structure, capturing the attitude of the woman's pose.

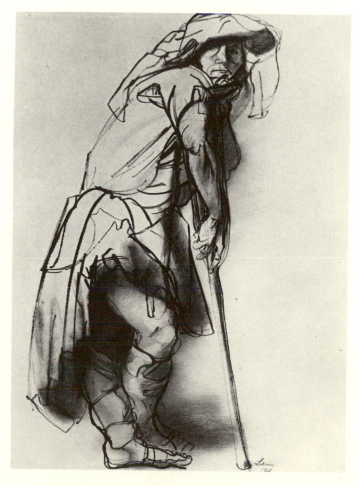

30. Rico Lebrun.
Woman Leaning on a Staff. 1941.
Ink and chalk, 25¼ × 11¼″ (64 × 29 cm).
Collection Mr. and Mrs. Thomas Freiberg.

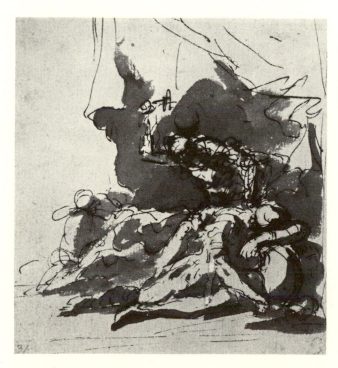

29. Salvator Rosa. *Jael Killing Sisera.* 17th century.
Pen and ink with wash, 6⅛ × 5½″ (16 × 14 cm).
Pierpont Morgan Library, New York
(Janos Scholz Collection).

Artists have used gesture in many ways. Wolfgang Hollegha's gestural notation *Fruits* (Fig. 31) is a record of the energy that went into making the marks. The drawing is thereby infused with a vitality and immediacy. The quickly scribbled lines reveal the visual connection between the artist and the objects. Alice Yamin has used gesture to organize and compose her still life (Fig. 32), to indicate the spatial relationship between the objects, and to infuse the inanimate objects with a vitality and movement that makes them seem to dance about the page. In all these drawings the strokes convey an immediacy and directness that gives us an insight into the artist's vision.

right: 31. Wolfgang Hollegha. *Fruits.* 1963.
Pencil, 4'3" × 5' (1.3 × 1.5 m).
Courtesy the artist.

below: 32. Alice Yamin. *Cocktail Series.* 1966.
Carbon, 25½ × 20" (65 × 51 cm).
Collection CIBA-Geigy Corporation, Ardsley, N.Y.

Before You Begin

Some general comments are in order before you actually begin to draw. You may first want to consult Guide A, "Materials," on pages 229 to 234. It contains a comprehensive list of materials for these and all the problems in the book. Gesture drawing can be done in any medium, but compressed charcoal is recommended in the beginning. Also, since gesture drawing involves large arm movements, use paper no smaller than 18 by 24 inches.

It is essential that you stand (not sit) at an easel, especially until you have fully accomplished the technique of gesture. Stand at arm's length from your paper, placing the easel so that you can keep your eyes on the still life or model at all times. Make a conscious effort to keep your drawing tool in contact with the paper for the entire drawing. In other words, you are to make continuous marks.

In the beginning, make the drawing fit the size of the paper. Try to fill the paper with the composition. Later you can place several gestures on a page. In the initial stage, however, you are becoming acquainted with the limits of the paper.

Generally a still life or figure is recommended in these problems. However, the techniques of gesture are appropriate for any subject.

These problems should be timed. Spend no more than 3 minutes on each drawing. Alternate between 15- and 30-second gestures, then extend the time gradually to 3 minutes. The value of gesture is lost if you take more time. The goal is to see quickly and with greater comprehension. Immediacy is the key. Spend at least 15 minutes at the beginning of every drawing session on these exercises.

Mass Gesture

These first problems deal with *mass gesture,* so called because the drawing medium is used to make broad marks—to create mass rather than line. Use the broad side of a piece of compressed charcoal broken to the length of 1½ inches. Later you may use a wet medium applied with a brush at least 2 inches wide.

Problem 1 Once you have placed the charcoal on the paper, keep your marks continuous. Do not lose contact with the paper. Look for the longest line in the subject. Is it a curve, a diagonal, a horizontal line, a vertical line? Allow your eyes to move through the still life, connecting the forms. Do not follow the edge or outline of the forms. Make the motion of your hand follow the movement of your eyes.

Do not be concerned with copying what the subject looks like. You are describing the subject's location in space, the relationships between forms. Keep eyes and hand working together. Your eyes should remain on the subject, only occasionally refer-

ring to your paper. This will be uncomfortable at first, but soon you will learn the limits of your page and the relationships of the marks on it without looking away from the subject.

If you are drawing from a model, have the model change poses every 30 seconds. Later increase the pose to 1, then 2, then 3 minutes. The poses should be energetic and active, and different poses should be related. Figures 33 to 36 illustrate some of the ways students have responded to this problem.

left: 33. Mass gesture. Student work. Charcoal.

below: 34. Mass gesture. Student work. Wet charcoal.

left: 35. Mass gesture. Student work. Charcoal.

below: 36. Mass gesture. Student work. Charcoal.

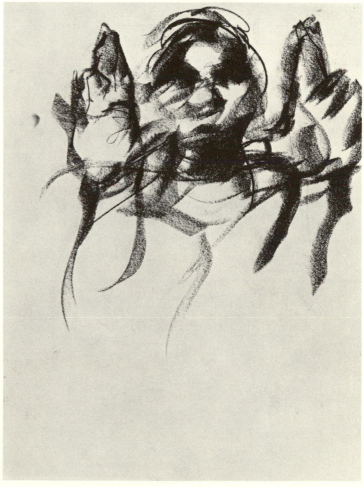

37. Mass gesture with emphasis on negative space. Student work. Wet charcoal.

38. Mass gesture with emphasis on negative space. Student work. Wet charcoal.

Problem 2　Use a tricycle or the branch of a tree as your subject. Look at the intervals of empty space between the parts. If your subject is a tree, for example, look at the spaces between leaves and twigs. Draw in these blank, *negative* spaces first. Emphasize the negative spaces in your drawing.

While the tricycle or tree branch offers you some obvious enclosed negative spaces, any subject would be appropriate for this problem. For example, in Figures 37 and 38 students have used a figure in an environment as subject, but the focus has remained on the negative shapes surrounding the figure.

Problem 3　In this problem you are to emphasize *depth,* not merely the spaces between objects. Make an arrangement of seven to ten various-sized bottles, arranging them in a deep space. In your drawing, note the *base line* of each bottle. The base line is the imagined line on which each object sits. Noting the base line will help you locate objects in their proper spatial relationship to each other.

Establish the gesture by pressing harder on the charcoal when you draw the objects farther away; lighten the pressure to draw the objects nearer to you. Draw each object in its entirety even though objects overlap and you cannot see the entire object. In other words, draw the forms as though they were transparent.

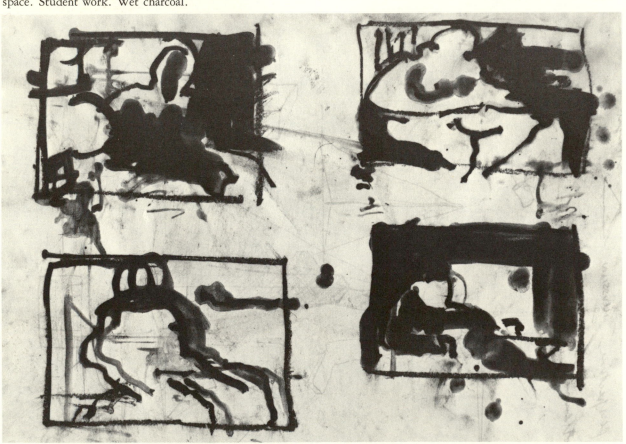

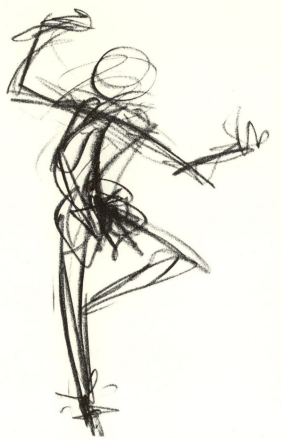

Line Gesture

Line gesture is related to mass gesture (Figs. 39–41). Like mass gesture, it describes interior forms, following the movement of the figure. Unlike mass gesture, it uses thin, narrow lines. The lines are tangled and overlapped, energetically stated. The lines may look like a scribble, but not a meaningless one. The pressure you apply to the drawing tool is important; heavy dark lines are varied with lighter ones. As in mass gesture, the tool is kept in constant contact with the paper. Experimentation with linear media is encouraged. Any implement that flows freely is recommended. Found or traditional implements are appropriate.

above left: 39. Line gesture. Student work. Charcoal.

above right: 40. Line gesture. Student work. Charcoal.

right: 41. Line gesture. Student work. Brush and ink.

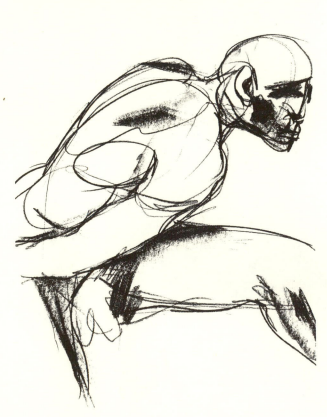

left: 42. Line gesture using darker line to emphasize weight and tension. Student work. Charcoal.

below: 43. Line gesture using darker line to emphasize weight and tension. Student work. Charcoal.

left: 44. Line gesture using darker line to emphasize weight and tension. Student work. Charcoal.

Problem 4 Draw a 3-minute line gesture using a model. During the last minute of the drawing use a heavier, darker line to emphasize those areas where you feel tension: where the heaviest weight, the most pressure, or the most exaggerated shape exists (Figs. 42–44).

Problem 5 Have a model take two poses and alternate between them every 30 seconds. Draw both poses. You may choose to overlap the figures. Use balsa stick and ink, charcoal pencil, or conté crayon (Fig. 45).

You may vary this problem by having the model take two poses in which one part of the body remains in the same position. For example, the legs might stay still while the torso moves.

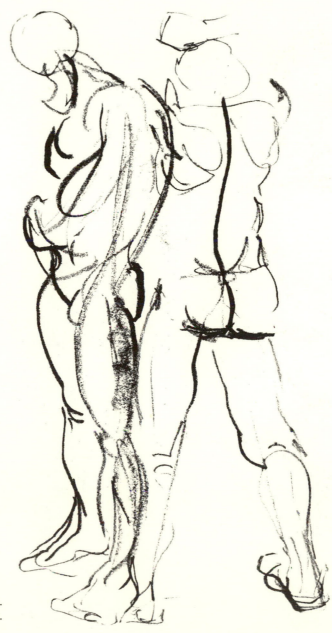

45. Line gesture using overlapping figures. Student work. Charcoal.

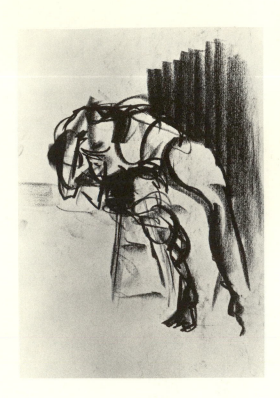

Mass and Line Gesture

The techniques of mass gesture and line gesture combine to create mass and line gesture. This style of drawing makes alternating use of thick and thin lines and broad marks (Figs. 46, 47).

Problem 6 Begin with a 15-second mass gesture of a still life or model, then alternate the side and tip of your charcoal. Use thin lines as well as broad marks. Define the more important areas with sharper lines. Continue to draw the forms as though they were transparent; let your pencil feel around the forms (Figs. 48–50).

left: 46. Mass and line gesture. Student work. Charcoal.

below: 47. Mass and line gesture. Student work. Charcoal.

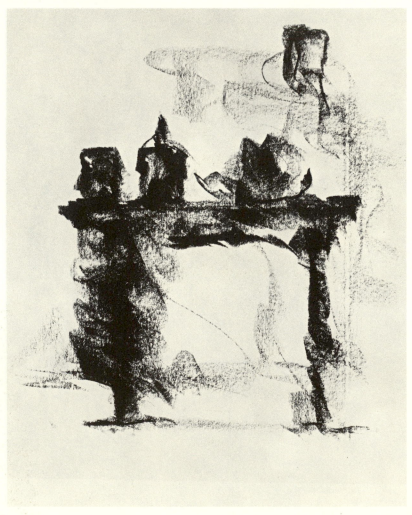

right: 48. Mass and line gesture.
Student work. Charcoal.

below: 49. Mass and line gesture.
Student work. Charcoal.

50. Mass and line gesture.
Student work. Charcoal.

51. Mass and line gesture.
Student work. Ink and wash.

Problem 7 Alternate media, using a 2-inch varnish brush and compressed charcoal. First, make a charcoal mass gesture of a still life or model; then, with a water and brush gesture, dissolve the charcoal marks. Restate the charcoal marks with a line gesture. Repeat this problem using ink and an ink wash (Fig. 51).

Problem 8 Choose a spot in the middle of a still life—it can be a positive or negative space—and begin your gesture at that point. Then try the following variations of this problem:

- Start at the top of the page.
- Start in the middle of the page.
- Start at the bottom of the page.
- Start at the side of the page.
- Start at the top of the still life.
- Start at the bottom of the still life.
- Start at the side of the still life.

In all your drawings try to fill the entire space.

Scribbled Line Gesture

The scribbled gesture is a tighter network of lines than was used in the preceding problems. Fill the form from the inside by creating a tangled mass resembling wire. Begin at the imagined center of the object and make the lines go from the inside out. The outside edge of the form will be fuzzy, indefinitely stated. The darkest, densest lines will be in the interior of the form (Figs. 52, 53). Again, the drawing tool remains in constant contact with the paper. The scribbles should be varied, with some tight rotations as well as broader, more sweeping motions (Fig. 54).

above: 52. Scribbled line gesture. Student work. Charcoal.

left: 53. Scribbled line gesture. Student work. Charcoal.

below: 54. Scribbled line gesture. Student work. Pencil.

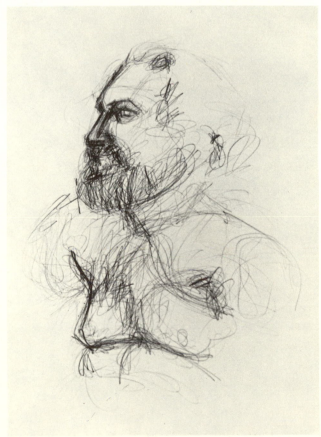

Problem 9 Sometimes found tools can result in exciting marks. Do a number of line gestures using the following materials or any others that occur to you:

- a china marker
- a twig dipped in ink
- a balsa stick dipped in ink
- a 6B pencil
- a carrot or potato stick dipped in ink or black acrylic
- a "found" drawing tool, such as a piece of styrofoam, a tennis ball, or a piece of crushed paper

Problem 10 Do a scribbled line drawing with the emphasis on negative space (Figs. 55, 56). The positive shapes will be much lighter, much whiter than the empty space. If most of your drawings have begun in the center of the page or at the top, try to change your approach and begin at one side or at the bottom.

55. Scribbled line drawing
with emphasis on negative space.
Student work. China marker and charcoal.

56. Scribbled line drawing
with emphasis on negative space.
Student work. China marker.

Sustained Gesture

Sustained gesture combines a description of what the object is doing with what it looks like. The latter was not a concern in earlier problems. Sustained gesture begins in the same spirit as before, with a quick notation of the *entire* subject. However, after this quick notation an analysis and examination of both the subject and the drawing take place. At this point you make corrections, accurately developing scale and proportion between the parts. In addition to drawing *through* the forms, you define some edges. The result is that the sustained gesture drawing actually begins to look like the subject being drawn.

Before drawing a still life, think of a verbal description of what it is "doing." If you speak of a *drooping* flower, an immediate visual image comes to mind. This is a good way to approach sustained gesture. Look at your subject. Is the bottle *thrusting* upward into space? Is the drape *languishing* on the table? Find descriptive terms for the subject.

If you are drawing a figure, take the pose of the model yourself. Hold the pose for 3 minutes. Where do you feel the stress? Where is the most tension, the heaviest weight in the

pose? Emphasize those areas in your drawing by using a heavier, darker line. Lighten your marks where there is less stress or weight. Think of the attitude of the model. This will add variety and interest to the exercises and will help infuse the drawings with an expressive quality.

Quick gestures take no more than 3 minutes. The sustained gesture takes longer—5, 10, even 15 minutes—as long as the spirit of spontaneity can be sustained.

Problem 11 Make a sustained gesture study of a still life or model. Begin very lightly and darken your marks only after you have settled on a more definite corrected shape. Draw quickly and energetically for 2 minutes. Then stop and analyze your drawing in relation to the subject. Have you generally stated the correct proportion and scale between the parts? Is the drawing well related to the page? If not, redraw lightly, making corrections. Alternate drawing with examination of the subject. Avoid making slow, constricted marks, so you do not change the style of the marks you have already made. Of all the problems discussed, you will find this exercise is the most open-ended for developing a drawing (Figs. 57–60).

57. Sustained gesture.
Student work. Charcoal.

above left: 58. Sustained gesture.
Student work. Charcoal.

above right 59. Sustained gesture.
Student work. Charcoal.

right: 60. Sustained gesture.
Student work. Lithographic pencil.

Summary: The Benefits of Gesture

Gesture drawing is a record of the energy that went into making the marks, and this record makes a visual connection between the artist and the subject drawn. Gesture drawing, then, encourages empathy between artist and subject. The gestural technique gives the drawing vitality and immediacy. It is a fast, direct route to the "second self," the part of us that has immediate recognition, that sees, composes, and organizes in a split second. Through gesture drawing we bring what we know and feel intuitively to the conscious self, and this is its prime benefit.

Gesture also trains us to search out the underlying structure. It helps us to digest the whole before going to the parts, to concentrate in an intense and sustained way.

Another advantage of the gestural beginning is that it furnishes a blueprint for more sustained drawing. In learning to translate three-dimensional forms onto a two-dimensional surface, gesture drawing makes us aware of the limits of the page without our having to refer constantly to it. It helps us place shapes and volumes in their proper scale and proportion. It introduces the lights and darks into the drawing.

Finally, gestural drawing provides a flexible and correctable beginning for a more extended drawing. It gives options for developing the work. You can extend the drawing over a period of time. Gesture provides you with a route to a finished drawing.

Spatial Relationships of the Art Elements

Part II

Shape and Volume

Chapter Three

ince our ideas about ourselves and the world are constantly changing, it is logical that the art reflecting our ideas changes also. These philosophical ideas—what we think about ourselves and about our relationship with nature and society—affect the conventions of our art. The elements of art—shape, volume, value, line, texture, and color—have remained the same throughout the ages. However, the ways they are used and combined to create different kinds of space have undergone changes.

In this chapter and throughout the book, we are translating objects as they exist in real space—with height, width, and depth—onto a flat surface having only height and width. The space conveyed can be relatively *flat,* or *shallow,* or it can be *illusionistic,* giving the impression of space and volume. In the Amédée Ozenfant still life (Fig. 61) the space is compressed. The objects seem to occupy a shallow space. Although Sue Hettmansperger has chosen a more abstract subject for her drawing (Fig. 62), she creates the illusion of volume by shading, or *modeling.* The forms seem to advance toward the viewer, pressing out of the picture plane. In his drawing of the Guggenheim Museum (Fig. 63), Richard Hamilton achieves an even greater sense of volume. Although the space behind the building is flattened out, the building itself is illusionistically volumetric.

61. Amédée Ozenfant. *Untitled (Still Life).* 1924. Pastel, 11¾ × 8⅝″ (30 × 22 cm). Fort Worth Art Museum.

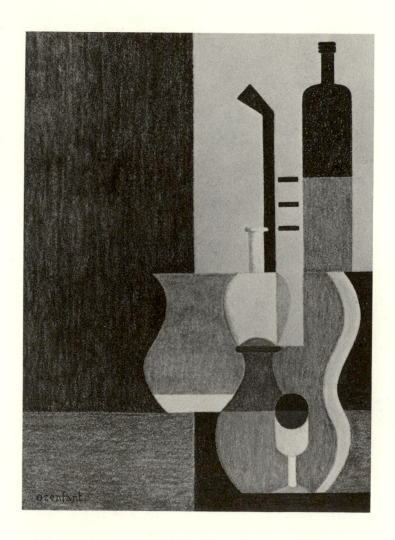

62. Sue Hettmansperger.
Untitled. 1975.
Watercolor and pencil,
23 × 25″ (58 × 64 cm).
North Carolina National Bank.

63. Richard Hamilton.
The Solomon R. Guggenheim. 1965.
Pastel and gouache,
20 × 33″ (51 × 84 cm).
Courtesy the artist.

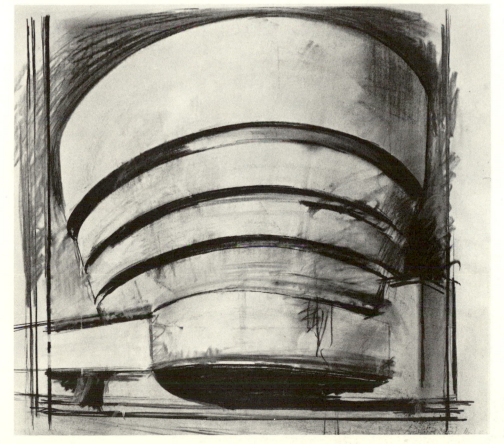

In addition to being relatively flat or illusionistic, the space conveyed can even be *ambiguous*—not clearly flat or clearly three-dimensional. Ambiguous space is a combination of both two- and three-dimensional elements. The sketch of Picasso by Jasper Johns (Fig. 64) incorporates collage and drawing and combines illusionistic space with flat outline. The effect is one of spatial ambiguity.

We all have a subjective response to space: Each of us experiences and interprets space in an individual way. A child's idea of space differs from an adult's. Space has been treated differently in different eras and cultures. The flattened space in a Mixtec *codex,* or manuscript book (Fig. 65), contrasts sharply with the illusionistic space in a Renaissance drawing (Fig. 66), although both were produced during the same period. In the Mixtec drawing the space remains flat because of the use of unmodeled, or flat, value shapes and outline, as well as the use of staggered base lines, the imaginary lines on which the figures stand. In the Renaissance drawing, however, the artist directs the eyes of the viewer into a stepped progression of space. This effect is achieved by drawing the figures and buildings in accurate proportion to each other and by making the forms smaller as they recede into the distance. Unlike the Mixtec artist, the Renaissance artist had as a goal the depiction of real space.

Whether the emphasis is on flat, illusionistic, or ambiguous space, the concept of space is of lasting interest to artists. Space is to the artist what time is to the musician. Although ambiguous space has been of continuing interest to the 20th-century artist, a range of spatial concepts from shallow to deep are evident in the art of today.

This chapter will discuss shape and volume in drawings. Beginning with shape, let us consider the way the elements can be used to create different kinds of space.

64. Jasper Johns.
Sketch for *Cup 2 Picasso/Cups 4 Picasso.*
1971–72. Collage and watercolor,
15½ X 20¼″ (39 X 51 cm).
Courtesy the artist.

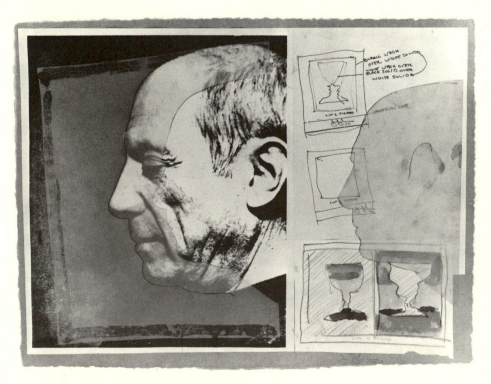

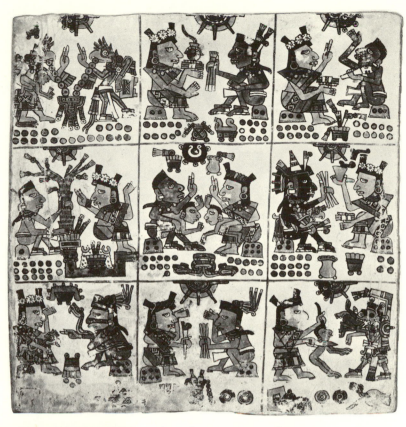

above: 65. *Nine Pairs of Divinities.*
Mixtec codex, Mexico.
14th–16th century.
Vatican Library, Rome.

left: 66. Federigo Zuccaro.
Emperor Frederic Barbarossa
before Pope Alexander III. Late 16th century.
Pen and ink, wash over chalk;
10⅜ × 8½″ (26 × 21 cm).
Pierpont Morgan Library, New York
(Janos Scholz Collection).

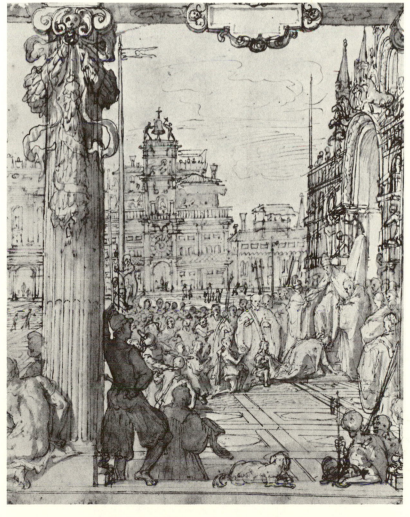

above: 67. Peter Plagens. *Untitled (48-76).* 1976.
Pastel, oil pastel, and gouache; 32 × 47″ (81 × 119 cm). Courtesy the artist.

below: 68. Joan Miró. *Album 13.* 1948.
Lithograph, 17½ × 21⅞″ (45 × 56 cm). Courtesy Galerie Maeght, Paris.

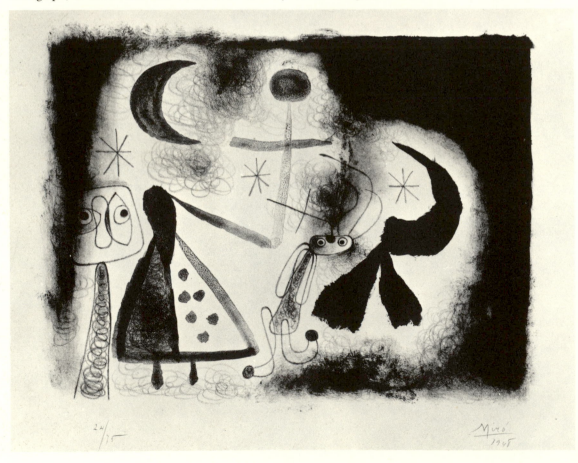

Shape

An object's shape tells you what that object is. A shape is a con-figuration that has height and width and is therefore two-dimen-sional. Shapes can be divided into two basic categories: *geometric* and *organic*.

Geometric shapes are created by mathematical laws. They include squares, rectangles, triangles, trapezoids, hexagons, and pentagons, as well as circles, ovals, and ellipses. Peter Plagens is an artist who juxtaposes geometric shapes against an expression-istic background, resulting in a tension between control and looseness (Fig. 67).

Organic shapes, sometimes referred to as *biomorphic* or *amoeboid* shapes, are free-form, less regular than geometric shapes. Joan Miró's lithograph *Album 13* (Fig. 68) illustrates his frequent use of amoeboid shapes.

A combination of geometric and organic shapes is also used. The collage by Romare Bearden (Fig. 69) combines geometric and amoeboid shapes in a well-integrated composition. The figures in Bearden's collage are composed of organic shapes, while the background is completely geometric—squares and rectangles. The overall spatial effect is ambiguous because of the illogical size of the figures and their placement in the composition.

69. Romare Bearden.
Interior with Profiles. 1969.
Collage, 3'3¾" × 4'1⅛" (1.01 × 1.27 m).
First National Bank of Chicago.

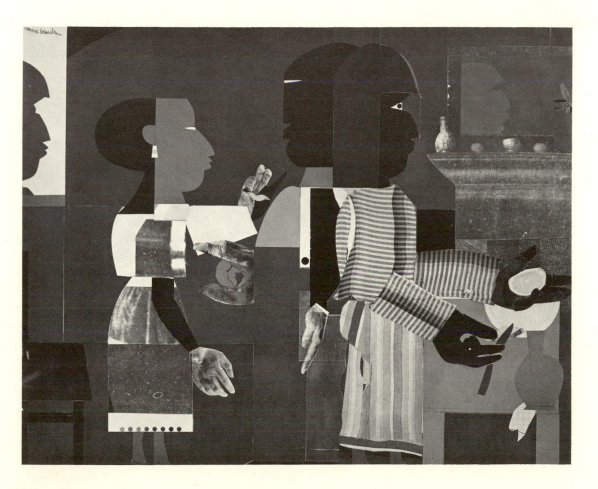

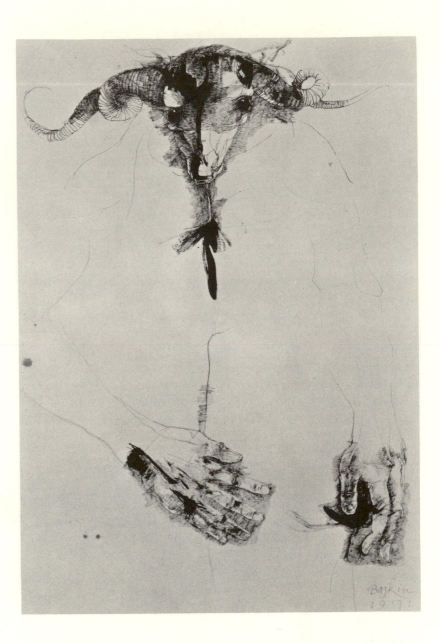

71. Incomplete shapes are perceived
as completed or closed.

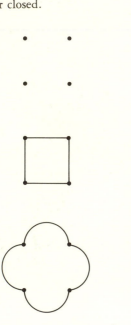

72. The four dots are perceived as forming
a square rather than a more complex shape.

73. Smaller shapes are perceived as part
of their larger organization.

Shapes can be made by value, line, texture, or color. They may even be *suggested* or *implied*. In the drawing *Egyptian Ballet—Horns and Hands* (Fig. 70), Leonard Baskin suggests or implies the shape of the man-goat figure with a minimal use of line. The negative white space is *conceptually* filled. Although the shape of the figure is not explicitly shown, we imagine it to be there.

Our perception is such that we fill in an omitted segment of a shape and perceive that shape as completed or closed (Fig. 71). In doing so, we tend to perceive the simplest structure that will complete the shape rather than a more complex one (Fig. 72). We also group smaller shapes into their larger organizations and see the parts as they make up the whole (Fig. 73).

Shapes of similar size, color, or form attract each other, and in this way the artist directs the eyes of the viewer through the picture plane. In Hans Hofmann's work *Quartet* (Fig. 74), the

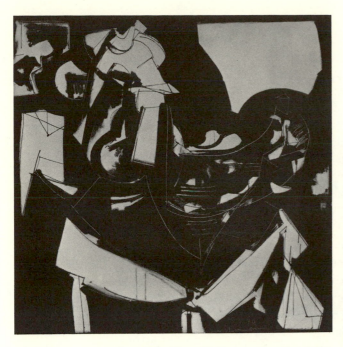

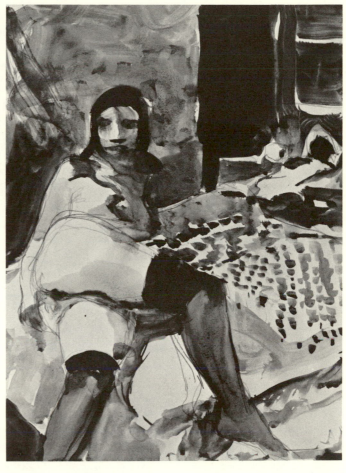

above: 74. Hans Hofmann. *Quartet.* 1949.
Oil on canvas, 4'2" (1.27 m) square.
Courtesy André Emmerich Gallery, New York.

right: 75. Richard Diebenkorn. *Girl Looking in Mirror.*
1962. Ink wash and pencil, 17 × 12⅜" (43 × 31 cm).
San Francisco Museum of Modern Art (purchase).

large shapes appear to advance and the small shapes appear to
recede. This kind of attraction and tension between shapes forms
a major theme in Hofmann's work.

Positive and Negative Space

On the *picture plane*—the surface on which you are drawing—
there is another distinction between shapes, that between *positive*
and *negative.* Positive shape refers to the shapes of the objects you
are drawing. Negative space describes the space surrounding the
positive forms. Negative space is *relative* to positive shapes. In
Richard Diebenkorn's drawing (Fig. 75) a woman is reclining on
a bed; the bed is on the floor and in front of a wall. The floor
forms a *ground* for the *figure* of the bed; the bed and wall form a
ground for the figure of the woman. Thus, the floor and wall are
negative to the bed, and the bed is negative to the woman.

We are conditioned to search out positive shapes in real life, but this habit must be broken in making art. In Dmitri Wright's stencil print (Fig. 76) we can see a changing emphasis from the positive images to the negative space surrounding them. The print resembles a photographic negative. Wright's use of value and the fact that we cannot exactly locate the objects contribute to a feeling of emptiness. On the picture plane all shapes, both positive and negative, are equally important. Combined, they give a composition unity. Paul Wieghardt's integration of positive and negative shapes is so complete that it is nearly impossible to classify each shape as either positive or negative (Fig. 77).

In Ellsworth Kelly's print (Fig. 78) the positive and negative shapes switch with each other. In one interpretation of this print we see the gray, almost tangent semicircles as the positive shape. In another interpretation we see the gray shapes as background to the black form in the center. We are confused as to which is the "correct" view and this ambiguity gives a power to the print. This positive/negative interchange is a characteristic of Kelly's work.

The terms *positive/negative* and *figure/ground* are interchangeable. Other terms are *foreground/background*, *figure/field*, and *solid/void*. Negative space is also called *empty space* or *interspace*.

76. Dmitri Wright. *Untitled.* 1970. Stencil print, 23⅞ × 36⅛″ (61 × 92 cm). Brooklyn Museum (gift of the artist).

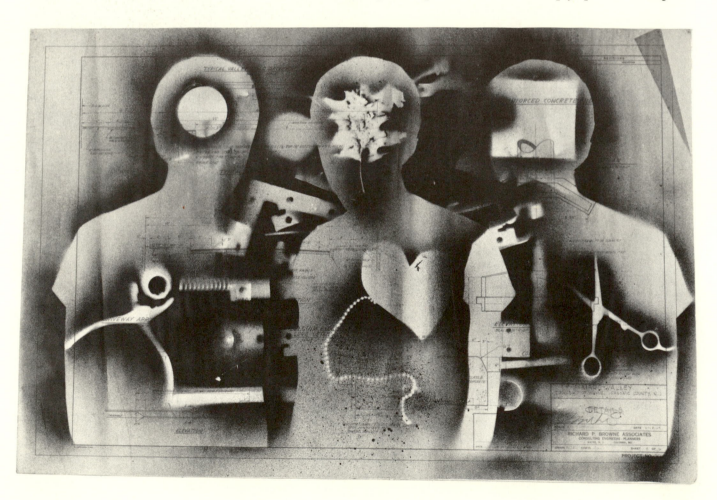

Volume

You probably are aware that it has been difficult to speak of shape without occasionally referring to *volume*. Volume is the three-dimensional equivalent of two-dimensional shape. In the graphic arts and in painting, volume is the illusion of three-dimensional space. *Mass* deals with the weight or density of an object. Volume defines mass; it gives mass perimeters.

Shapes have volume when they are read as planes. A cube can demonstrate how shape becomes volume. If you take a cube apart so that its six sides, or *planes,* lie flat, you have changed the

right: 77. Paul Wieghardt. *The Green Beads.* 1951.
Oil on canvas, 39⅜ × 20″ (101 × 77 cm).
Collection Mr. and Mrs. Seymour Banish,
Santa Barbara, Calif.
(© Mrs. Nelli Wieghardt)

below: 78. Ellsworth Kelly.
Color Paper Images—XI. 1976.
Colored pulp laminated to handmade paper,
46½ × 32½″ (118 × 83 cm).
Published by Tyler Graphics Ltd. © 1976.

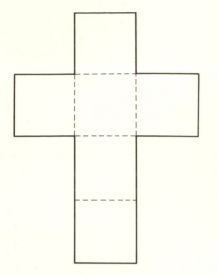

cube from a three-dimensional form into a two-dimensional shape (Fig. 79). This new cross-shape form is made up of the six planes of the original box and is now a flat shape. If you reassemble the box, the reconnected planes (the sides, top, and bottom) once again have volume. By turning the box in your hands you can see all six planes. If you make a representation of the box seen from below eye level with one of its corners turned toward you, it will be composed of only three visible planes. Even if you draw only these three planes, the illusion of three-dimensionality remains. If you erase the interior lines, leaving the outer outline only, you have again changed volume into a flat shape.

The key word here is *plane.* By connecting the sides, or *planes,* of the cube, you make a *planar analysis* of the box. You make shape function as a plane, as a component of volume. Henry Moore's interlocking planes create the effect of rounded volumes, as in Figure 80.

We have one more bridge in transforming shape into volume: *modeling.* Modeling is the use of light and dark on a surface to make a shape become volumetric. You can see the modeling technique clearly in the pencil drawing by Léger in Figure 81. Figure 82 reduces Léger's composition to shape alone. By com-

above: 79. Cross-shape form made from an opened box.

below: 80. Henry Moore. *Family Group.* 1951. Chalk and watercolor, 17 × 20″ (43 × 51 cm). Collection R. Clarke, Christchurch, New Zealand.

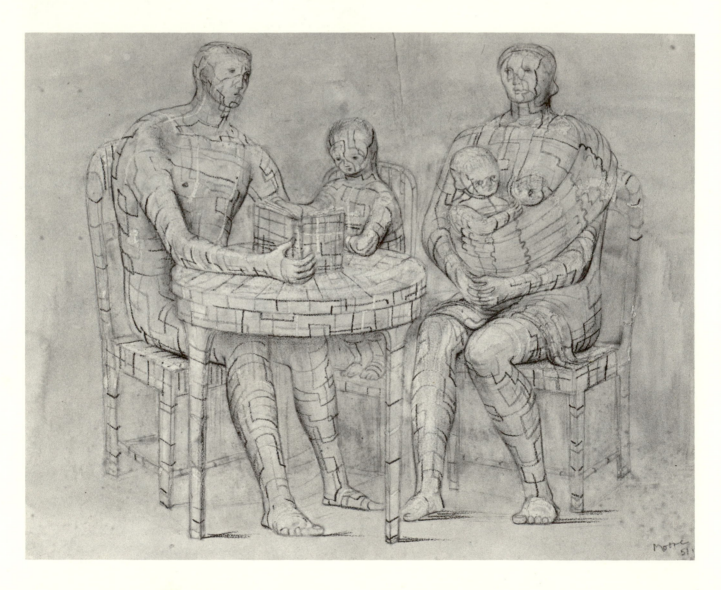

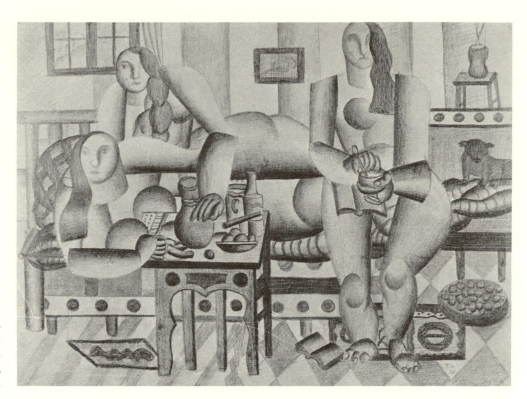

81. Fernand Léger.
Three Women. 1920. Pencil,
14½ × 20″ (37 × 51 cm).
Rijksmuseum Kröller-Müller,
Otterlo, Netherlands.

82. Shape analysis
of Figure 81,
Fernand Léger's *Three Women*.

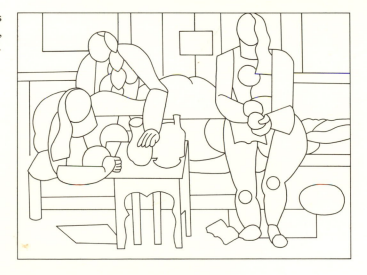

paring the two you can see how Léger has used modeling to transform these shapes into volumes. Notice also the spatial contradiction achieved by combining flat cutout shapes with fully rounded forms.

The following exercises will help you think about shape and volume in new ways.

Problem 12 Make a quick, continuous line drawing of a still life. By using a single, overlapping line, you will automatically create a number of enclosed shapes. Redraw on top of this drawing. Regardless of the actual shapes in the still life, reduce the forms to rectangles and squares.

below: 83. Geometric and amoeboid shapes. Student work. Charcoal and conté.

right: 84. Geometric and amoeboid shapes. Student work. Charcoal and conté.

Repeat the problem, using ovals and circles. You will, of course, again have to force the geometric shapes to fit the actual still-life forms.

Look carefully at the subject. Which shapes are actually there? Which shapes are implied? What types of shapes predominate? In asking these questions you are giving yourself some options for the direction the drawing is to take. You may see that circular forms predominate and may or may not choose to emphasize the circular motif in the drawing. In stopping the drawing to make a quick analysis, you are bringing to consciousness information that will be helpful as you extend the drawing.

Problem 13 Draw the objects *and* the negative shapes in a still life, using a variety of geometric shapes (Fig. 83). Repeat the problem using organic shapes (Fig. 84).

Problem 14 With landscape as a subject, draw only organic forms for both positive and negative shapes. Make sure the negative spaces form enclosed shapes. Repeat this problem ten or more times, varying the composition each time.

Problem 15 Choose any subject; landscape, still life, or model will work equally well. Do a drawing in which you invent some negative shapes that relate to the positive shapes of your subject (Figs. 85, 86).

Problem 16 Begin by making a collage of torn paper to represent the negative spaces in a still life. Then do a simple line drawing of a still life; allow line to cross over the collage shapes to help integrate the positive and negative areas (Fig. 87). Use enclosed shapes.

above: 85. Invented negative shapes.
Student work. Lithographic crayon.

right: 86. Invented negative shapes.
Student work. Charcoal.

below: 87. Collage shapes.
Student work. Collage and ink.

Problem 17 Make an arrangement of several objects. In this drawing, emphasize negative space between the objects by making it equal in importance to the positive shapes (Figs. 88, 89).

Problem 18 For this drawing you are to invent a subject. It may be taken from your memory of a real object or event, or it may be an invented form or abstraction, but it will be a mental construct. Look back at the conceptualized drawings in Chapter 1 (see Figs. 4–6) to refamiliarize yourself with their nature.

Once you have thought of a subject, draw it by using enclosed shapes in both positive and negative space. You may wish to use outlining to define the shapes, or you could let texture or value define them. Fill the entire page with your composition. There should be no leftover space. The whole surface of your paper should be filled with definite enclosed shapes (Figs. 90–92).

left: 88. Emphasis on negative shapes. Student work. Conté.

below: 89. Emphasis on negative shapes. Student work. China marker with turpentine.

above: 90. Enclosed shapes. Student work. Pen and ink.

right: 91. Enclosed shapes. Student work. Pen and ink.

below: 92. Enclosed shapes. Student work. Pen and ink.

KING TUT FLOATING BESIDE A PYRAMID ON THE FLOOR PLAN OF SAINT PETERS ON THE DESERT FLOOR

left: 93. Progression of space.
Student work. Charcoal.

above: 94. Modeled negative space.
Student work. Charcoal.

below: 95. Modeled negative space.
Student work. Charcoal and ink.

Problem 19 Arrange several objects in deep space. Then draw these objects, exaggerating the space. Arrange large and small shapes on your paper, overlap planes, and use different base lines for each object.

Think in terms of the different levels of negative space—horizontal space between the objects, vertical above them, and diagonal between them as they recede into the background. Imagine that between the first object and the last there are rows or panes of glass. Due to the cloudy effect of the glass, the last object is more indistinct than the first. Its edges are blurred, and its color is diminished. A "haze" creates a different kind of atmosphere between the first and the last object (Fig. 93). Try to emphasize in your drawing the differences between the foreground, middle ground, and background of the still life.

Problem 20 This problem is an extension of the preceding one, but you may use a model or a still life. You are to model negative space, to make the shapes change from light to dark. Concentrate on the different *layers* of space that exist between you and the back of the still life or figure. Different lights and darks will indicate the varying levels.

This modeling of negative space is a *plastic* rendering of the subject, a three-dimensional description of the space. The objects need not be recognizable in your drawing, but there should be a feeling for the different levels of space (Figs. 94–97).

left: 96. Composition through a viewer. Student work. Charcoal.

right: 97. Composition through a viewer. Student work. Charcoal.

left: 98. Planes into volume. Student work. Conté.
below: 99. Planes into volume. Student work. Charcoal.

Spatial Relationships of the Art Elements

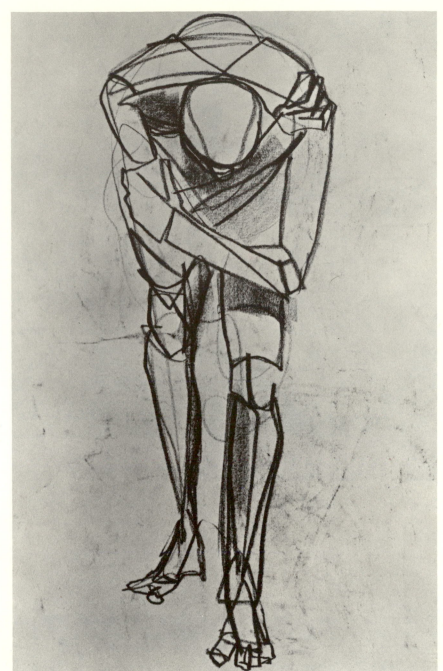

100. Planes into volume.
Student work. Charcoal.

Problem 21 Using paper bags, stacks of boxes, or bricks as subject, draw the *edges* of planes rather than the outside outline of the objects (Fig. 98). Concentrate on the volumetric aspect of the subject (Fig. 99). The same technique can be used for figure drawing emphasizing connecting planes (Fig. 100).

Problem 22 With your own face as subject, do a planar analysis. Make several drawings. Begin by drawing the larger planes or groups of planes. Then draw the smaller units. Work from the general to the specific.

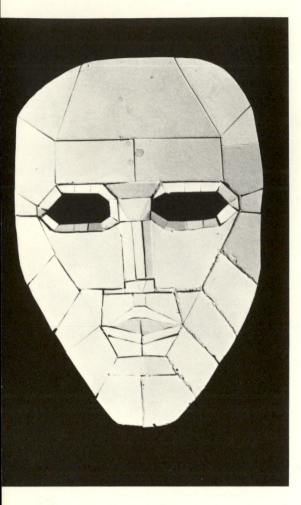

After you have become familiar with the planar aspects of your face, construct a three-dimensional mask (Fig. 101) from cardboard or Bristol board. The sculptured mask should be no smaller than life-size. You will need to keep a sketch pad handy to draw the pattern of the planes. This interplay between stating the form two-dimensionally and making a three-dimensional object will strengthen your understanding of the process involved in creating the illusion of volume.

Cut out the planes and use masking tape to attach them to one another. Look for the most complex network of planes. Note how the larger shapes contain smaller, more detailed ones.

Making a three-dimensional analysis is very involved. When you have completed this problem, you will have gained a real insight into how the larger planes "contain" the smaller detailed planes, as well as how large planes join one another to create a three-dimensional structural framework.

Paint the cardboard mask with white paint or gesso (Fig. 102). Use two coats to cover the masking tape. You have now deemphasized the edges of the planes to create a more subtle relationship between them. Place your mask under different lighting conditions in order to note how different light emphasizes different planes of the face.

Problem 23 For this problem it is preferable to use a model. Read through all the instructions carefully before beginning to draw. You will need at least an hour for the drawing.

Use a 6B pencil that is kept sharp at all times. To sharpen the pencil properly, hold the point down in contact with a hard, flat surface. Sharpen with a single-edge razor blade, using a downward motion. Revolve the pencil, sharpening evenly on all sides. Use a sandpaper pad to refine the point between sharpenings. Draw on white charcoal paper.

above: 101. Planar analysis. Student work. Cardboard.

below: 102. Planar analysis. Student work. Cardboard.

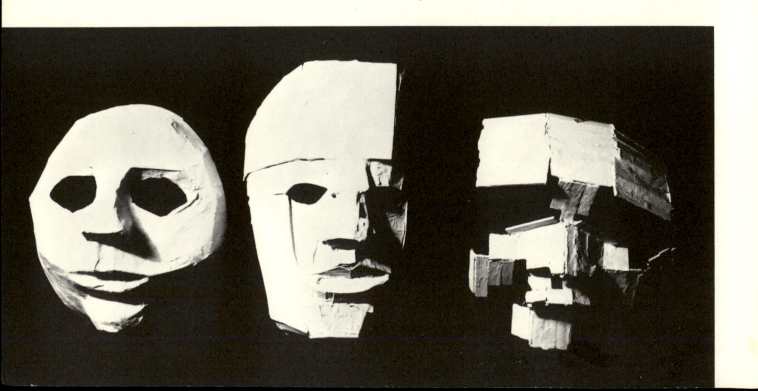

Begin with a light line gesture to establish proportions and organizational lines. Again, as in the head study, analyze the figure according to its composition of planes. Begin with the largest planes and work from the general to the specific. Determine where the figure turns at a 90-degree angle from you and enclose that plane. Look for the major volumes of the body and draw the planes that make up these volumes. After you have drawn for a few minutes, rub the drawing with a clean piece of newsprint. Rub inward toward the figure. Redraw, not just tracing the same planes, but correcting the groupings. Alternate between drawing and rubbing. Continue to group planes according to their larger organization (Fig. 103).

This technique is different from the continuous movement of the gesture and overlapping line drawings. Here you are attempting to place each plane in its proper relation to every other plane. *Try to imagine that the pencil is in contact with the model.* Keep your eyes and pencil moving together. Do not let your eyes wander ahead of the marks.

When viewed closely, this drawing might resemble a jigsaw puzzle. Each plane is a closed shape. When you stand back from

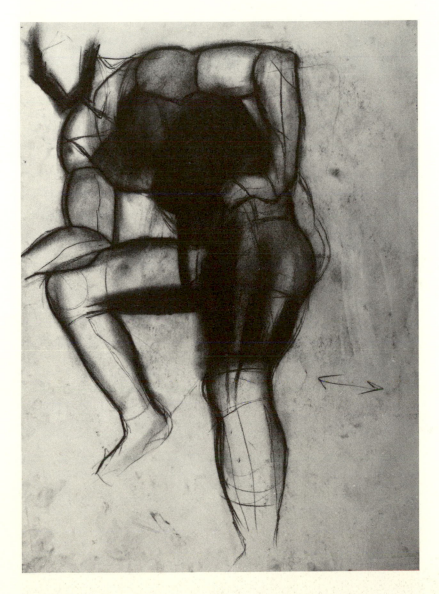

103. Rubbed planar drawing. Student work. Charcoal pencil.

left: 104. Rubbed planar drawing. Student work. Charcoal pencil.

right: 105. Rubbed planar drawing. Student work. Charcoal pencil.

the drawing, however, the planes begin to create volume, and the result may be a more illusionistically volumetric drawing than you have done before (Fig. 104). The rubbing and redrawing should give the planes a roundness and depth (Fig. 105).

Two warnings: Do not rub the drawing with your fingers, because the oil from your hands will transfer to the paper and make splotchy marks. Do not rub the drawing with a chamois skin or you will remove too much of the drawing.

Following the instructions carefully will help you increase your ability to concentrate and to detect planes and groups of planes that are structurally related.

Problem 24 Look closely at the works by Henry Moore illustrated in Figures 80 and 175. If possible, find illustrations of some of his other works as well as of works by Isamu Noguchi and Yves Tanguy. In your sketchbook invent some organic, bonelike volumes with openings through their surfaces. Draw these forms from a variety of views; that is, imagine what they would look like from various angles when they are turned in space. Concentrate on volume. What are some drawing techniques that you could use to enhance their three-dimensional aspects? Using the volumes that you have invented, make the following four drawings:

1. Use three base lines. Arrange all your forms parallel to the picture plane, creating as shallow a space as possible.
2. Place several of the forms in a landscape setting, creating as deep a space as possible. Use a separate base line for each object.
3. Arrange the forms as if they were weightless, floating above you.
4. Draw your objects as if you were high above them, looking down—a bird's-eye view.

106. Ambiguous space. Student work. Pencil.

Remember to sustain the idea of volume in your imagined forms. Keep in mind their spatial setting.

Summary: Different Kinds of Space

A shape is two-dimensional if it has the same value or color over its entire surface. Uniform texture, uniform value, and uniform color will make even volume look flat (Fig. 106). A form outlined by an unvarying line creates a two-dimensional effect.

Shapes functioning as planes, as the sides of a volume, give an illusion of three-dimensionality. Shapes can be given dimension by tilting them, truncating them, making them move diagonally into the picture plane.

When both two- and three-dimensional elements are used in the same drawing, the result is ambiguous space. If a shape cannot be clearly located in relation to other shapes in the drawing, ambiguous space again results (Fig. 107).

If a line delineating a shape varies in darkness or thickness, or if the line breaks (that is, if it is an implied line), the shape becomes less flat. Imprecise edges, blurred texture, and the use of modeling tend to make a shape more volumetric. Modeling—the change from light to dark across a shape—links shape and volume, creating the illusion of three-dimensionality.

107. Ambiguous space. Student work. Charcoal.

Value

Chapter Four

Value is the gradation from light to dark regardless of color. This *achromatic* approach (relating to light and dark rather than to hue) is our concern in this section.

Value is determined both by the actual color of an object and by the degree of light that strikes it. An object can be red or blue and still have the same value. What is important is the lightness or darkness of the color. It is difficult to learn to separate color from value, but we have two good examples of this being done in everyday life—in black-and-white photography and in black-and-white television.

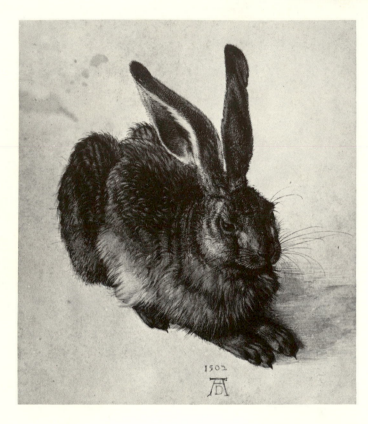

left: 108. Albrecht Dürer. *Young Hare.* 1502. Watercolor, 9⅞ × 8⅞″ (25 × 23 cm). Albertina, Vienna.

below: 109. Wayne Thiebaud. *Rabbit* from 7 *Still Lifes and a Rabbit.* 1970. Lithograph, 22¼ × 30″ (57 × 76 cm). Brooklyn Museum; published by Parasol Press, New York.

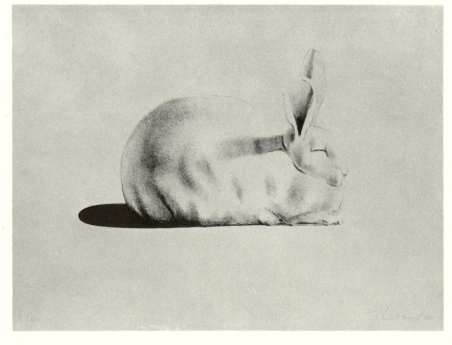

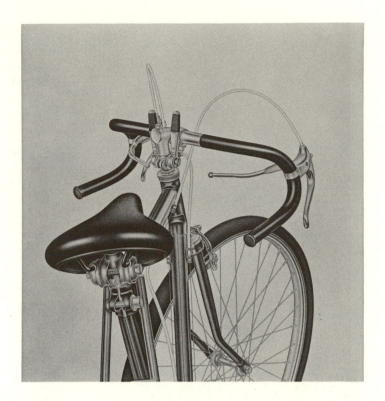

110. Alan Dworkowitz. *Bicycle II*. 1977. Graphite, 20 × 18″ (51 × 46 cm). Courtesy Louis K. Meisel Gallery, New York.

If you squint your eyes while looking at an object or at color television, the colors diminish and you begin to see patterns of light and dark instead of color patterns. When the value is the same on both the object and its background, you easily lose the exact edge of the object—both object and negative space are united by the same value. Although value can be confined to a shape, it can also cross over a shape and empty space; it can begin and end independently of a shape.

Artists can depict an object's actual appearance or reject the value patterns seen in nature; they can create their own value patterns and their own kind of order. Albrecht Dürer was governed by actual appearances in his rendering of a hare (Fig. 108). Texture, lighting, and details testify to Dürer's close, accurate observation. Wayne Thiebaud's *Rabbit* (Fig. 109), however, does not conform to actual appearance. The animal is strangely isolated, its form generalized. The value patterns are exaggerated by Thiebaud's intense light. Whether Thiebaud actually set up artificial lighting or invented it in the drawing, his manipulation of value is still an intense and personal one. As a result of the artists' use of value the two drawings give us very different feelings.

Value describes objects, the light hitting them, and their weight, structure, and space. Value also describes an artist's feelings. So value can have two functions: it can be *objectively* as well as *subjectively* descriptive. Alan Dworkowitz' drawing of the bicycle (Fig. 110) is objectively stated, nearly photographically accurate. The viewer has the impression that Dworkowitz, while taking an unusual viewpoint in relationship to the bicycle, has recorded its parts exactly as they appear.

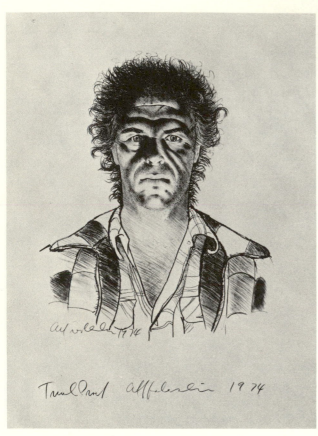

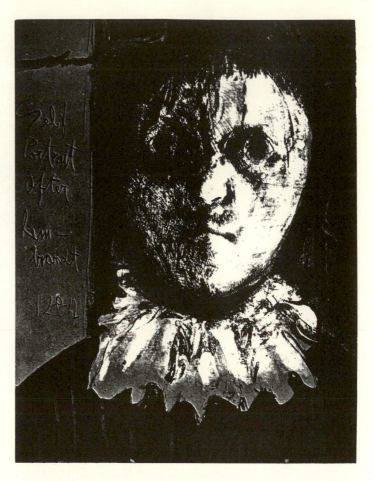

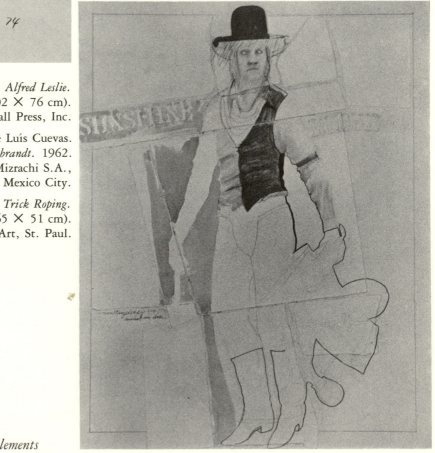

above: 111. Alfred Leslie. *Alfred Leslie.*
1974. Lithograph, 40 × 30″ (102 × 76 cm).
© Landfall Press, Inc.

above right: 112. José Luís Cuevas.
Autoretrato como Rembrandt. 1962.
Lithograph. Courtesy Galeria de Arte Mizrachi S.A.,
Mexico City.

right: 113. Walter Piehl, Jr. *Trick Roping.*
1973. Pencil and wash, 25¾ × 20″ (65 × 51 cm).
Minnesota Museum of Art, St. Paul.

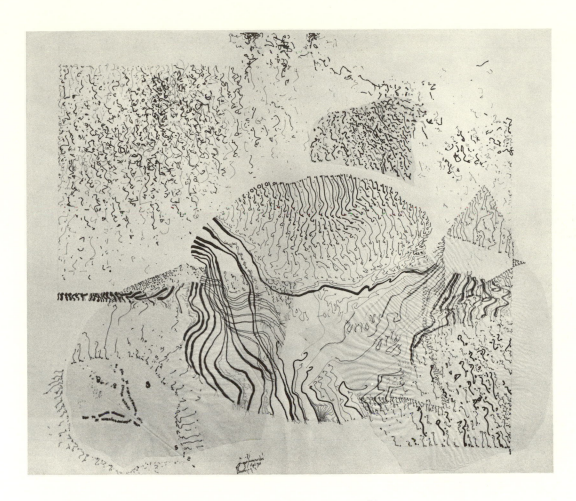

114. Mary Bauermeister. *Drawing No. 16, Three Pergaments.* 1964.
Ink and collage, 19½ × 23½″ (50 × 60 cm).
Courtesy Galeria Bonino, New York.

Alfred Leslie's self-portrait in Figure 111 is also accurate and
well observed, but there is a sense of drama, even of apprehen-
sion, as we view the drawing. This effect of tension is gained by
Leslie's use of value. The striking contrasts and the use of
underlighting produce a very different mood than does the
Dworkowitz drawing. Leslie uses a subjective approach, as does
José Cuevas in his self-portrait (Fig. 112). Cuevas' lithograph is
even more exaggerated and expressionistic, and his use of value is
further removed from actual appearance than is Leslie's. In all
three of these works the total effect of the drawing is made possi-
ble by the artist's use of value.

In the graphic arts there are two basic ways to define a
form—by line or by placement of two values next to each other.
Most drawings are a combination of line and value. Walter Piehl
in *Trick Roping* (Fig. 113) combines pencil with wash, creating
both line and value. Successful value drawings, however, can be
made using line alone. An example is Mary Bauermeister's ink
drawing (Fig. 114). The artist may also use value alone, as in the

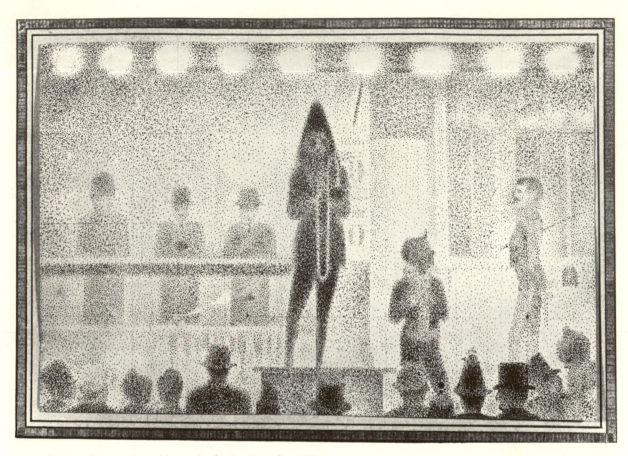

115. Georges Seurat. *Ensemble* (study for *La Parade*). 1887.
Pen and ink, 5 × 7⅜″ (13 × 19 cm).
Courtesy Sotheby Parke Bernet and Co., London.

Georges Seurat drawing *Ensemble* (Fig. 115). Seurat uses value shapes exclusively in many of his drawings. He exerts absolute control over his medium, pen and ink, producing a subtle value range. The same texture throughout the confined shapes produces a relatively flat space in his drawings.

Value can define a focal point, especially if the rest of the drawing is stated in line. In his *Portrait of a Man* (Fig. 116), Rico Lebrun focuses attention on the subject's face by careful rendering and well-observed use of value. The finished quality of the face contrasts sharply with the gestural, linear suggestion of the body. The energy of the marks is an intriguing foil to the treatment of the head.

Jenny Snider's pencil drawing *Dislocated I* (Fig. 117) shows how even linear drawings have value because of the line's gradation from light to dark. Change in value can occur by controlling the pressure applied to the drawing tool. A lighter value results when ink or paint is diluted. Tonal quality can be made by smudging, rubbing, and erasing. Value can be created by grouping lines—by crosshatching, tangling, or scribbling them one over the other, as illustrated by the Robert Straight drawing *Crossfire* (Fig. 118).

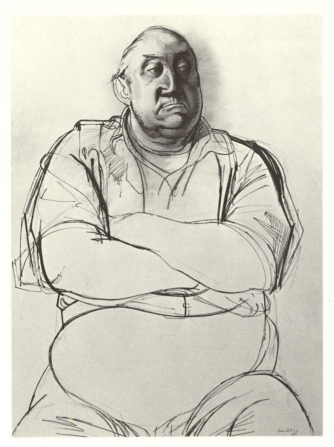

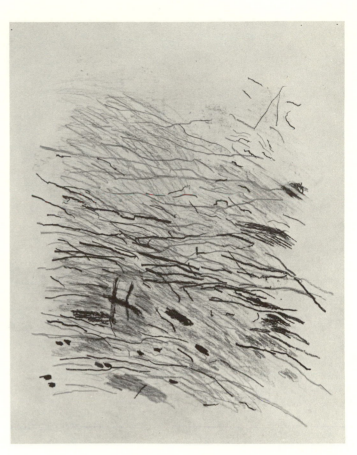

116. Rico Lebrun. *Portrait of a Man.* 1939.
Ink and chalk. Private collection.

117. Jenny Snider. *Dislocated I.* 1973. Colored pencil.
Courtesy Nancy Hoffman Gallery, New York.

118. Robert Straight.
Crossfire. 1974.
Pastel and mixed media,
27 × 40″ (68 × 102 cm).
State University College
at Potsdam, N.Y.

119. Danielle Fagan. *Untitled.* 1979.
Conté, 18 × 24″ (46 × 61 cm).
Courtesy the artist.

Value Used Arbitrarily

Artists sometimes ignore natural laws of value, such as the way light falls across a form. They are then said to be using value *arbitrarily*—to create a focal point, to establish a balance between parts, or to call attention to a particular shape. These uses of value are based on intuitive responses or the need to comply with compositional demands. In other words, arbitrarily stated values are light and dark patterns that differ from actual values.

Danielle Fagan, in her drawing of a still life (Fig. 119), has distributed value shapes arbitrarily. She has ignored the weight of the objects, employed an arbitrary light source, and minimized the weight and structure of the objects. A value pattern has been established to make a cohesive composition.

Problem 25 Using the broad side of a piece of charcoal, make a drawing of a still life. Begin with a continuous overlapping line. Then study the drawing and arbitrarily decide which shapes to make dark. Establish a light and dark pattern, basing your decisions on your reaction to the work rather than on the actual appearance of the still life.

Lead the viewer's eyes through the picture plane by the location of these dark shapes. Add gray values in the drawing, establishing a secondary pattern. You can create a focal point using areas of sharp contrast. Your drawing will be an example of the arbitrary use of value.

Repeat the problem, using ink and ink wash. Begin with a 15-second gesture to state major organizational lines. Define the subject more clearly with ink line. Allow the ink to wash over objects and space. Do not confine the wash areas to positive shapes only. Let the values begin and end independently of objects.

Problem 26 Make a continuous overlapping line drawing of an object; fill the page using background shapes. The overlapping lines will create some repeated shapes. Using black, white, and two shades of gray, distribute values within the defined shapes. State the values arbitrarily, not according the actual appearance of the objects (Fig. 120).

Problem 27 Draw a model in pencil using enclosed shapes. Rather than using only flat shapes and value patterns, model some of the shapes to give them a more volumetric appearance. Combining flat shapes and modeled volumes in the same drawing creates ambiguous space (Fig. 121).

left: 120. Value used two-dimensionally. Student work. Charcoal.

below: 121. Modeled and flat value. Student work. Pencil.

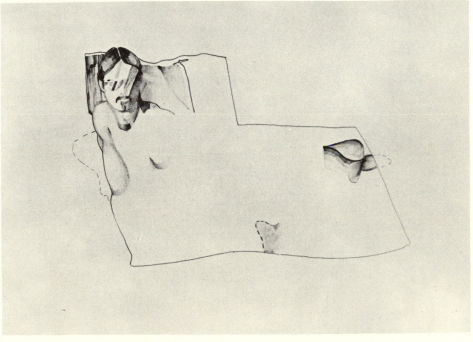

above: 122. Danielle Fagan. Untitled. 1979. Conté, 18 × 24″ (46 × 61 cm). Courtesy the artist.

below: 123. Value by plane. Student work. Pen and ink.

Descriptive Uses of Value

Value can be used to describe structure, weight, light, and space, as well as the artist's feelings. The problems in this section deal with each of these descriptive uses of value.

Value Used to Describe Structure

Value can describe the structure, or *planar makeup,* of an object (Fig. 122). Light reveals structure, but values can be distributed according to a close analysis of an object's planes. In other words, the use of value to describe structure need not depend on the natural laws of light. Look back at the rubbed drawings that were made to study volume (see Figs. 103–105). In these drawings value was used to indicate structure, to establish planes, and to create volume, regardless of the light that fell on the object.

Problem 28 Cut several pieces of cardboard into 2-inch squares. Place some acrylic paint on a flat surface. Dip the edges of the cardboard pieces in the paint and use the edges to draw a still life or model. By using the edge of these cards, you will create planes.

Draw quickly, changing the direction of planes according to the shapes of the subject. You are stating planes in an arbitrary manner, not necessarily following the actual planar direction of the form you are drawing. In spite of this, your drawing should begin to have a structural look. Repeat the problem several times. With each drawing, try to be more accurate when indicating the direction of planes.

Problem 29 Using a graphite stick and a still life of paper bags, make your marks change directions just as the planes in the bags change. For example, make the strokes go vertically for those planes that face you and diagonally for those planes that recede into space. The change in the direction of the strokes should emphasize the planar structure of the bags.

Problem 30 Using a skull or head as model, make a drawing emphasizing the planar aspects. State the larger planes—forehead, sides of cheeks. Move from large planes to smaller ones. Group lines within the planes to create value. Change line direction to indicate change of plane (Fig. 123).

Problem 31 In this drawing you are to reduce the figure to two values—black and white—and to two basic planes—front and side. First carefully examine the figure. Determine where the head, arms, legs, upper and lower torso face you and exactly where these forms turn away from you at a 90-degree angle. In other words, imagine that the figure is composed of only two planes—front and side. Draw a line separating the planes. Place a flat value within the planes that recede, leaving the rest of the figure white (Fig. 124). Here you are using value to describe both the structure of the figure and its recession into space.

Value Used to Describe Weight

A third way to use value is to define the weight or density of the object being drawn. We sense the pressure of gravity in all objects in actual life. The artist frequently enforces this by placing darker values at points of greatest pressure or weight, or at places where the greatest tension occurs (Fig. 125).

above: 124. Value by plane. Student work. Charcoal.

below: 125. Danielle Fagan. *Untitled.* 1979. Conté, 18 × 24″ (46 × 61 cm). Courtesy the artist.

Problem 32 Concentrate on the density, or weight, of the model you are drawing. Exaggerate the model's weight; double its mass. Beginning in the imagined center of the figure, create a dense mass, moving outward from the central core. Revolve your drawing tool to make a heavy, weighty mass of tangled line. The outside edge of the drawing should be fuzzy and ill defined (Figs. 126, 127).

Problem 33 Again you are to make two drawings using a model. First, using compressed charcoal, fill the form quickly from the inside out. As you reach the outer edge of the figure, lighten your marks. Using a sharper, more defined line, make contact with all the surfaces and contours of the figure. Imagine that you are coating the figure with thin webbing or that you are wrapping it in line like a mummy (Fig. 128).

Repeat the problem using a white medium on black paper. Instead of drawing the entire figure, choose an area to render in mass and line. That is, develop a focal point (Fig. 129).

Problem 34 Using a figure or other large subject such as a heavy machine, make an active scribbled line drawing. Work with a linear tool such as pen and ink, a china marker, or pencil. Instead of focusing on the core of the subject, try to model its exterior mass with tangled lines. Give a sculptural quality to

above: 126. Value by mass. Student work. Charcoal.

right: 127. Value by mass. Student work. Charcoal.

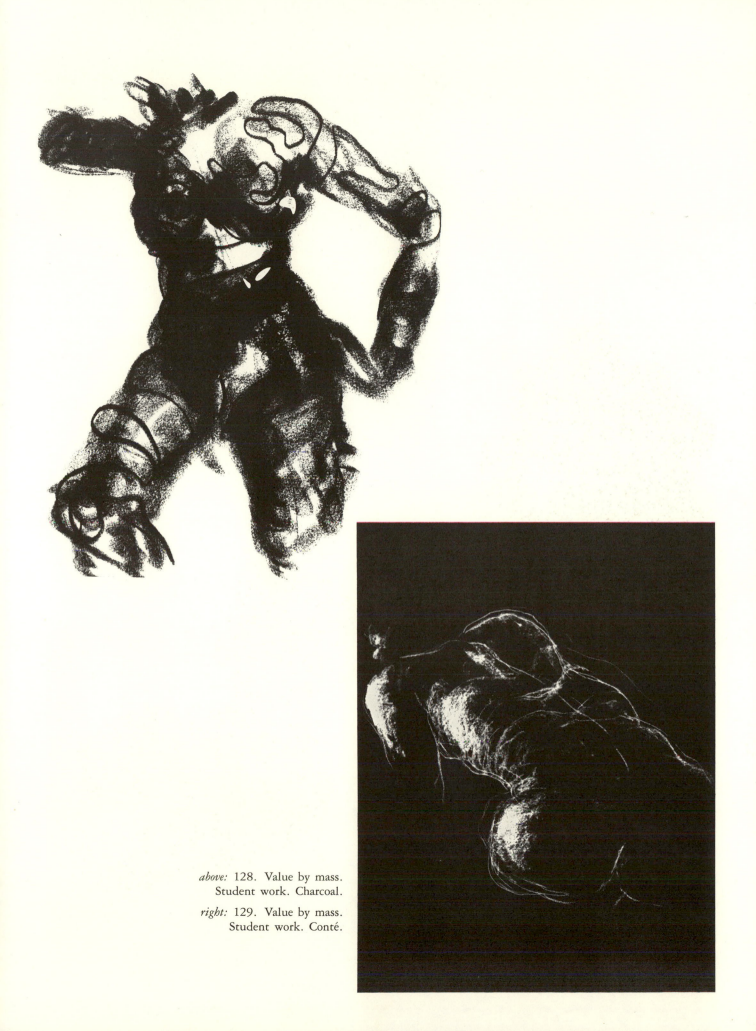

above: 128. Value by mass.
Student work. Charcoal.

right: 129. Value by mass.
Student work. Conté.

left: 130. Scribbled lines creating value. Student work. Charcoal pencil.

below: 131. Danielle Fagan. *Untitled.* 1979. Conté, 18 × 24" (46 × 61 cm). Courtesy the artist.

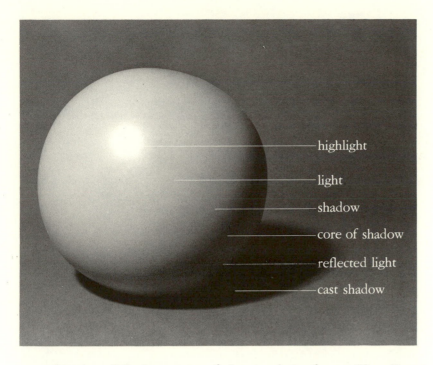

highlight
light
shadow
core of shadow
reflected light
cast shadow

132. Six categories of light as it falls over a form.

your drawing. Dig into space; feel around the forms. Your lines probably wrap the figure horizontally rather than encase it vertically. Combine both directions. Make the lines heaviest in those areas of greatest weight. Let your marks go into the negative space; do not confine them to the positive shapes (Fig. 130).

Value Used to Describe Light

Light falling on an object makes patterns that obey certain rules. If light falls from one direction onto an object, the value patterns created reveal the structure of the object—its volumetric and planar aspects. For example, a sphere under a single light source will have an even change in value over its surface. In the graphic arts, modeling—the gradual blending from light to dark to create three-dimensional illusion—is called *chiaroscuro*. On the other hand, a cube or any angular form will have an abrupt change from light to dark on its surface. Its planes are emphasized by the light (Fig. 131).

Generally light can be reduced to six categories as it falls over a form: *highlight, light, shadow, core of shadow, reflected light,* and *cast shadow* (Fig. 132). Multiple light sources on an object can result in ambiguous space because the form revealed by one light may be canceled by another.

Whatever the lighting conditions, artists must create their own value patterns to produce unity in their art or to help establish the mood they want. In the problems that follow you will progress from a limited value range to a more expanded one—from two values to six values. Each problem will increase your understanding of value. The problems build on one another and should be done in the order in which they are presented.

133. Value scale,
from 100% white to 100% black.

Problem 35 Set up a still life of five or more objects with nonreflective surfaces or use a figure as subject. Study the subject carefully, and on a value scale from 1 to 10 (Fig. 133) find its midpoint value. Squint your eyes to remove color, so that you see only value patterns. This drawing will be a value reduction. You are to reduce all values in the subject to either black or white. Note both the actual values of objects and the light patterns on

134. Value reduction to two values.
Student work. Acrylic.

135. Value reduction to two values.
Student work. Acrylic.

136. Value reduction to four values.
Student work. Ink and conté.

them and classify these values as black or white: values from 1 to 5 white, from 6 to 10 black.

Draw the subject lightly in pencil; then use black acrylic and make everything that is darker than the midpoint value a flat, unmodulated black. Erase the pencil lines, leaving the rest of the drawing white. Values will cross over objects and negative space; that is, value will not necessarily be confined to an object. Your finished drawing will be spatially flat, very dramatic, and quite abstract (Figs. 134, 135).

Problem 36 Use a still life or figure as a subject. First, lightly cover your paper with charcoal until it has an even value 4 or value 5 gray tone (see Fig. 133). Make the marks vertically at first, then horizontally. Rub the paper lightly with a chamois skin to smooth out the marks. Repeat until you have an even untextured mid-gray surface.

Choose four divisions of value—the gray of your paper, a darker gray, white, and black. The light patterns on the still life will govern your decisions. You are trying to divide accurately the values in the still life according to the light patterns on it. Draw the darkest darks with compressed charcoal and clean out the whites with a kneaded eraser. You are modeling the values. Values should cross over objects and negative space as in Figure 136.

137. Value study on toned paper.
Student work. Charcoal.

Your drawing will resemble the actual appearance of the still life more closely than a drawing that only uses two values—black and white. The toned paper will help you control the grays (Fig. 137).

Problem 37 Draw a still life in a medium of your choice. Carefully observe the light patterns on the still life. Use a value range to depict the six categories of light referred to in Figure 132. Set up lighting conditions so that you have a highlight, light, shadow, core of shadow, reflected light, and cast shadow. Have the light come from only one direction. Use no more than six values and try to control them, making the transitions gradual and smooth (Figs. 138, 139).

Problem 38 Draw a still life accurately. Make a sustained gesture drawing and carefully correct scale and proportion between parts. Then match the values in the still life with pieces of paper torn from magazines. The color of the paper is not important because you are matching only value. Translate the chromatic scale in the still life to an *achromatic* value scale. In other words, carefully match the actual value in the still life while disregarding the color. Your concern is value, not hue.

left: 138. Light range limited to no more than six values. Student work. China marker.

below: 139. Light range limited to no more than six values. Student work. Pencil.

140. Matching values. Student work. Collage.

141. Matching values. Student work. Collage.

142. Danielle Fagan. *Untitled*. 1979. Charcoal, 18 × 24″ (46 × 61 cm). Courtesy the artist.

143. Modeled space. Student work. Charcoal.

Cover the entire surface of your paper with collage. Do not confine yourself to flat areas of value. Use as much texture as you like. However, do try to match accurately the actual values in the still life (Figs. 140, 141).

Value Used to Describe Space

Artists can use value to indicate space. Artists may comply with nature and describe space as it actually appears—as three-dimensional space—or they can promote the *feeling* of space by the use of value. Spatial depiction has many manifestations. There is no one single way to promote the feeling of space, but in every case the handling of space is a result of the artist's decision—a mental construction of space. For example, Danielle Fagan, in her drawing in Figure 142, has chosen a logical approach to the depiction of space—a progression of values that goes from light to dark. The resulting space is not an especially deep one but there is, nevertheless, a feeling of space that pervades the drawing.

Problem 39 Begin with a light gesture using compressed charcoal. Put more pressure on the forms farther away. Imagine that your paper has depth, that it is a box. Try to feel to the back of the forms. Model the objects as if they were made of clay (Fig. 143).

above: 144. Modeled space. Student work. Charcoal.

right: 145. Value crossing over negative and positive shapes. Student work. Charcoal.

Repeat the problem. This time the values should progress from dark to light diagonally from bottom left to top right, and from light to dark diagonally from bottom right to top left as in Figure 144.

Problem 40 Using a figure or still life as a subject, organize your drawing so that it contains both a dark positive against a dark negative shape *and* a light positive shape against a light negative shape. The same drawing should also contain a dark positive against a light negative and a light positive against a dark negative. Remember that values may begin and end independently of a shape; values may cross over objects and negative space (Figs. 145, 146).

Expressive Uses of Value

Value can describe an object in space, but the most exciting aspect of value is its use as a forcefully expressive tool. We have already discussed the principles of value—the observation of natural laws and how this observation can help you use value. Your attitude as

146. Value crossing over negative and positive shapes. Student work. Charcoal.

147. Philip Pearlstein. *Female Model on Ladder*. 1976.
Sepia wash, 29½ × 41″ (75 × 104 cm).
Courtesy Allan Frumkin Gallery, New York.

an artist—your intellectual and emotional responses—is the other
determinant of how you use value.

The way the artist chooses to use value is as important as the
subject to be drawn. Value may be used objectively as in Philip
Pearlstein's *Female Model on Ladder* (Fig. 147). The artist has
placed the values according to the actual lighting on the figure.
On the other hand, in Robert Rauschenberg's mixed media col-
lage (Fig. 148) value is used in an entirely arbitrary manner,
without reference to a light source. The objects Rauschenberg uses
as his subject are juxtaposed at will, and his arbitrary use of value
is in keeping with his intuitive response to the subject and his
materials.

Value is a strong determinant in the depiction of emotions.
An example is pathos. Striking contrasts of light and dark help to
achieve the special *angst* of Howard Warshaw's work on paper *Red
Man* (Fig. 149). The subtle way Arshile Gorky has used value in

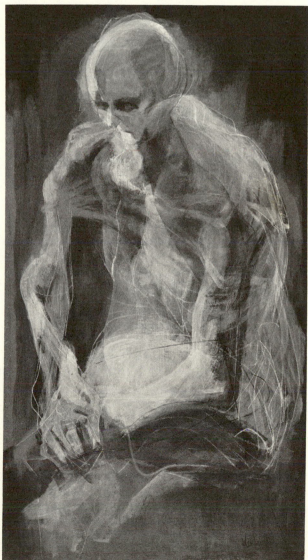

left: 148. Robert Rauschenberg. *Untitled (Combine).* 1973. Mixed media, 5 × 2′ (1.52 × .61 m). Fort Worth Art Museum (Benjamin J. Tillar Trust).

below: 149. Howard Warshaw. *Red Man.* 1967. Acrylic on paper, 5′5″ × 3′ (1.65 × .91 m). Courtesy Mark Ferrer, Carpinteria, Calif.

150. Arshile Gorky. *The Artist's Mother*. 1930.
Charcoal, 24 × 18½" (61 × 47 cm).
Art Institute of Chicago (Worcester Sketch Fund Income).

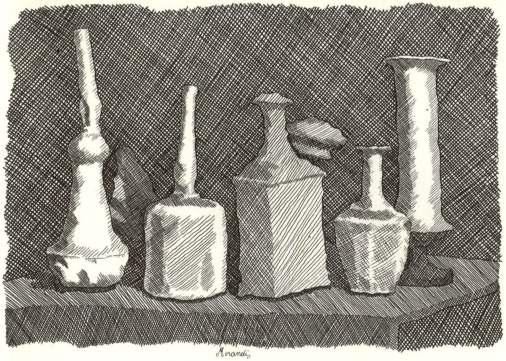

above: 151. Claes Oldenburg.
*Plan for Vacuum Cleaner,
From Side.* 1964.
Chalk and wash on gray paper,
40 × 26" (102 × 66 cm).
Courtesy the artist.

left: 152. Giorgio Morandi.
Nature Morte au gros traits.
1931. Etching,
9⅝ × 13¼" (25 × 34 cm).
Courtesy Harriet Griffin Gallery,
New York.

153. Giorgio Morandi.
Natura Morta di Vasi su un Tavolo. 1931.
Etching, 9⅝ × 13¼″ (25 × 34 cm). Private collection.

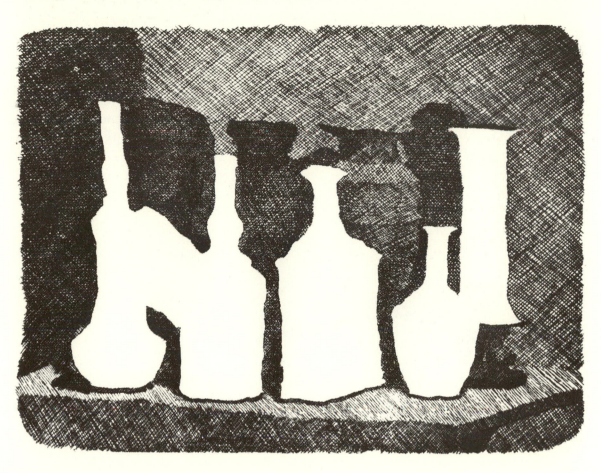

the charcoal drawing of his mother (Fig. 150) achieves the effect of a more classical detachment.

The creating of unusual spatial effects through value can be seen in the works of Claes Oldenburg and Giorgio Morandi. In Oldenburg's vacuum cleaner study (Fig. 151) the chalk lines of the object on the dark ground give the effect of a photographic negative, of space being mysteriously reversed. The commonplace object becomes ghostlike and supernatural. In the two companion prints by Morandi (Figs. 152, 153) there is again a reversal of the usual relation between objects and space. In the first print the bottles are slightly modeled, creating a sense of shallow space. In the second version the bottles have been "cut out," with the resulting spatial effect much flatter than in the first print. The pair of prints presents us with an eerie vanishing act.

Problem 41 Do two drawings of the same subject. In the first render the subject as objectively and as descriptively as possible. Match the values in your drawing with the values of your subject. Record actual appearances as impersonally as possible. Use pencil or conté crayon.

In the second drawing, draw the object subjectively. Project a feeling onto the subject, using a value range that will underscore your attitude (Figs. 154, 155).

Problem 42 In this problem you are to do three drawings exploring the expressive uses of value. In all three drawings the patterns of light and dark should convey your emotional intent rather than describe actual appearances. Your subject may be a recognizable object or an abstracted image.

In the first drawing use compressed charcoal. Make dark tones to evoke a somber mood (Figs. 156–158).

left: 154. Descriptive value: objective.
Student work. Conté.

below: 155. Descriptive value: subjective.
Student work. Conté.

above: 156. Value used to establish mood. Student work. Charcoal.

right: 157. Value used to establish mood. Student work. Charcoal.

below: 158. Value used to establish mood. Student work. Charcoal.

159. Close value range.
Student work. Conté.

In your second drawing use a light value range with gradual transitions between values. Try to produce a feeling that will be reinforced by the light tones (Figs. 159, 160).

In the third drawing use highly contrasting values. Use a wet medium and make a drawing that has a dramatic effect created by the stark contrast in values (Figs. 161, 162).

Problem 43 Create some stream-of-consciousness visual statements. Let your thoughts flow. Your drawings should reflect the movement, or "stream" of your ideas. Patterns of light and dark will be divorced from any actual object, but should be

160. Close value range.
Student work. Vine charcoal.

right: 161. High-contrast study. Student work.
Resist drawing with rubber cement and ink.

below: 162. High-contrast study. Student work.
Lithographic crayon with turpentine.

163. Stream-of-consciousness statement.
Student work. Brush and ink.

related to feelings. These drawings should be unpremeditated,
direct responses to both the medium you are using and the emo-
tions you are experiencing (Fig. 163).

Summary: Spatial Characteristics of Value

Of all the art elements, value has the greatest potential for spatial
development. When value defines light, structure, weight, or
space, it is being used three-dimensionally. A combination of
these approaches may result in ambiguous space.

If more than one light source is used, each source may cancel
volumetric qualities revealed by another. As a result, the drawing
may have a sense of ambiguous space. A combination of flat value
and modeled value also produces ambiguous space.

Flat patterns of light and dark confined within a given shape
make the space seem shallow. Uniform lines within a shape keep
the shape flat. In the same way, a uniformly textured surface pat-
tern has a tendency to flatten.

On the other hand, volumes with gradual transitions from
light to dark are seen as three-dimensional. When value defines
the edges of planes and these planes behave according to the rules
of perspective, the resulting space is illusionistic. Movement from
foreground to background in a stepped progression of value planes
produces a three-dimensional space. Irregular lines to build lights
and darks make a drawing more dimensional than do uniform
patterns of line.

Line

Chapter Five

The problems you have done so far have given you considerable experience using line. You have drawn with gestural line, structural line, organizational line, analytical measuring line, directional line, outline, scribbled, tangled, and wrapping lines, continuous overlapping lines, thick and thin lines, and with lines grouped to make value.

Line is the one art element that can most easily stand alone. It can describe both a subject and the feelings of the artist. Just as an artist's sensitivity determines the kind of value patterns chosen, an artist's personality is the strongest determinant of the quality of line used. Value must be compatible with the feeling and meaning of a work. In the same way, the kind of line an artist uses must correspond in character to the basic content and mood of the work.

Determinants of Line Quality

A first step in becoming sensitive to line is to recognize the inherent qualities of various linear drawing tools. While materials sometimes can be made to work in ways contrary to their natural uses, the advantages and limitations of a medium are important. From everyday experience we are acquainted with some linear drawing tools that move effortlessly to create lines: pencil, felt-tip marker, ball-point pen, and pen and ink. Some media that produce a grainy, abrasive line are charcoal, pastels, chalk, and conté crayon. China markers and lithographic pencils contain grease and can easily be smudged or dissolved.

The surface on which a line is drawn is another strong determinant of the quality of that line. An example is a comparison between the character of a line made on glass and a line made on brick. In the Mexican stamp seal in Figure 164 the incised or engraved lines on clay produce a different effect from the painted line on the glazed pottery effigy bottle in Figure 165.

above: 164. Stamp seal with double bird design. Mexico, Colima. A.D. 900–1400. Dallas Museum of Fine Arts (gift of Raymond D. Nasher).

right: 165. Elliptical effigy bottle. Chupícuaro style, from Guanajuato, Mexico. 300 B.C.–A.D. 300. Dallas Museum of Fine Arts (gift of Mr. and Mrs. Stanley Marcus Foundation).

166. Leonard Baskin. *Ajax: Ink.* 1962.
Ink, 40 × 26″ (102 × 66 cm).
Collection H. Shickman,
Delphic Arts, New York.

The surface that receives the mark affects the line quality just as the tool that makes it, and the beginning artist must learn to assess both implement and surface. It is difficult, for example, to make a clean, crisp line with pen and ink on newsprint because of the paper's absorbency.

The strongest determinant of a line's quality, however, is the sensitivity of the artist. Some artists have preference for a particular medium. Leonard Baskin, for example, uses pen and ink in many of his drawings, and his use of line emphasizes his sometimes brutal subjects (Fig. 166).

An artist's style is in part conveyed by the line quality used; it is like handwriting. Just as familiarity with a person's handwriting makes that writing identifiable, familiarity with an artist's work makes the linear style identifiable. Picasso's subjects, style, and use of line, for example, are easily identified (Fig. 167). He combines well-controlled, descriptive contour lines with expressive, decorative scribbles. Another artist whose line quality is a trademark of his style is Henri Matisse (Fig. 168). His line fits his wish to make art that is as comfortable as an armchair. He effects a relaxed, intimate mood by the use of decorative line.

Ben Shahn, George Grosz, and Honoré Daumier are social commentators with widely different ideas. Their art reflects these differences. Shahn's indignation at the injustices done to helpless, ordinary people is aptly stated by his heavy, editorial-cartoonist lines. In the brush drawing in Figure 169, he depicts the news analyst Ed Murrow slaying "the dragon" Joseph McCarthy. The weight of the lines convey the tension in the subject matter. The lines used to define the heroic figure of Murrow contrast with the scratchy, constricted lines used to depict the dragon. The caustic accusations of Grosz, on the other hand, are conveyed primarily by his crabbed, angular, nervous line (Fig. 170). Grosz' subjects do not invoke sympathy; indeed, he presents them for condem-

167. Pablo Picasso.
2.9.67 II (Scène Mythologique). 1967.
Pencil, 29½ × 22⅜" (75 × 57 cm).
Courtesy Éditions Cercle d'Art, Paris.

left: 168. Henri Matisse.
Reclining Nude II with a Stove. 1928–29.
Lithograph, 21⅛ × 17¾″ (55 × 45 cm).
Baltimore Museum of Art (Cone Collection).

below left: 169. Ben Shahn.
Ed Murrow Slaying the Dragon of McCarthy. 1955.
Brush drawing, 12¼ × 9½″ (31 × 24 cm).
Courtesy Kennedy Galleries, New York.

below: 170. George Grosz. *Drinkers.* 1916.
Pen and ink, 12⅞ × 8¼″ (33 × 21 cm).
Fort Worth Art Museum, Tex.

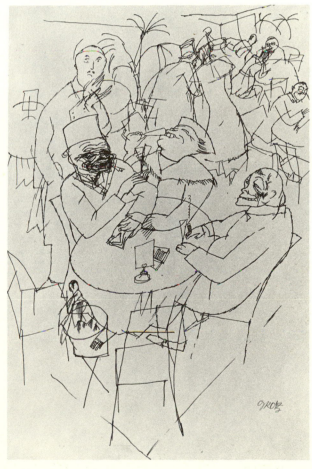

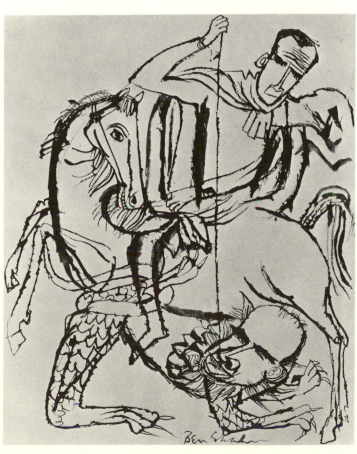

171. Honoré Daumier. *La Défense.* c. 1860–70.
Pen and ink and wash, 7 × 8⅜″ (18 × 21 cm).
Courtesy Sotheby Parke Bernet and Co., London.

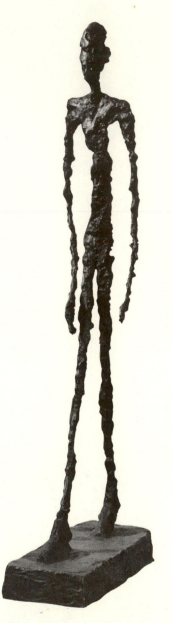

left: 172. Alberto Giacometti.
Standing Female Nude. 1946.
Pencil, 19⅝ × 12⅝″ (50 × 32 cm).
Private collection, Paris.

above: 173. Alberto Giacometti.
Walking Man. c. 1947–49.
Bronze, height 27″ (69 cm).
Hirshhorn Museum and Sculpture Garden,
Smithsonian Institution, Washington, D.C.

nation. Daumier, a social satirist of the 19th century, produces a gestural immediacy through line. The viewer responds to the energetic intensity of Daumier's work (Fig. 171). Shahn, Grosz, and Daumier all portray passionate convictions, and the linear technique of each artist helps carry his unique message.

Alberto Giacometti's analytical, nearly transparent line is in complete accord with his sculpture (Figs. 172, 173). His drawings and his sculpture are linear; in both he makes use of attenuated line. Space penetrates and diminishes his subjects.

In contrast to Giacometti, Henry Moore's art explores the idea of weight and mass (Figs. 174, 175). The subjects of Moore's drawings, as well as those of his sculptures, are connected to the earth from which they seem to emerge. Unlike Giacometti, Moore is interested in the volumetric, sculptural qualities of a subject. His line feels around forms, encasing them as if they were cocoons. His forms have a roundness and solidarity that makes them seem like mountains emerging from the earth. They are in sharp contrast to Giacometti's weightless figures.

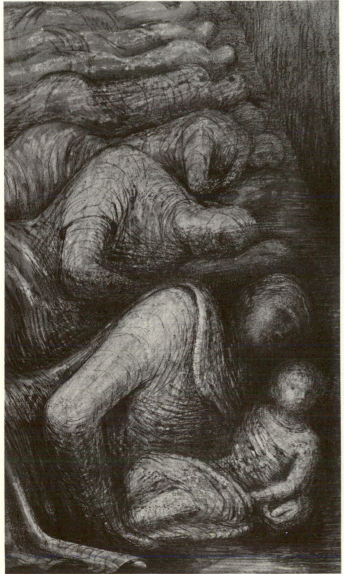

left: 174. Henry Moore. *Row of Sleepers.* 1941.
Wax, chalk, pen, and watercolor;
21¼ × 12⅝″ (55 × 32 cm).
Collection British Council, London.

below: 175. Henry Moore. *Reclining Figure.* 1935–36.
Elm wood, length 42″ (107 cm).
Wakefield Metropolitan District Council Art Gallery and Museums, Yorkshire, England.

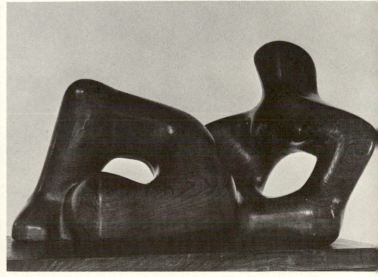

above: 176. Cy Twombly. *Untitled*. 1961.
Pastel and pencil, 13 × 14″ (33 × 35 cm).
Collection Martin Visser, Bergeyk, Netherlands.

right: 177. Jean August Dominique Ingres.
Henry VIII of England,
after Hans Holbein the Younger.
1806–20. Pencil, 9½ × 6⅞″ (24 × 18 cm).
Courtesy Sotheby Parke Bernet and Co., London.

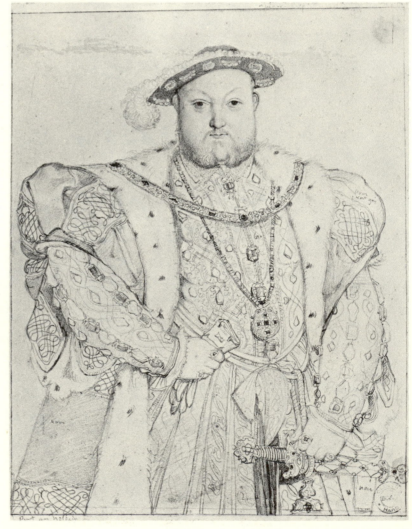

above: 178. *Dancing Woman,*
detail of fresco, Tomba del Triclinio, Tarquinia.
Etruscan. c. 470 B.C.

right: 179. *The Large Giraffe.*
Adjefou, from Tassili-n-Ajjer, Algeria.
Prehistoric. Fresco,
3′5″ × 5′2⅜″ (1.05 × 1.6 m).

Artists from prehistoric times to the present have left us a rich storehouse of various types of line. They can range from the childlike scribbles of Cy Twombly (Fig. 176) to the well-controlled line of Jean Auguste Dominique Ingres (Fig. 177). Line can be used to produce a mood of lightness, gaiety and movement, as in the Etruscan wall drawing in Figure 178. The repetition of the line is in keeping with the rhymthic pattern of the dancer's movement. In the Tassili fresco *The Large Giraffe* (Fig. 179) contour line is used sparingly to indicate simple shapes. Seldom does an artist confine the use of line to one type,

however. The complexity of Leonel Góngora's drawing in Figure 180, for instance, is a result of a variety of line types.

You can learn about line from observation and drawing. The problems in this chapter will acquaint you further with some types and functions of line.

Types of Line

Mechanical Line

Mechanical line is an objective, nonpersonal line that maintains the same width along its full length. An example can be seen in an architect's ground plan in which various kinds of lines indicate different materials or levels of space (Fig. 181).

Two artists, Sol LeWitt and Stuart Davis, have adapted mechanical line to artistic purposes. In his five-part wall drawing (Fig. 182) LeWitt uses ten thousand lines each 12 inches long. The individual line is unvarying, deliberate, and controlled. Stuart Davis, in his drawing *Davits* (Fig. 183), uses a "billboard" style along with a mechanical application of line. Note his heavy outlining of forms with a line of unchanging weight and value.

Problem 44 Using mechanical line, draw multiple views of an object—top, bottom, sides. You may keep the views separate, or you may overlap and superimpose them. Keeping in mind that mechanical line maintains its width along its full length, use a drawing tool that will produce this kind of mark, such as pencil, felt-tip marker, ball-point, or lettering pen.

180. Leonel Góngora.
Transformation of Samson and Delilah into Judith and Holofernes. 1970.
Lithograph, 29½ × 22″ (75 × 56 cm).
Courtesy the artist.

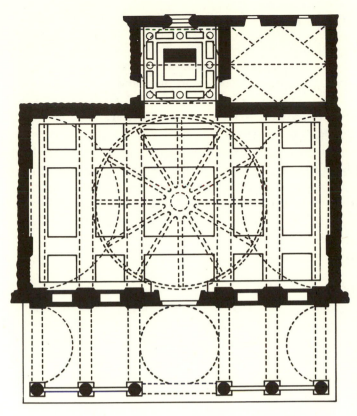

above: 181. Plan of Pazzi Chapel, Cloister of Church
of Santa Croce, Florence. c. 1429–33.

right: 182. Sol LeWitt.
Wall Drawing—Part Two with Ten Thousand Lines 12″ Long,
detail. 1971. Graphite on wall, entire work 9′4″ × 46′8″
(2.84 × 14.22 m). Courtesy John Weber Gallery, New York.

183. Stuart Davis. *Davits.*
1932. Brush and ink with chalk,
21¼ × 28¼″ (51 × 72 cm).
Fogg Art Museum,
Harvard University,
Cambridge, Mass.
(bequest of Meta and Paul Sachs).

Organizational Line

Organizational line provides the framework for a drawing. The framework can be compared to the armature upon which the sculptor molds clay or to the floor plan and scaffolding of a building. It is sometimes called *directional* or *diagrammatic* line.

Alberto Giacometi makes use of organizational line in his drawing *Still Life* (Fig. 184). The lines are not confined by the limits of the objects. They extend into space; they define and help relate the background shapes to the objects. Giacometti has stated the most indicative lines of the entire composition; his approach is analytical. In most finished drawings, organizational lines are not readily apparent; Giacometti, however, not only uses them to organize his drawings, but allows them to remain as a part of the total visual statement.

Problem 45 Choose a still life with several objects and background shapes and make a sketch using organizational line. You can begin with horizontal and vertical lines, extending them into space. Generally state the placement of objects as they relate to each other and to the space they occupy. Make the objects transparent by extending lines until you have defined the exact height and width of each object. When you are satisfied with your analysis and your compositional framework, finish your drawing. From this point you can make your drawing representational or you can complete it in an abstract manner.

Contour Line

Chapter 2 cited two basic approaches to drawing and said they both involved time. A gestural approach is quick and immediate, one that sees forms in their wholeness. A second approach is a slower, more intense inspection of the parts, called *contour* line. Contour line is a single, clean, incisive line.

Contour line defines edges. It is, however, unlike outline, which states only the outside edge of an object. Contour delineates the edges of *planes*. The quickest way to understand the difference between contour line and outline is to look at Figure 185. Outline makes the hand appear flat; it simply differentiates between positive and negative shape. The contour drawing emphasizes the hand's three-dimensional appearance. If you were drawing a pencil using contour line, you would draw a line at the edge of every shift in plane. The ridges along the length of the pencil, the juncture of the metal holder of the eraser and the wood, the insertion of the eraser into its metal shaft—all are planar changes that would be indicated by contour line.

Problem 46 Using a 2B pencil with the point kept sharp, do a contour drawing. Do not look at your paper; keep your eyes on the subject you are drawing. Imagine that you actually are touching the subject with the point of your pencil. Do not let

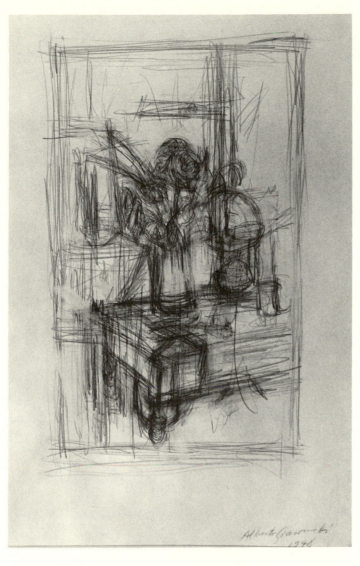

left: 184. Alberto Giacometti. *Still Life*. 1948.
Pencil, 19¼ × 12½″ (49 × 32 cm).
Fort Worth Art Museum, Tex.

below: 185. Contour. Student work. Pencil.

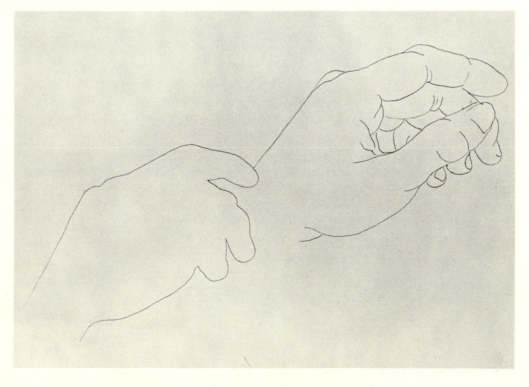

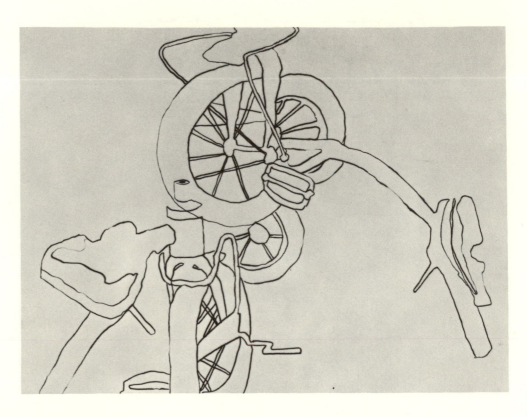

above: 186. Contour. Student work. Pencil.

left: 187. Contour. Student work. Pencil.

below: 188. Contour. Student work. Ink.

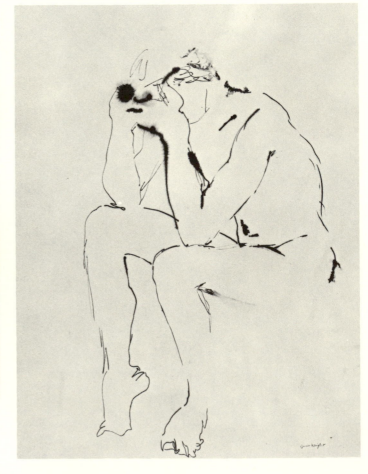

your eyes move more quickly than you can draw. You may begin at an outside edge, but when you see a plane turn inward, follow that plane to its end. In a figure drawing, for example, this technique may lead you to draw the interior features and bone structure of the face without completing its outside contour. It is imperative to keep eye and hand coordinated.

A word of caution: Do not draw shadows. Draw only where there is an actual, structural plane shift. Do not enter the interior of a form and aimlessly draw nonexistent planes or make meaningless decorative lines. In this regard, contour drawing is unlike a continuous overlapping line drawing.

When you have drawn to the end of an interior shape, you may wish to return to the outside contour. At that time you may look down and realign your pencil point with the previously stated edge. With only a glance for realignment, continue to draw, keeping your eyes on the subject. Sustain the drawing as long as possible. Spending an hour on a single drawing will help you tremendously. Do not worry about distortion or inaccurate proportions; they will improve after a number of sessions dedicated to contour drawings (Figs. 186, 187).

Contour drawing demands a single, incisive, clean line. Clustered lines are not used in contour, and no erasure is allowed for correction. This is a problem that should be done often, several times in each drawing session. It is an essential, basic technique to use throughout your drawing career. (Figs. 188–191).

above: 189. Contour. Student work. Pencil.

below left: 190. Contour. Student work. Pencil.

below: 191. Contour. Student work. Pencil.

Quick Contour Line

The quick contour line technique (Figs. 192–195) is a variation of the basic contour drawing. It is an exercise requiring less time for each drawing. You may look at your drawing more frequently than in a slow contour. The inspection of forms, however, is just as intense. Quick contour might be considered a shorthand version of the slow contour. A single, incisive line is still the goal. However, the movement of the line is faster, less determined. In quick contour you are trying to catch the *essence* of the subject.

Problem 47 Do several quick contour drawings. Experiment with different media, keeping in mind the importance of a precise, single line (Fig. 196). Do several drawings of the same subject. Begin with a 15-minute drawing. Later, reduce the amount of time spent on each drawing.

left: 192. Quick contour.
Student work. Charcoal pencil.

below: 193: Quick contour.
Student work. Charcoal pencil.

right: 194. Quick contour.
Student work. Ink.

below: 195. Quick contour.
Student work. Charcoal pencil.

below right: 196. Quick contour.
Student work. Conté.

left: 197. Quick contour with focal area using value. Student work. Pencil.

below: 198. Exaggerated contour. Student work. China marker.

As a variation on the preceding problem, begin with a quick contour, then develop a focal area using value (Fig. 197).

Exaggerated Contour Line

One of the surprises of contour drawing is the unpredictable distortion that occurs. Exaggerated contour takes advantage of these distortions. It even intentionally promotes them (Fig. 198).

Problem 48 Your subject in this problem is a model standing or seated on a high stool. Lightly dampen your paper before you begin to draw. Use ink and a pointed stick at least 10 inches long. Begin by drawing the feet of the model. Use a contour line, but consciously exaggerate the figure. Draw until you have reached the middle of the page (you should be about knee level). Squeeze the remainder of the figure into the remaining space. The dampened paper will affect the ink, and a different kind of linear quality will result (Figs. 199, 200).

below left: 199. Exaggerated contour. Student work. Ink.

below right: 200. Exaggerated contour. Student work. Ink.

Cross-Contour Line

Cross-contour lines describe an object's horizontal or cross-contours rather than its vertical edge. They emphasize an object's volume. Henry Moore's air-raid shelter drawings (see Fig. 174) are excellent examples of this technique. The lines go from side to side rather than up and down.

Problem 49 Draw a figure or draped fabric, keeping your implement continuously in contact with the surface of your paper. Imagine that the line is a thread that wraps the forms horizontally, encasing its mass. Carefully observe the subject's cross-contours and indicate accurately its undulating shape (Figs. 201–205).

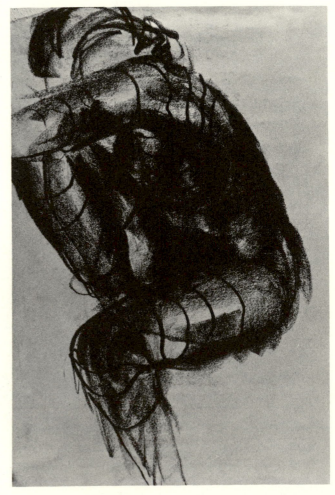

above: 201. Cross contour. Student work. Ink.
right: 202. Cross contour. Student work. Charcoal.

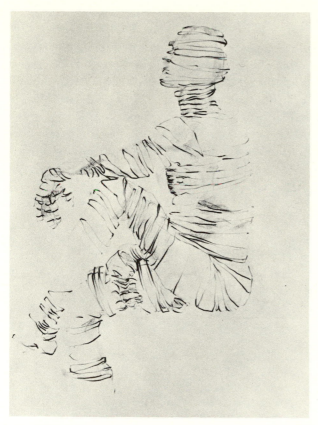

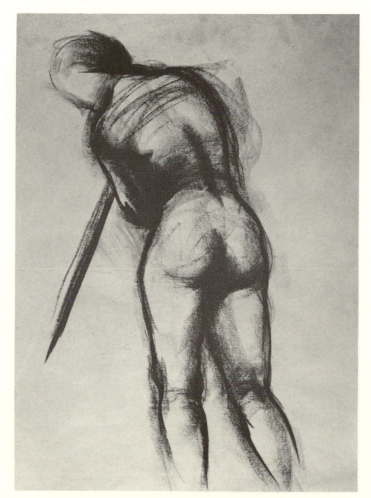

above left: 203. Cross contour. Student work.
Charcoal pencil.

above right: 204. Cross contour.
Student work. Ink.

left: 205. Cross contour. Student work.
Charcoal.

Structural Line

Structural line indicates plane direction and reveals planar structure. Structural line builds volume, and creates a three-dimensional effect. Although a drawing can be made using only structural lines, these lines are usually found in combination with either organizational line or contour line. Structural lines can be grouped and are then perceived as value. In *Entropic Landscape* (Fig. 206), Smithson makes wide use of structural lines.

206. Robert Smithson. *Entropic Landscape.* 1970.
Pencil, 19 × 24″ (48 × 61 cm).
Courtesy John Weber Gallery, New York.

207. Structural lines. Student drawing. Felt-tip marker.

Problem 50 Using a felt-tip marker, make a contour drawing of a figure. Use structural lines to indicate the direction of planes, to create values and to build volume (Fig. 207). You can use parallel lines or cross-hatching. Remember, the closer the lines are massed, the darker the value.

Lyrical Line

Pierre Bonnard, Edouard Vuillard, Henri Matisse (see Figs. 168, 314) and Raoul Dufy are some artists who use lyrical, decorative line. Lyrical lines are like arabesques—they can be ornately intertwined or wander gracefully across the page. Contour line and decorative line can be combined to produce a lyrical mood, as in Dufy's *Yellow Violin* (Fig. 208).

Generally, the more deliberately controlled a line, the more objective it is. The more spontaneously a line is stated, the more subjective it is. Lyrical line falls under the subjective category.

208. Raoul Dufy. *The Yellow Violin.* 1949.
Oil on canvas, 39½ × 32″ (100 × 81 cm).
Art Gallery of Toronto
(gift of Sam and Ayala Zacks, 1970).

Problem 51　Using an article of clothing as your subject, do a lyrical line drawing (Fig. 209). Use an implement that is free-flowing, one that is not scratchy. Either brush and ink or pen and ink would be a good choice for this drawing. Try drawing in time to music.

Constricted, Aggressive Line

A constricted line makes use of angular, crabbed, assertive marks. Such marks are aggressively stated. They may be ugly and scratchy, appropriate for bitter expression. They convey the feeling of tension.

Problem 52　Look at the drawing by George Grosz (see Fig. 170). Draw a scene that depicts a situation toward which you feel great antipathy. Use constricted, aggressive lines to convey your strong, negative feelings. Work with a sharp-pointed implement or ink and wash (Figs. 210–213).

209. Lyrical line. Student work. Ink.

210. Crabbed line. Student work. Ink.

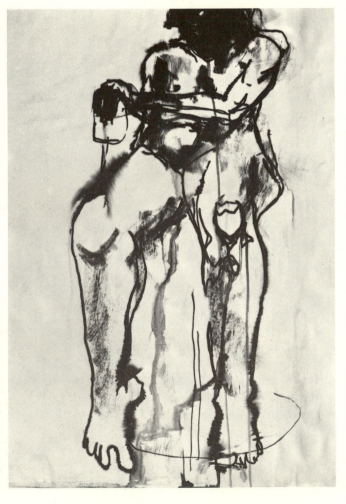

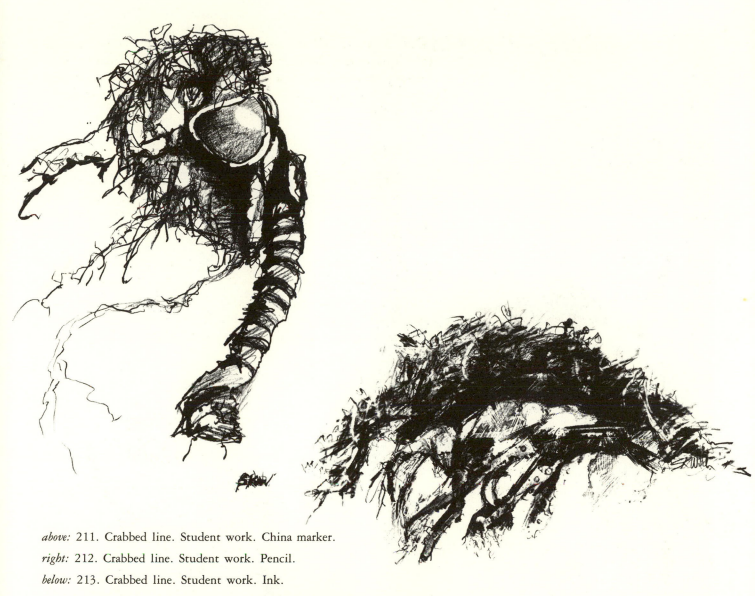

above: 211. Crabbed line. Student work. China marker.

right: 212. Crabbed line. Student work. Pencil.

below: 213. Crabbed line. Student work. Ink.

above: 214. Soga Shohaku. *Jittoku.* Mid-18th century.
Sumi ink, 4'1⅛" × 1'9" (1.25 × .54 m).
Dallas Museum of Fine Arts
(gift of Mr. and Mrs. Lawrence S. Pollock).

right: 215. Gaston Lachaise. *Draped Figure.* 1906–10.
Brush and wash, 8½ × 5¾" (22 × 15 cm).
Fort Worth Art Museum, Tex.
(estate of Isabelle Lachaise).

Calligraphic Line

Calligraphic line resembles handwriting and makes use of free-flowing, continuous movement. Eastern art developed the beauty of calligraphy; *Jittoku* (Fig. 214), a Japanese ink and brush drawing, combines calligraphy—handwriting—with an image. Both image and writing are a result of a brilliant calligraphic approach. Instrument, media, surface, and technique are welded in this type of drawing. Calligraphy is related to gesture; the variations of the line encompass the full range from bold to delicate, from thick to thin. The marks are sweepingly graceful.

Gaston Lachaise's draped figure (Fig. 215) is Oriental in feeling because of its calligraphic notation. The flourish with which Lachaise made his marks and the control of the brush determined the quality of the line. Mark Tobey was influenced by Eastern calligraphy and adapted the technique in his linear intertwinings (Fig. 216). These overall textural patterns are called "white writing."

216. Mark Tobey. *Calligraphy in White.* 1957.
Tempera, 35 × 23¼" (88 × 59 cm).
Dallas Museum of Fine Arts
(gift of Mr. and Mrs. James H. Clark).

217. Paul Cézanne. *View of a Bridge.*
c. 1895–1900.
Watercolor, 18¾ × 23½" (49 × 60 cm).
Yale University Art Gallery, New Haven, Conn.

Problem 53 Using ink and a bamboo-handled Japanese brush, practice writing your name. Change scale, making the transitions of the marks gradual and graceful. Apply different pressures to the brush to create flowing motions. Experiment with the way you hold the brush—sometimes hold the bamboo handle near the end, sometimes near the brush. Using drapery as your subject, do a drawing using calligraphic line.

Implied Line

An implied line is one that stops and picks up again. The viewer conceptually fills in the breaks. Paul Cézanne, in his *View of a Bridge* (Fig. 217), groups lines to suggest planes. He does not explicitly close shapes—shapes are implied through use of the broken lines. Cézanne is noted for his "sliding plane" technique. In this watercolor the exact edge of a form is never stated.

Implied line results in an interchange between positive and negative shapes. It brings the negative space into the implied positive shapes, creating spatial ambiguity. This "lost and found" line requires a viewer's participation since line and shape must be filled in mentally.

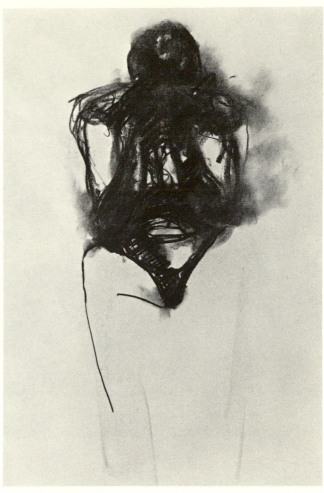

left: 218. Implied line. Student work. Lithographic crayon.

above: 219. Implied line. Student work. Charcoal.

Problem 54 Using a figure as subject, do two drawings. In the first make broad use of implied line (Fig. 218). Be conscious of the pressure on your drawing tool, lightening the pressure as the line begins to break. The lines should change from light to dark along their length.

In the second drawing, use line to suggest or imply a shape. In Figure 219 the upper part of the figure is stated in value. The lower part of the figure is implied by a line that only begins to delineate the knee before it stops.

above: 220. Marcia Isaacson.
Bellsmith's Family Members.
1970. Pencil,
29¾ × 41½″
(76 × 105 cm).
Minnesota Museum
of Art, St. Paul.

right: 221. Larry Rivers.
Edwin Denby III.
1953. Pencil,
16⅜ × 19¾″
(42 × 50 cm).
Museum of Modern Art,
New York
(anonymous gift).

Blurred Line

Blurred lines are smudged, erased, or destroyed in some way—either by rubbing or by erasure. They are frequently grouped to form a sliding edge; they are not as precisely stated as implied lines. Marcia Isaacson, in her pencil drawing *Bellsmith's Family Members* (Fig. 220), uses blurred and erased lines to suggest the direction of a light source. The erased lines are the lightest values in the drawing. Her blurred lines contrast with the accurately rendered focal point of the woman's face. The edges between woman and dog are blurred, thereby creating a spatial ambiguity. The erased lines unite the two figures so that it is impossible to know which figure is in front and which recedes.

Larry Rivers, in his drawing of Edwin Denby (Fig. 221), uses blurred lines to create a contemporary portrait. He combines a gestural approach with blurred lines to contrast with the more precisely stated half-face of his friend. Blurred and smudged lines are much in favor with today's artists.

Problem 55 Do a drawing in which every line is blurred, smudged, or erased. Use a soft pencil and gummed eraser. Group line to create value. With your eraser make sweeping motions that go counter to the pencil marks; erase and blur the already established lines. Blur and smudge the line with the eraser and your fingers, redrawing and erasing until the drawing is finished (Figs. 222, 223).

above: 222. Erased and blurred line. Student work. Pencil and charcoal.

below: 223. Erased and blurred line. Student work. Mixed media.

A charlot Chaplin
marc chagall 1929

Whimsical Line

A playful, whimsical line quality is appropriate for a naïve, childlike subject. This subjective type of line is intuitive and direct. The whimsical line may change width arbitrarily and wander around the page. Whimsy is more a feeling than a technique. The line used in Marc Chagall's drawing *To Charlie Chaplin* (Fig. 224) is compatible with the playful treatment of his subject. Paul Klee was a master of whimsical line (Fig. 225). While his drawings are appealingly naïve, they incorporate sophisticated, formally organized devices. Klee combines geometric abstraction with fantasy (Fig. 226).

226. Paul Klee.
Drawing for battle scene
of *The Seafarers*. 1923.
Pencil, 9 × 13⅝″
(23 × 35 cm).
Paul Klee Foundation,
Kuntsmuseum, Bern.

Problem 56 Klee's suggestion to take a line for a walk is a good one with which to conclude our problems dealing with line. Choose a subject toward which you adopt a whimsical attitude. Use a line that reinforces your light, playful mood. The figure is a particularly good subject since caricaturelike distortions can be whimsical (Figs. 227, 228).

below left: 227. Whimsical line.
Student work. Ink.

below right: 228. Whimsical line.
Student work. Lithographic crayon.

Summary: Spatial Characteristics of Line

While we generally have confined each problem in this chapter to the use of one kind of line, most artists do not limit their line so severely (Fig. 229). You should experiment, employing several linear techniques in the same drawing.

Subjective lines are generally more dimensional than objective lines. This is because a subjective line changes width, changes from light to dark, and is more suggestive of space than a flat line of maintained width. Outlining makes shapes appear flat; contour line is more dimensional than outline.

A contour of varying width is more dimensional than one of uniform weight. A discontinuous, or broken, line is more spatial than an unvarying one.

When line is stated primarily horizontally and vertically—that is, when it remains parallel to the picture plane—a shallow space results. If, however, lines penetrate the picture plane diagonally, a three-dimensional space is produced. Generally, a buildup of lines is more volumetric than a single line.

If lines are grouped in a single direction to create value, the resulting space is flatter than if the lines are not stated uniformly. Lines that create a repeating pattern of texture make a flatter space than those stated less predictably.

Again a reminder: You must analyze all the lines in a drawing in order to determine the entire spatial effect.

229. A variety of line types. Student work. Charcoal and ink.

Texture

Chapter Six

Art depends on the strong relationship between the senses of sight and touch—between our visual sense and our tactile sense. We can imagine how a surface feels simply by looking at it, and we can also imagine how a surface looks by touching it. This mental sight-and-touch relationship is a vital one in all the arts, but it is especially important in the graphic arts, where one must rely on visual textures more than on actual tactile ones. Painting and sculpture, for example, are far more tactile than the graphic arts.

Texture, however, does play a highly active role in the graphic arts. The emphasis in drawing is more on visual textural effects—the contrasts between rough and smooth, between coarse and glossy, or between soft and hard can be communicated visually without actually using glossy or rough media. The textural quality of a work depends on the surface on which it is drawn, the texture inherent in the tool used, the way the artist controls the tool, and any additions to the surface.

Texture, like value and line, is a key art element. Even more than the other elements, it gives information about materials and media. There are three basic categories of texture: *actual, simulated,* and *invented.* Of course, *texture* in its most literal meaning refers strictly to the sense of touch. This is the category of *actual* texture. However, for the artist, the visual appearance of a work—its surface quality and marks made by the tool—is most important. While this type of texture may have only a subtle tactile quality, it does have a visual quality that contributes strongly to the textural character of the drawing. Therefore, the

below left: 230. Jean Dubuffet. *Metro.* 1949. Incised ink on gesso, on cardboard; 12⅝ × 9⅞″ (32 × 25 cm). Museum of Modern Art, New York (Joan and Lester Avnet Collection).

below right: 231. Franz Kline. *Untitled.* c. 1954. Oil on paper, 11 × 8½″ (28 × 22 cm). Fort Worth Art Museum. (Benjamin J. Tillar Trust).

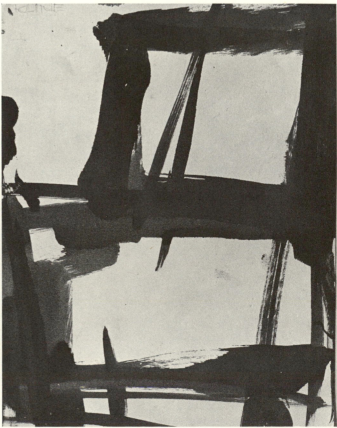

visual texture of the medium is an especially important category in the graphic arts. The categories of *simulated* and *invented* textures refer to visual effect rather than actual tactile quality.

Actual Texture

Actual texture refers to the surface of a work (smooth or rough canvas, for example), the texture of the medium (such as waxlike crayons, which leave a tactile buildup on the surface), and any materials added to the surface. The marks of the tool also provide actual texture in a drawing.

In his work *Metro* (Fig. 230), Jean Dubuffet masses ink and gesso on cardboard and then scratches lines into the surface. The actual textures of the surface and the medium combine here with the visual texture of incised linear shapes to carry out the primitive effect the artist intended.

Franz Kline's abstract drawing in Figure 231 shows how texture, here created by oil applied with a brush, can dominate a work. The brushmarks are emphasized, and their texture does not imitate the texture of some other substance. The marks are autonomous; they stand only for themselves. The effect is one of spontaneity and immediacy.

In Jasper Johns' *Study for Skin I* (Fig. 232) the texture of the charcoal medium, simply and directly applied, provides the unity for the drawing. Another example of the actual texture of a medium—one not easily recognizable without knowledge of the technique used—can be seen in *Smoke Drawing* (Fig. 233) by Otto

232. Jasper Johns. *Study for Skin I*. 1962. Charcoal, 22 × 34″ (56 × 86 cm). Courtesy Leo Castelli Gallery, New York.

Piene. The artist held the paper above a candle flame and allowed the carbon deposits to collect on the paper. This technique, called *fumage,* creates a visually smooth, slick texture.

The style of Abstract-Expressionist Willem de Kooning can in large part be recognized by observing his textural surface. In his drawing *Woman* (Fig. 234), multiple blurred lines cross over the figure and negative space to create a spatially ambiguous effect. (De Kooning uses a similar technique in his thickly painted canvases.) Implicit in De Kooning's drawing is a statement about the richness and ambiguity of woman. Texture, then, not only conveys information about the artist's medium, but also gives information about subjective and expressionistic intent as well.

Finally, any real material added to the surface of the work also comes under the category of actual texture. We can divide such additive materials into two classifications. *Collage* is the addition of any flat material, such as paper, fabric, or cardboard, to the surface of a work. (A term for gluing paper only to the picture plane is *papiers collés.*) *Assemblage* is dimensional material assembled into a composition by any means—glue, nails, wire, or rope, for example. Collage and *papiers collés* usually remain flat, although collage can be built up in relief. Assemblage is not flat. Depending on the dimensional items added to the surface, an assemblage may range from a low relief to a totally three-dimensional composition.

Collage is a widely used technique. In Wilfred Higgins' work (Fig. 235) the collage elements operate on two levels. They make flat shapes and values which become a part of the total piece, helping to create a relatively two-dimensional space. Collage shapes, however, still remain what they are—alien elements glued to the surface of a work of art, a work otherwise traditional in its use of materials. The space in Robert Motherwell's *Surprise and Inspiration* (Fig. 236) is more ambiguous. Motherwell has painted over parts of the collage with gouache and oil, making it impossible to distinguish clearly the additive elements or to specify their exact location in space.

233. Otto Piene. *Smoke Drawing.* 1959. Smoke, 19⁷/₈ × 28¹/₈″ (50 × 71 cm). Courtesy the artist.

136

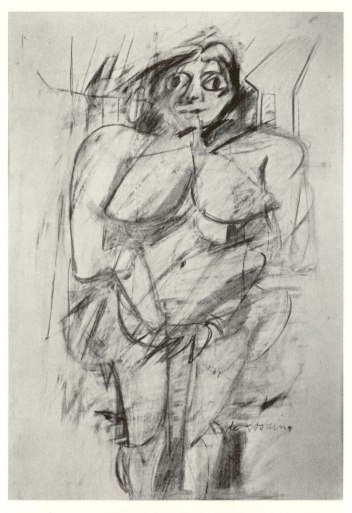

above left: 234. Willem de Kooning. *Woman.* 1952.
Pastel and pencil, 21 × 14″ (53 × 36 cm).
Collection Mr. and Mrs. Stephen D. Paine, Boston.

left: 235. Wilfred Higgins. *Untitled.* 1978.
Paper and fabric collage, 20 × 16″ (51 × 41 cm).
Courtesy the artist.

above: 236. Robert Motherwell. *Surprise and Inspiration.*
1943. Gouache and oil with collage,
40⅛ × 25¼″ (102 × 64 cm).
Peggy Guggenheim Foundation, Venice.

above: 237. Tom Wesselmann.
3-D Drawing for Still Life #42. 1964.
Charcoal with real objects,
4' × 5' × 8" (1.22 × 1.52 × .2 m).
University of Texas (gift of James A. Michener).

below: 238. Joseph Cornell.
Setting for a Fairy Tale. 1942–46.
Construction, 11³⁄₈ × 14¹⁄₂ × 4" (29 × 37 × 10 cm).
Peggy Guggenheim Foundation, Venice.

Assemblage is a crossover category that combines two- and three-dimensional elements. In Tom Wesselmann's charcoal *3-D Drawing for Still Life #42* (Fig. 237), which includes real objects, we have difficulty distinguishing the real from the drawn. Without seeing the actual piece we can only speculate which objects are dimensional and which ones are illusionistically dimensional. We can see that the shelf is an actual dimensional plane that juts out from the wall, but are both bottles or only the one with a drawn label real? This confusion is intended and is a result of the sameness of texture throughout the piece.

Another artist known for his assemblages is Joseph Cornell. His work affords an intimate view into his personality. Cornell's well-crafted works are shadowbox glimpses into a private, intense world (Fig. 238).

Simulated Texture

Simulated texture, as its name implies, is the imitation of a real texture. Texture has always been used to imitate nature, to represent actual appearance. Contemporary artists continue to use texture in this way. Simulation can range from a suggested imitation to a highly believable trick-the-eye *(trompe-l'œil)* duplication.

In Ben Schonzeit's *Ice Water Glass* (Fig. 239) we see a realistic transcription of the object. Schonzeit's intent is to present objectively the reflective surfaces of the ice, glass, and water. The achievement of an imitation of real textures, a *trompe-l'œil*, usually results in the illusion of a three-dimensional image. However, this simulation can also be two-dimensional as in Braque's work (Fig. 240), where the texture of the wood grain is imitated, not real.

above: 239. Ben Schonzeit. *Ice Water Glass.* 1973. Acrylic on canvas, 6 × 4′ (1.83 × 1.22 m). Private collection, Va.

below: 240. Georges Braque. *Still Life on a Table.* 1913. Collage, 18¹/₂ × 24³/₄″ (47 × 62 cm). Collection Monsieur and Madame Claude Laurens, Paris.

Crossover Category

Related to both actual texture and simulated texture is the transfer of a texture from one surface to another. This transfer can be made by taking a rubbing from an actual textured surface or by transferring a texture from a printed surface onto the drawing. Transferred textures cannot clearly be categorized as actual texture or as simulated texture because they possess elements of both; they belong to a crossover category. The Surrealist Max Ernst introduced the technique of *frottage,* the transfer of texture by rubbing. In *The Earth Seen from the Earth* (Fig. 241), Ernst took rubbings from a number of surfaces and combined them into one image.

Transfer from a printed surface is a popular contemporary technique. The image to be transferred is coated with a solvent, then laid face down onto the drawing surface and rubbed with an implement, such as a wooden spoon, a brush handle, or a pencil. The marks made by the transfer implement provide an additional textural interest in a drawing. Robert Rauschenberg uses this technique in his silkscreens and his drawings. In *Canto XXI* (Fig. 242) Rauschenberg combines rubbed transfer with drawing media. The marks made by the implement provide a textural unity for the composition. This overall texture has the effect of flattening out the images.

above: 241. Max Ernst.
The Earth Seen from the Earth. 1925.
Pencil frottage, $7^5/_8 \times 6^3/_8''$ (19 × 16 cm).
© Private collection, U.S.A.

right: 242. Robert Rauschenberg.
Dante Drawing (Canto XXI). 1959.
Transfer and mixed media,
$14^1/_2 \times 11''$ (37 × 28 cm).
Museum of Modern Art, New York.

Invented Texture

Invented or decorative textures do not imitate textures in real life; the artist invents the textural patterns. Invented textures can be nonrepresentational line-and-dot patterns as in the textured shapes of Miguel Condé's ink drawing in Figure 243. They also may be abstracted, conventionalized textures that *symbolize* actual textures. Condé, for instance, symbolizes hair and the fabric of hats in his use of this type of conventionalized texture.

The lines in Vincent van Gogh's black-and-white drawing in Figure 244 do not simulate the actual texture of trees and foliage but represent them in a visually symbolic manner. In Van Gogh's subjective approach, streaked lines build on one another to make a highly agitated surface, creating a nervous movement over the entire picture. The texture of the drawing is Van Gogh's primary means of conveying a feeling of agitation.

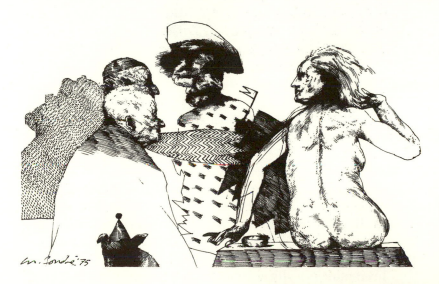

left: 243. Miguel Condé. *Untitled.* 1975. Pen and ink, 8 × 11¹/₂″ (20 × 29 cm). Courtesy Young-Hoffman Gallery, Chicago.

below: 244. Vincent van Gogh. *A Tree in the Garden of Saint Paul's Hospital with a Figure in the Background.* 1889. Chalk, pencil, pen, brush with ink, and watercolor; 18¹/₂ × 24¹/₂″ (47 × 62 cm). National Museum Vincent van Gogh, Amsterdam.

245. Neil Welliver. *Brown Trout.* 1975.
Etching hand-colored with watercolor,
26¹/₂ × 36″ (67 × 91 cm).
Courtesy Brooke Alexander, Inc., New York.

Another approach to the use of conventionalized texture is Neil Welliver's etching *Brown Trout* (Fig. 245). We have no difficulty reading the groupings of parallel lines as rocks and water. The artist has invented textures, using arrangements of lines and dots, which symbolize or refer to actual textures.

Even more visually abstract is the texture of hair and fabric in Michael Abyi's lively ink drawing on fabric (Fig. 246). His decorative line-and-dot patterning is used over the entire surface of the work. In this texture-filled composition, empty space is crowded out.

Roy Lichtenstein uses an even simpler textural notation in his pencil and tusche drawing *Tablet* (Fig. 247). He imitates the commercial designer's device of benday dots in order to provide a background for the glass. This invented texture, along with the flat black shapes and outlining, emphasizes the flatness of the picture plane.

Problem 57 In this problem you are to make three drawings using actual texture and additive materials. The first is *papiers collés,* the second collage, and the third assemblage.

For the first drawing use found and discarded papers or old drawings reassembled to create a new drawing. For example, if you have some old figure drawings, you might tear them up and

rearrange the pieces to make a landscape. Redraw over the glued papers, integrating the *papiers collés* with the supporting paper.

In the second drawing attach one element of collage—paper, fabric, cardboard, or any flat material. The collage piece may be of any size, but it should be highly tactile. You could use a piece of sandpaper, for example. Simulate the texture of the collage in two areas of your drawing. Try to make the simulated areas and the collage element indistinguishable when viewed from a distance. Trick the eye into believing there are three pieces of collage.

For the third drawing make an assemblage. Combine some drawing with three-dimensional pieces. You probably will want to choose a sturdier surface than paper for your support. Gessoed cardboard or backing board would provide a stable ground. Having made the assemblage, you might choose to paint the entire surface and then draw over the paint. Painting the assemblage one solid color will integrate the three-dimensional elements.

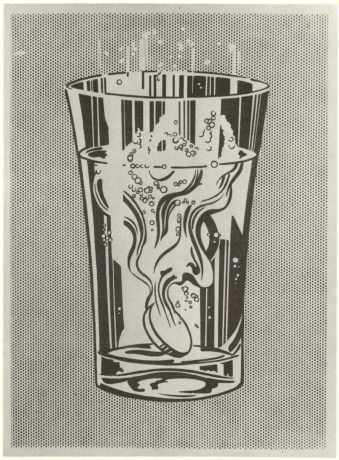

left: 246. Michael Abyi.
The Twins Who Killed Their Father Because of His Properties.
Ink on fabric, 33 × 22" (84 × 56 cm).
Collection Claudia Betti.

below: 247. Roy Lichtenstein. *Tablet.* 1966.
Pencil and tusche, 30 × 22" (76 × 56 cm).
Courtesy Leo Castelli Gallery, New York.

Problem 58 This problem is an exercise in simulated texture. Use a saltine cracker as your subject. Draw on a surface no smaller than 12 inches square. Use a 4B pencil. Render the texture of the cracker as accurately as possible; simulate the cracker's surface. Keep in mind that a cracker of this scale will have an increased thickness. You might use cast shadows along the edge of the cracker and its "craters" to help emphasize its volumetric aspect.

Problem 59 In this problem on invented texture you are to make two drawings. In the first use invented, nonrepresentational texture as in the Michael Abyi drawing (see Fig. 246). Other good examples of decorative texture can be seen in the two student drawings in the chapter on shape (see Figs. 90 and 92). You may use a recognizable subject, but the texture should not refer to a real texture.

In the second drawing, use conventionalized, symbolic texture to represent various surfaces in an imaginary scene. For example, grass might be indicated by a patterning of dots, the foliage of a tree by overlapping teardrop shapes. Use lines and dots to create a variety of textures that symbolize real textures.

248. Jasper Johns. *Target*. 1958.
Pencil and collage,
14⁷/₈ × 13⁷/₈" (38 × 35 cm).
Fort Worth Art Museum.

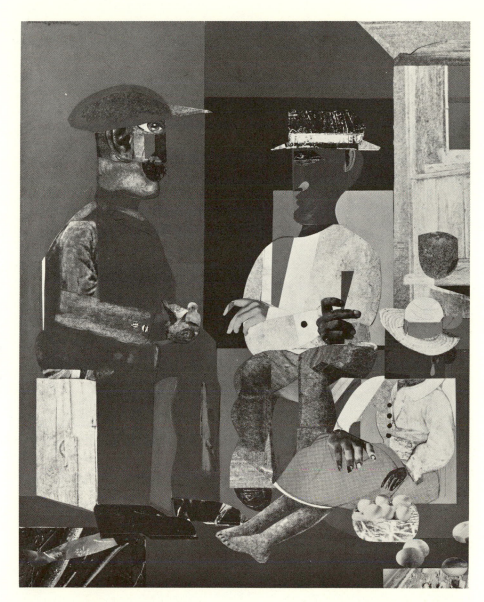

249. Romare Bearden. *Eastern Barn.* 1968. Collage of paper on board, 4′7½″ × 3′10″ (1.44 × 1.17 m). Whitney Museum of American Art, New York.

Summary: Spatial Characteristics of Texture

Generally, uniform use of textural pattern and invented texture results in a relatively shallow space. A repeated motif or texture that remains consistent throughout a drawing tends to flatten it. A good example of this effect is seen in Jasper Johns' drawing *Target* (Fig. 248). The overall consistency of the marks reinforces the flatness of the image. While the marks diminish in size somewhat in the center, this is not enough to disturb the sense of a two-dimensional space.

The use of simulated and invented texture in the same drawing results in arbitrary space, as does a combination of simulated texture and flat shapes. For example, in Romare Bearden's work *Eastern Barn* (Fig. 249) the modeled hands in the center of the picture provide a contrast with the flat collage pieces and flat patterns of texture.

250. Audrey Flack.
Dolores of Córdoba.
1971. Oil on canvas,
5'10" × 4'2" (1.78 × 1.27 m).
Courtesy Louis K. Meisel Gallery,
New York.

Simulated texture is illusionistically more dimensional than invented texture. If sharpness of textural detail is maintained throughout the drawing, space will be flatter. Diminishing sharpness of textural detail results in a three-dimensional space. Objects in the foreground that have a clearer textural definition than those in the background usually indicate an illusionistic space. However, blurring of textural detail may be done for focal emphasis rather than for spatial definition, and in this instance space may be ambiguous. In the Audrey Flack painting *Dolores* (Fig. 250) there is a sharper focus on the face, and especially the tears, than on the surrounding headdress. The complicated texture around the face is somewhat blurred. This blurring by contrast emphasizes the sharpness of the details in the face.

James Rosenquist combines all three kinds of texture—actual, simulated, and invented—in his lithograph *Iris Lake* (Fig. 251). Here texture is Rosenquist's prime concern and becomes the subject of the work. We see the invented texture of the image on the left, the simulated texture of crushed paper in the center, and the actual texture in the marks and rubbings on the right image. The piece is spatially ambiguous because Rosenquist places illusionistically three-dimensional elements in a flat, white field. Sometimes the shapes seem to lie on top of the white surface plane; sometimes they seem to be holes through the surface.

In summation, simulated texture is generally more dimensional than invented texture; invented texture is flatter. Repeated patterns or textural motifs result in a flatter space. Spatial ambiguity results from a use of simulated and invented texture.

251. James Rosenquist. *Iris Lake.* 1974. Lithograph, 3'1½" × 6'2" (.93 × 1.88 m). Courtesy Multiples, Inc., New York.

Spatial Illusion

Chapter Seven

Chapters 3 through 6 dealt with the spatial relationships of the art elements and the ways each element can be used to produce pictorial depth. Pictorial space may be relatively flat, illusionistically three-dimensional, or ambiguous, depending on how shape, value, line, and texture are used. In some drawings images seem to jut out toward the viewer. In others the objects seem to recede. Forms may appear volumetric or flat. Objects and figures may occupy a jumbled, fragmented, illogical space.

Space is to the artist what time is to the musician. It is an essential ingredient in all art work. In architecture we are actually contained by the space of the building; in sculpture we must move around the work to see it in its entirety; and in painting and the graphic arts, where the space is a pictorial one, we are shown an illusion of space. Space, then, is a factor that must be considered in all works of art.

Our ideas about space have changed radically in this century. Scientific exploration of space has exceeded the most active speculations of the last century. Along with this new knowledge and discovery, the ways artists depict space have changed also. The Renaissance humanistic philosophy that "man is the measure of all things" is in striking contrast to our conception of an expanding universe where the human being is less significant. Our relationship to the world is no longer so human-centered.

Since it has become so difficult to locate our exact position in the universe, it is no wonder that many artists today use ambiguous space in their works. This is not to say that an artist always predetermines the kind of space to be used in a work. The type of space an artist depicts is intuitive, not accidental. The intuitive response to space comes not only from a cultural base but from a private, personal one as well. The artist does not necessarily determine the kind of space to be used beforehand; other considerations, such as subject and intent, enter into the decision. The artist considers whether the work is primarily informational, expressive, or documentary, for example.

You, as an artist, must have an understanding of space to analyze both your own work and the work of other artists. This understanding gives you wider choices in both meaning and technique. Knowing which techniques give the effect of two-dimensional, three-dimensional, or ambiguous space keeps you from making unintentional contradictions in your work. If consistency in a given work is important—if it is important that the drawing appear relatively flat or, conversely, that it carry an illusion of deep space—knowledge of how the elements work will help you carry out your intention.

Eye Levels and Base Lines

One important matter that the artist must consider in the treatment of space is the use of *eye levels*. An eye level is an imaginary horizontal line that is parallel to the viewer's eyes. When we look

straight ahead, this line coincides with the horizon. If we tilt our heads—if we move our angle of vision to a higher or lower position—this eye-level line will also change, thereby making the horizon line seem higher or lower. Another important consideration is the *base line,* or the imaginary line on which an object sits. Base line and eye level are closely related. Base lines change as eye levels change. If all the objects in a given picture share the same base line—that is, if the base line remains parallel to the picture plane—space will be limited. If objects sit on different base lines—if these lines penetrate the picture on a diagonal—the resulting space will be deeper. Spatial manipulation—the devices an artist uses to direct the eye of the viewer through the picture plane—is a continuing concern. An important means of such manipulation is the treatment of eye levels and base lines.

Keep in mind that eye level is only one determinant of pictorial space. The space an artist uses is *relative;* it is not possible to determine the spatial quality of a work by eye level alone. In fact, the same eye level can result in a shallow or deep space depending on other determinants in the work, such as scale, proportion, subject, and the way the art elements are combined.

An example of extreme manipulation of eye level is the ceiling fresco by Giovanni Battista Tiepolo (Fig. 252). To look at the original painting the viewer stands on the floor and looks up at the ceiling. Even the reproduction shown here gives us the

252. Giovanni Battista Tiepolo.
Apollo Presenting to Frederick Barbarossa
His Bride, Beatrice of Burgundy (detail). 1751.
Ceiling fresco. Kaisersaal,
Episcopal Palace, Würzburg.

sensation of lifting our eyes (and head) upward. We are not looking straight ahead at the horizon line; our eyes are directed upward into a swirling, limitless space. This effect of expansive space is partially achieved by Tiepolo's control over the viewer's eye level. (Other devices Tiepolo uses in order to promote the feeling of space include skillful modeling to create volumetric forms and simulating the textures of swirling drapery and clouds to produce an aerial effect.)

One-Point Perspective

In contrast to the Tiepolo painting, Raphael, in his *School of Athens* (Fig. 253), directs the eye of the viewer through the center of the arches into an architectural space. The floor tiles, the colonnades of the building, even the figures themselves—especially the figure that reclines on the steps to the right of the two central figures—lead the eye of the viewer to a point of convergence where the two main figures stand. This device, in which the lines meet at a single point on the horizon, is called *one-point perspective*. (Another example of one-point perspective is the visual impression

253. Raphael. *The School of Athens*. 1510–11. Fresco, 25'3" (7.58 m) at base. Stanza della Segnatura, Vatican, Rome.

that railroad tracks converge at a single point on the horizon.) In addition to his consistently maintained eye level, Raphael produces this sense of space by overlapping figures, making objects smaller as they recede, blurring the detail in the background, and arranging figures on receding base lines.

An example of a contemporary use of one-point perspective, with a fixed, straight-on eye level, is the painting *Henry Geldzahler and Christopher Scott* (Fig. 254) by David Hockney. The space, as Hockney uses it, is much shallower than that in *The School of Athens*. The lines on the floor, the angle of the couch, and the sides of the table all point to the face of the seated man. The space is limited, and even though there is an outside window behind the central figure, our eyes are stopped abruptly by the flat wall and by the rigidly confining framework of the window and the building outside. In the Hockney painting the space seems to exist on only four or five planes, unlike Raphael's fresco, which gives the effect of many planes and a deeper space. The psychological effect of Hockney's painting is slightly disquieting, and it is the artist's treatment of space that contributes to the uneasiness that the viewer experiences.

254. David Hockney.
Henry Geldzahler and Christopher Scott. 1969.
Acrylic on canvas, 7 × 10' (2.13 × 3.05 m).
Collection Harry N. Abrams Family.

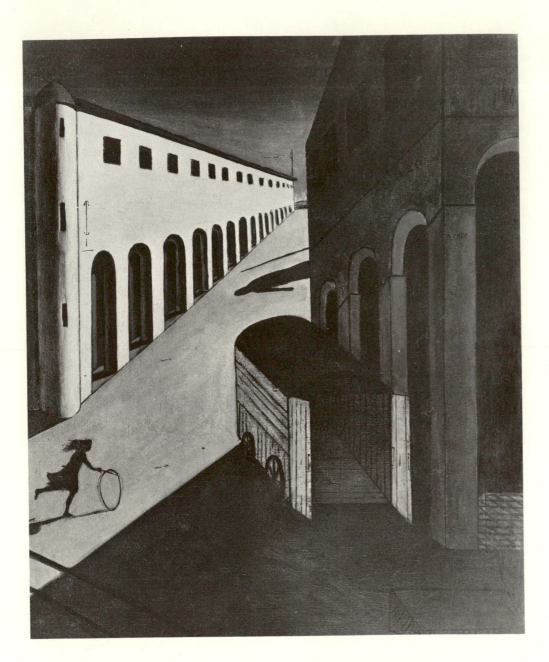

255. Giorgio de Chirico.
The Mystery and Melancholy of a Street. 1914.
Oil on canvas, 34³/₈ × 28¹/₂″ (87 × 72 cm).
Collection Mr. and Mrs. Stanley Resor,
New Canaan, Conn.

Multiple Eye Levels

The extremely disorienting effect that can be achieved by changing eye levels in the same painting is illustrated by Giorgio de Chirico's eerily disturbing *Mystery and Melancholy of a Street* (Fig. 255). In addition to the unreal lighting, sharp value contrasts, and extreme scale shifts which contribute to the surreal, otherworldly effect, the most jarring result is produced by Chirico's forcing the viewer to change eye levels from one part of the painting to the other. He uses one eye level for the cart, another for the building in the foreground, and still another for the white building on the left. The diagonals recede into the distance at a dizzying rate, unlike the lines in Raphael's fresco, which recede in a gradual and expected manner.

For comparison, another David Hockney painting, *Model with Unfinished Self-Portrait* (Fig. 256), also combines multiple eye levels in the same painting, but the effect is quite different than Chirico's. The foreground of the painting uses a consistent and logical eye level and perspective. The objects and reclining figure in the foreground seem to occupy a "real" space; the viewer looks straight into the scene. The eye level remains constant throughout this section of the painting. But the unfinished self-portrait section—the top half of the painting—forces our eyes to shift radically. From the logically stated space of the figure on the bed, the eye level changes to a jolting bird's-eye view of the desk, and to still another eye level for the seated figure. In fact, the smaller vase of flowers is seen from a different eye level than the desk or seated artist. The geometric shape behind the seated artist is a clue that Hockney is consciously playing games with perspective. Hockney's work centers around changing eye levels.

256. David Hockney.
*Model with Unfinished
Self-Portrait.* 1977.
Oil on canvas, 5' (1.52 m) square.
Collection Mr. and Mrs.
Werner Böninger, Germany.

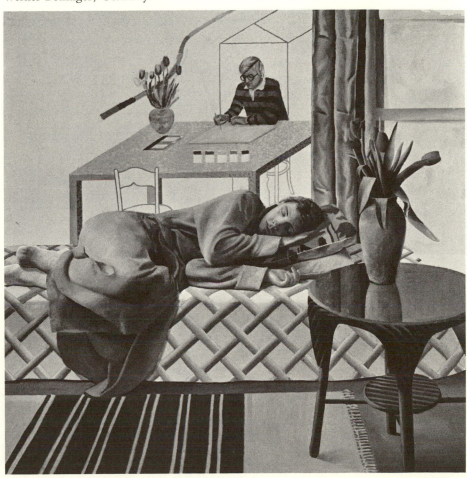

Parallel Base Lines

above: 257. Wall painting, from Tomb 261, Thebes. c. 1500 B.C. 29¹/₂ × 41¹/₄″ (75 × 105 cm).

below: 258. Öyvind Fahlström. *Performing Krazy Kat III.* 1965. Variable painting, tempera on canvas and metal with movable magnetic elements; 4′6¹/₂″ × 3′1¹/₂″ (1.38 × .93 m). Collection Robert Rauschenberg, New York.

An ancient Egyptian mural (Fig. 257) and a 20th-century comic-strip-style painting by Öyvind Fahlström (Fig. 258) illustrate how parallel base lines create space that is predominately two-dimensional. These parallel base lines within the same picture plane give the effect of stacked panels or frames and encourage the viewer to "read" the page from top to bottom or from bottom to top. Parallel base lines call attention to the two-dimensionality of the picture plane.

154

In these two works there are shifts in eye level from frame to frame, though it is more pronounced in the Fahlström painting. Both works use a number of common devices to maintain a relatively shallow space. In each work there is little or no modeling; value remains flat within a given shape. Repeated shapes are used. There is limited use of diagonals; shapes remain parallel to the picture plane and are primarily horizontal and vertical. Outlines and invented textures made up of lines and dots are used throughout both works. The size and placement of figures in the Egyptian relief are arbitrary; they fit a religious and social hierarchy rather than a visual reality. Size and placement of images in the Fahlström piece are also arbitrarily determined. The emphasis in the Egyptian drawing is on positive shapes, which fill the grid but create little depth. The contemporary work makes more use of negative space, indicated by horizon lines that vary slightly from frame to frame.

Red Grooms also uses multiple base lines in his etching *45 Characters* in Figure 259. The exaggerated and humorous figures could be actors in an American comedy of manners. The stacked base lines require a sequential reading from left to right. In the third line, however, we read from right to left, due to the characters' change in direction.

In the following problems you will experiment with different eye levels. Keep in mind that it is not eye level alone that creates spatial illusion. You will need to use the other art elements as well. All four problems use the same still life as a subject, but the eye levels vary.

259. Red Grooms. *45 Characters.* 1973.
Etching hand-colored with watercolor,
19 × 17³/₄″ (47 × 45 cm).
Courtesy Brooke Alexander, Inc., New York.

Problem 60 For this problem you are to set up a still life comprised of four or five items. Place the objects on a table in front of a window. Arrange a few more objects on the windowsill. Use multiple parallel base lines as in the Egyptian wall drawing (Fig. 257). Draw the objects on the same base line in each frame. Make use of repeated shapes, flat values, invented texture, and outlining to create a relatively shallow space. Keep the objects parallel to the picture plane. Scale and proportion may change from panel to panel.

Problem 61 Using the same still life as in Problem 60 as a subject, imagine that you are an ant looking up at the objects. Exaggerate the distance upward between you and the still life and between the still life and the view out the window. Try to depict a deep space, keeping objects that are closer to you in sharper focus. Make textures and values diminish in sharpness of detail as objects recede.

Problem 62 In this problem you are to use one-point perspective. Station yourself directly in front of the still life. Draw the objects with a fixed eye level. Make any diagonals that you use converge at the center point in the still life. Create a center of interest in the center of the drawing. The depth of space in this drawing is flexible; you may either create an illusionistically deep space or one that is relatively flat. If you choose to depict a deep space, arrange the objects on different base lines, on a diagonal receding into space. If your preference is a shallower space, crowd objects on the same base line, limit the space between base lines, and reduce the number of receding planes.

Problem 63 This time draw the same still life making use of changing, or multiple, eye levels within the same drawing. The resulting space will be ambiguous. Use one eye level for the window, another for the tabletop, and still another for the objects on the table. The effect may be extremely disorienting or only slightly off-balance, depending on the degree of the change from one viewpoint to another and on your use of value and lighting effects.

The type of space an artist uses is relative; it is seldom possible to classify a work as strictly two- or three-dimensional. As a drawing student you may be required to create a flat or an illusionistic or an ambiguous space in a given problem, but as an artist your treatment of space is a matter of personal choice. Mastery of the spatial relationships of the elements will give you freedom in that choice. Your treatment of space should be compatible with the ideas, subject, and feeling in your work. Along with shape, value, line, texture, and color, proficiency with spatial effects can help you make an effective personal statement.

A Contemporary View

Part III

The Picture Plane:
A Key to Contemporary Concerns

Chapter Eight

Part II dealt with the way the art elements can be used to create spatial illusion and with some of the ways pictorial space can be controlled through eye level. As we have seen, treatment of space is a major concern of the artist. This chapter focuses on another major contemporary concern—recognition of the picture plane and how to handle the problems it presents. This is not to say that earlier artists have not been aware of the demands of the picture plane—its size, its flatness, its edges, its square corners. However, most innovations in form in the 1960s and 1970s have specifically and explicitly centered around the demands and limitations of the actual physical support or surface on which an artist works.

Denial and Assertion of the Picture Plane

Concern with the demands of the picture plane has manifested itself basically in two ways: *assertion* of the picture plane and *denial* of it. Both approaches, however, emphasize the importance the picture plane has had on formal considerations. Form, the inter-relationship of all the elements, is the way you say what you mean. In art, form and meaning are welded; form is the carrier of the meaning. It is the design or structure of the work, the mode in which the work exists. It is an order created by the artist. Let us look at some of the specific ways recognition of the picture plane—both denial and assertion of it—has affected the formal approaches and decisions of contemporary artists.

Perhaps the most obvious and visible denial of the picture plane has been the change of the traditional rectangular or square plane of the picture surface into different shapes. Frank Stella's large canvas *Quathlamba* (Fig. 260) is a good example of denial of the traditional canvas shape. This new shape presented Stella with a new problem—what image to put on it. Stella's solution was to use a motif that reinforces the shape, that points out and affirms its jutting and receding edges.

260. Frank Stella. *Quathlamba*. 1964. Metallic powder and polymer emulsion on canvas, 6'5" × 13'7" (1.96 × 4.14 m). Collection Mr. and Mrs. Carter S. Burden, Jr.

Another way to deny the traditional canvas shape is to make the image a continuous one—to negate the limitations of the edge by making the viewer imagine that if the plane were extended in any direction the image would also extend, unchanged. For example, if we imagine Vija Celmins' pencil drawing of the sea (Fig. 261) to encompass a larger view, it would still have the same continuous image over its surface. Top, bottom, and sides would be unchanged; that is, there would still be a continuous field of water. Celmins uses a recognizable subject and treats it realistically, but this continuous-field effect can be achieved with nonobjective forms as well.

If a recognizable subject is used, as in Stuart Caswell's *Chain Link Disaster* (Fig. 262), it must be one the viewer can imagine continues beyond the limits of the picture plane. In Caswell's

above: 261. Vija Celmins. *Untitled.* 1969.
Pencil and acrylic, $14^{1}/_{2} \times 19^{1}/_{4}''$ (37 × 49 cm).
Collection Charles Cowles, New York.

below: 262. Stuart Caswell. *Chain Link Disaster.*
1972. Pencil, $22 \times 28^{1}/_{4}''$ (56 × 71 cm).
Minnesota Museum of Art, St. Paul.

263. Jean Dubuffet. *Storm on the Steeple*. 1952.
Pen and ink, 18¾ × 23¾″ (48 × 60 cm).
Museum of Modern Art, New York
(gift of Mr. and Mrs. Lester Avnet).

work, the forms become smaller at the top, and darker values and larger shapes appear in the lower segment; nonetheless, there is a continuous surface and conceptually we defy the sides of the drawing. In other words, we do not feel that the drawing has a beginning and an end; it is continuous.

The same is true of Jean Dubuffet's *Storm on the Steeple* (Fig. 263), where the subject is not recognizable. The patterning, the repeated shapes, the sameness of line, and the sameness of value shapes create an overall texture that seems to continue beyond the confines of the picture plane. While there is a change in focus from top to bottom in both of these drawings, there is no single focal point, no area that has priority over another area. There is no beginning and end, no center of interest.

The works of Caswell and Dubuffet illustrate denial of the picture plane's limits. Let us look at two examples that illustrate assertion of the limits of the picture plane—dominance of the edge. The first example uses recognizable and illusionary imagery,

the second a conceptual approach. In the watercolor *Airplane Window* (Fig. 264), Yvonne Jacquette uses the airplane window as a border for the view outside the window. The window serves a triple function: it frames another image, it reiterates the size and shape of the picture plane, and it is a contemporary window into a contemporary space. Here the traditional Renaissance use of the picture plane as a "window into space" has been given a radically new 20th-century look. In this instance the two images—window and outside view—serve a contradictory function. The window-border has a beginning and an end—we know where it stops and where it starts—whereas the image outside the window is a continuous space, quite literally a limitless one. This highly complicated and sophisticated statement is delivered in a rather simple and straightforward way; both form and image are carriers of a complex message.

264. Yvonne Jacquette. *Airplane Window.* 1973. Watercolor, 12⅛ × 9″ (31 × 23 cm). Collection Mr. and Mrs. John Walsh, New York.

In sharp contrast to Jacquette's watercolor is Jim Nutt's *Thump and Thud* (Fig. 265). Here the picture plane contains its own frame in the form of a decorative border. Inside the border is a large figure whose frontality is reinforced by a vertical shape along the side and a horizontal one along the top. Outline, closed shapes, and repeated textural patterns all contribute to the flatness of the drawing, which echoes the flatness of the picture plane. Spatial ambiguity is achieved by a shift in scale between the frontal figure's hands and head, and by the tiny woman who stands on the border of the picture.

Problem 64 Make two drawings that deny the picture plane, one using recognizable images and one using nonobjective imagery. Create an overall textured surface so that any segment of the drawing is highly similar to any other segment. There should be no center of interest. Try to create an illusion that the image extends beyond the confines of the picture plane, creating a continuous surface.

265. Jim Nutt. *Thump and Thud.* 1973. Colored pencil, 30 × 27″ (76 × 69 cm). Museum des 20. Jahrhunderts, Vienna.

Problem 65 Make two drawings that assert the limits and flatness of the picture plane. In the first drawing choose a common, everyday object as subject. Present the object frontally. Enclose it with a patterned border. Use a conceptual approach. In the drawing of the typewriter in Figure 266, the student has given a mechanical object importance by conceptualizing it as somewhat anthropomorphic. The use of solid value shapes and outlining along with reverse perspective emphasizes the flatness of the picture plane.

In the second drawing, using a subject of your choice, concentrate on a more realistic depiction. Again, use a border to call attention to the flatness of the picture plane even though you have created a spatial illusion within the frame. The photocopy drawing in Figure 267 presents the continuous surface of a ballroom floor with moving images of women's feet. The plane of the floor repeats the flatness of the picture plane. An abrupt value change between the two borders of the drawing also calls attention to the flatness of the picture plane.

above: 266. Typewriter drawing. Student work. Acrylic.

right: 267. Color photocopy drawing. Student work. Mixed media.

left: 268. Robert Indiana.
The Great American Dream: Freehold. 1966.
Conté stencil rubbing, 40 × 26″ (102 × 66 cm).
Courtesy the artist.

below: 269. Judy Chicago.
Female Rejection Drawing,
from *The Rejection Quintet.* 1974.
Prismacolor, 40 × 30″ (102 × 76 cm).
On extended loan to San Francisco Museum of Modern Art.

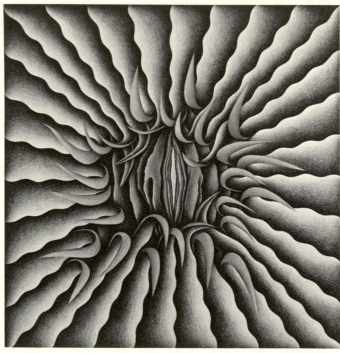

Arrangement of Images on the Picture Plane

The importance of the relationship between positive and negative space has been emphasized throughout the book. In dealing with the demands of the picture plane, the relationship between solid and void is again crucial. Because the size and shape of a picture plane is firmly established, positioning of positive and negative shapes on that plane becomes vitally important. Placement of an image calls attention to the shape and size of the plane on which it is placed. Center, top, bottom, and sides are of equal importance until the image is placed, which then gives priority to a specific area. Centralizing an image on a picture plane gives the maximum

balance and symmetry. A centralized image is stated frontally; this reinforces the horizontal and vertical format of the picture plane itself.

In the rubbing *The Great American Dream: Freehold* (Fig. 268), Robert Indiana centralizes a large heraldic image for Americans. The image is made static by its placement and by the enclosed shapes, especially the closed circle. Such complete balance in the positioning of the image permits no movement. The stars above the image are likewise symmetrically placed, as is the rectangular shape of the word "freehold." Heraldry is a branch of knowledge that deals with family pedigrees, that describes proper armorial insignia. Indiana's drawing makes a humorous comment on American democracy by creating a heraldic emblem for Americans.

Judy Chicago also uses a centralized image in her *Female Rejection Drawing* (Fig. 269). Unlike the Indiana image, which is static, this image seems to radiate from the center. The waving lines activate the drawing. The use of value and of shapes that extend to the edges of the drawing surface—thereby calling attention to both center and edge—creates a luminous flickering action that dramatizes the centralized image. The image is mysterious—small yet powerful.

In the Chicago and Indiana drawings, the center of the picture plane is activated by the placement of the image. In much contemporary work, however, the center is left empty. A void seems to crowd the images to the edge. This is especially true in Morris Louis' work (Fig. 270), in which attention to the edge is a dominant characteristic. We cannot classify the center space as simply leftover or empty space because it has a forceful power. It seems to squeeze the images in the painting down and out of the picture plane itself.

270. Morris Louis. *Alpha-Tau.* 1961. Acrylic on canvas, 8'5" × 19'3⅞" (2.59 × 5.95 m). St. Louis Art Museum (purchased with funds given by The Shoenberg Foundation).

In drawings with an overall surface pattern as discussed earlier, the image continues outside the picture plane itself; this again is the case in Susan Hauptman's *Line Drawing #46* (Fig. 271). We imagine the tangled weblike threads to extend beyond the limits of the picture plane. Placement of the images calls attention to the bottom and side of the picture surface and tests our sense of gravity. Does the thread fall to the bottom from the side image or is it being pulled forcibly by the bottom mass?

Don Scaggs combines a border of vinyl with a composition that occupies the edges of the picture surface in his diary drawings (Figs. 272, 273). An interesting interchange takes place in the center white space. At times it appears to be an empty, negative space; at other times it seems to be a female torso. The shapes at the edge press inward on the torso shape. We do not see a complete image; the torso shape and many of the shapes around the edges have been cut off, implying that the images continue beyond the confines of the border.

Another way in which contemporary artists have asserted the picture plane is by crowding the picture surface with a great number of images. This eliminates priority of focus. Like the continuous-surface approach, in which there seems to be no beginning or end, the images seem capable of being compiled *ad infinitum.* In addition to emphasizing the continuous surface of the

271. Susan Hauptman.
Line Drawing #46. 1970.
Pen and ink on masonite,
14 × 10½″ (36 × 27 cm).
Minnesota Museum of Art, St. Paul.

left: 272. Don Scaggs.
Diary 18/19: You Get a Line and I'll Get a Pole. 1974.
Colored pen and graphite, encased in vinyl envelope;
36 × 24″ (91 × 61 cm).
Courtesy the artist.

above: 273. Don Scaggs.
Diary 17/18: Dad's Chuckles. 1975.
Mixed media. 46 × 30″ (117 × 76 cm).
Courtesy the artist.

picture plane, seemingly unrelated images of contradictory size, proportion, and orientation announce that the picture plane is not a place for a logical illusion of reality. Rather, it is a plane that can be arranged any way the artist chooses.

Images are juxtaposed in odd ways in Dennis Corrigan's *Queen Victoria Troubled by Flies* (Fig. 274). The incongruity of the subject matter is underscored by the large scale of the flies and the inexplicable image the Queen is holding—or does the clownlike figure recede into her bosom? The confusion in form is compatible with the confusion of meaning.

274. Dennis Corrigan.
Queen Victoria Troubled by Flies.
1972. Cronaflex,
13 × 10½″ (33 × 27 cm).
Courtesy Associated American
Artists, New York.

QUEEN VICTORIA....
TROUBLED BY FLIES

In Öyvind Fahlström's work (Fig. 275) we are exhausted by the number of images, their scale and placement, and the difficulty of sorting out words and images. We do not know what to look at first. Positive shapes crowd out the negative shapes. Some semblance of order is introduced by the square segments, which read from left to right, but these give way to a burst of subjects that for the most part are unidentifiable. The result is a highly complicated and overall-textured surface that we cannot decipher. The drawing seems capable of continuing forever in just the same complicated way. The images cut off at top, bottom, and sides of the picture plane also suggest this. Fahlström asserts the picture plane as a place to deposit images, but denies it as a limiting factor in the drawing.

In the Fahlström drawing positive shapes crowd out negative shapes, and negative space is treated simply as leftover space. In contrast, some contemporary artists assert the picture plane by emphasizing the void, the empty or negative space. The assertion of a negative space that is congruent with the picture plane can be seen in John Dowell's etching *Whew!!* (Fig. 276). The small, rather insignificant-looking marks at the top of the page are overwhelmed by the vast amount of negative space. They are like a last gasp before the light is turned out. They appear to be energetic electric charges floating out of the void, floating up and out of the picture plane itself.

above: 275. Öyvind Fahlström.
Notes "150 Persons." 1963.
Tempera, collage, and ink;
$18^5/_8 \times 23^3/_4''$ (47 × 60 cm).
Collection Mr. and Mrs. E. A. Bergman, Chicago.

below: 276. John Dowell. *Whew!!* 1968.
Etching, $28^1/_4 \times 20^7/_8''$ (72 × 53 cm).
Courtesy the artist.

277. Alex Katz. *Homage to Frank O'Hara: William Dumas.*
1972. Lithograph, 33¼ × 25½″ (84 × 65 cm).
Courtesy Brooke Alexander, Inc., New York.

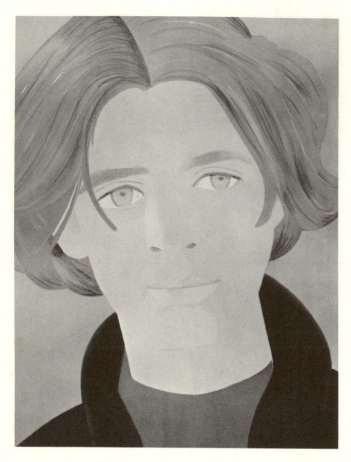

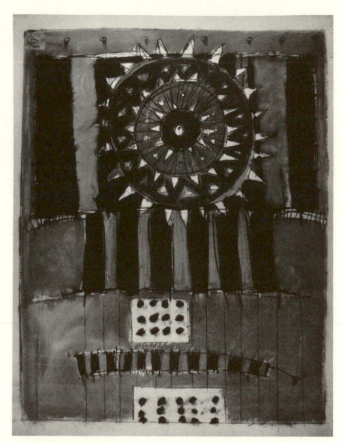

above right: 278. Centralized image.
Student work. Pastel and turpentine.

right: 279. Centralized image.
Student work. Pastel and turpentine.

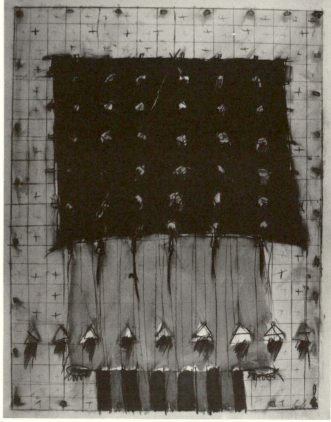

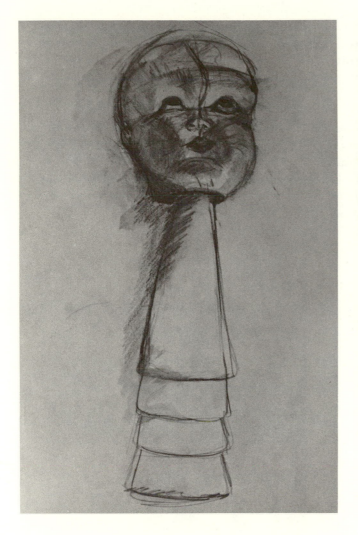

Alex Katz, on the other hand, uses a positive shape to crowd out the negative space in his lithograph *Homage to Frank O'Hara: William Dumas* (Fig. 277). We are confronted with the point-blank stare of the youthful face. Head, hair, and shoulders are cut off by the edges of the print. Katz denies the limits of the paper by this close-up, blown-up view. We know the figure's shape continues beyond the confines of the page. We are forced to come to terms with the unblinking eyes in the empty or negative shape of the face.

Problem 66 Make two drawings in which placement is the prime concern. In the first drawing use a centralized image. Present the image frontally (Figs. 278, 279). You may use an abstract image or you may use a recognizable subject (Figs. 280, 281).

In the second drawing emphasize the edges or corners of the picture plane. Position the image so that corners or edges are activated. Again, you may use an abstract image or you may use a recognizable subject.

In Figure 282 the student positioned modeled geometric shapes in such a way as to call attention to a corner and two sides of the picture plane. In Figure 283, using a still life as subject, the student placed the objects so as to call attention to a side and the bottom of the picture plane.

Problem 67 Using photocopies, make a collage of real objects (Fig. 284). Take care in choosing your objects; try for a wide range of textural variety. Place the objects directly on the copier. Do several copies, changing the composition each time. If the print seems unfinished, draw on its surface. Pencil and grease pencils are compatible media.

left: 282. Attention called to corner and sides of picture plane. Student work. Charcoal.

above: 283. Attention called to side and bottom of picture plane. Student work. Charcoal.

Problem 68 In this problem you are to make two drawings using subjects of your own choice. In the first drawing, juxtapose a small positive shape against a vast amount of negative space. Activate the void by the way you position the small shape. The empty space is literally the shape of the picture plane. Do not centralize the positive shape or there will be no tension or sense of movement.

In the second drawing use an image that completely fills the picture plane. For instance, you may enlarge a detail of a form. In any case, crowd out the negative space by filling the picture plane with a single image. Confront the viewer with a large image that is cut off by the top, bottom, and sides of the picture plane.

284. Collage using real objects.
Student work. Photocopy, tissue paper, plastic.

The Picture Plane: A Key to Contemporary Concerns 175

Division of the Picture Plane

Another formal means contemporary artists have used to meet the demands of the picture plane is the *grid,* which divides the picture plane into units or segments. In addition to reiterating the shape of the picture plane—its horizontal and vertical shape—the units introduce the element of *sequence,* which in turn brings up the idea of time. More traditional art is viewed synchronically; that is, the composition is seen all at once in its entirety. Grid compositions, on the other hand, are viewed both synchronically and linearly. We, of course, see the entire work at first glance, but when we take a more sustained look, the composition demands to be read sequentially, segment by segment. Casey Williams' work from his *Paper Drawing Series* (Fig. 285), for instance, demands to be read from upper left to lower right. Each unit of the grid undergoes a gradual and sequential change as the forms progress from simple shapes to more complex ones. There is only a slightly perceptible change in composition between each adjacent frame; from row to row there is a more pronounced, yet still gradual change; and from the first unit to the last one there is a decisive change.

Again, in Henry Whiddon's painting in Figure 286 the viewer sees the whole before moving to the parts. However, in

285. Casey Williams.
Untitled, detail from *Paper Drawing Series.* 1979.
Color photographs from cut paper,
40 × 30″ (102 × 76 cm).
Courtesy the artist.

this work we are not as strongly compelled to read the composition from upper left to lower right as we were in the Williams drawing. Whiddon directs our eyes through the picture plane in a less regular fashion. While one shape is maintained throughout the grid, value, color, and texture are used differently in each unit. The eyes of the viewer are led through the picture plane by these elements in a less predictable order. As a result, the composition is easier to assimilate in its entirety than the Williams work in which each unit or row maintains its separateness.

In the Williams work the grid divisions and the white spaces separating them never intrude upon each other. They remain distinct, with the white borders framing each individual component. In Whiddon's painting, however, the divisions are not so strongly reinforced. Whiddon both asserts and denies the grid; by use of value the units are sometimes destroyed, sometimes emphasized. At times the grid is only implied, as in the lower right-hand corner; at other times the separations are clearly delineated, as in the last frame in the second row. In Williams' work spatial illusion occurs inside the frames; the white lines between segments call us back to the flatness of the picture plane. In Whiddon's work there is an overall spatial ambiguity due to his assertion and denial of the grid format.

286. Henry Whiddon. *Woman*. 1968.
Polymer acrylic and metallic leaf,
4 × 3′ (1.22 × .91 m).
Courtesy the artist.

Rob Erdle uses an implied and irregular grid in his watercolor in Figure 287. The units in this grid are not all of the same size or shape. Each segment is slightly tilted, slightly off-square; they are not strictly geometric. The irregular shapes of the grid units and the interior shapes that overlap adjacent units create a complicated interplay. This unpredictable type of grid, while affirming the picture plane on one hand, seems also to defy its flatness. We feel that if each unit in Erdle's work were cut out and reassembled in a strictly horizontal and vertical format, the newly constructed plane would be larger than the original one.

above: 287. Rob Erdle. *Tetuan.* 1976. Watercolor and graphite, 3′ × 4′4″ (.91 × 1.32 m). Collection Ken Hilton, Birmingham, Ala.

right: 288. Bernard Cohen. *Untitled 1964.* 1964. Crayon and pencil, 20⅝ × 25″ (52 × 64 cm). Private collection, London.

Bernard Cohen, too, uses an unpredictable grid pattern in his untitled crayon and pencil drawing (Fig. 288). He combines a variety of approaches in the same work. While the grid calls attention to the picture plane, the overall textured surface of the background seems to continue beyond the stated limits of the page, thus denying the edge of the picture plane. Our reading of the drawing from left to right is interrupted when we try to compare the larger background drawing with the images inside the grid units. Is the larger drawing a detail taken from one of the smaller grid images? Does the enlargement come from the first unit, the second unit, or the unit on the right? In the lower center of the drawing, Cohen begins to tilt and overlap the geometric sections, creating spatial ambiguity in an otherwise relatively flat space. The waving lines carry the movement away from the rhythmic repetition of the value shapes, activating the drawing. This contrast between the static geometric shape of the grid and the highly active surface with its curvilinear lines contributes tension and complexity to the drawing.

The sequential linear pattern of the grid introduces our final discussion of contemporary approaches to the picture plane, *stopped frames,* or cinematic structure. While grids can be read in a number of ways—horizontally, diagonally, or vertically—in cinematic structure each frame follows the other in sequential order; there is a linear reading of a repeated image. There is also a definite sense of time lapse and movement—either of the image itself or by the artist creating the image.

While most stopped-frame compositions use a regular geometric frame (like a segment of a piece of film) a linear, sequential arrangement can be achieved by omitting the frames. May Stevens uses a linear progression in her drawing *Big Daddy Paper Doll* (Fig. 289). The central character, who is nude and startlingly white, is flanked by different costumes that identify his various

289. May Stevens. *Big Daddy Paper Doll*. 1970. Screenprint, 14 × 35″ (36 × 89 cm). Courtesy Lerner-Heller Gallery, New York.

roles. While the white figure is dominant, it is as empty as the uniforms alongside it. There is a suggestion of repeated images; if we could look beyond the confines of the left and right edges of the picture plane, we would not be surprised to find that the line of empty costumes continues.

The device of stopped frames, or cinematic structure, both reinforces and denies the picture plane. Visual reinforcement comes from the contained images. Conceptual denial is suggested by the idea of continuation, by the idea that with a longer lapse of time come more stopped-frame images.

Problem 69 Make three drawings using grids. Use a machine part as subject. You may repeat the same image in each unit (Fig. 290), change the image from unit to unit (Fig. 291), or change the scale of the object from unit to unit as in the concentric grid in Figure 292.

In the first drawing use a grid in which each unit is the same size. Be sure that the divisions between the units are distinct; make the grid prominent. Try to produce a drawing that will be read from left to right.

In the second drawing lightly establish a grid; then use value, texture, and line to negate the regular divisions. Lead the eye of the viewer through the picture plane by your distribution of value. Try to achieve an overall effect as opposed to a sequential reading of the drawing.

In the third drawing use a grid of irregular units (Fig. 293). You may overlap the sections, use grids in one area only, or simply imply a grid arrangement.

290. Drawing using a grid.
Student work. Graphite.

above: 291. Drawing using a grid.
Student work. Ink wash.

right: 292. Concentric grid drawing.
Student work. Conté.

below: 293. Drawing using a grid of irregular units.
Student work. Acrylic, pencil.

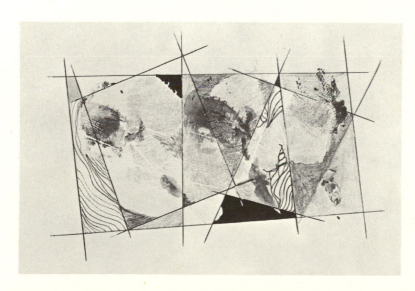

above: 294. Image repeated in linear sequence. Student work. Etching.

Problem 70 In this problem you are to repeat an image in a linear sequence. The repeating units may progress from left to right across the page, or they may move up the page from bottom to top. The subject is your choice. Keep in mind the importance of a time lapse. This may be achieved by having the image undergo slight changes from frame to frame.

For example, in Figure 294 the student used an abstract landscape as subject. The single line of images moves across the page with a minimum of changes from one frame to the next. There is a sense of expectation as we view the individual units. The embossed white empty spaces are a jolting interruption in the otherwise subtly sustained progression.

In Figure 295 the frames move from bottom to top. The student has moved in closer for each new view of the face, thereby producing a sense of movement along with the sense of time lapse. This idea of movement is enhanced by the movement of the simple, flowing shapes of the hair.

Summary: Personal Solutions

We have looked at and discussed a number of ways contemporary artists have dealt with the demands of the picture plane. Our list is by no means comprehensive, for each time artists are confronted with the clean, untouched surface of the picture plane, new problems arise. Out of the artist's personal and very subjective experience come the solutions to these problems. In many artists' work the response to the demands of the picture plane is highly conscious; in other artists' work the response is intuitive.

In your own work, whatever approach you take, the solutions or resolutions should not be turned into formulas, for there are no pat answers to any problem in art. Involvement in your own work, and familiarity with the concerns of other artists will help you solve your own problems in a personal and exciting way.

left: 295. Image repeated in linear sequence.
Student work. Acrylic, ink.

Thematic Development in Drawing

Chapter Nine

Thematic drawings have an image or idea in common. They are usually part of a sustained series of drawings. Artists have always worked in thematically related series, but the current concern with process has made thematic development especially evident today. Galleries and museums not only display works in series dealing with a single theme, but also show working drawings leading to more finished pieces. The trend toward thematically related works is a particularly current one. This chapter focuses on the ways thematic series can be developed.

There are a number of reasons to develop a series of drawings based on a single theme. The most basic reason is that art involves the *mind* as well as a coordination between eyes and hand. Art sometimes begins with an exercise in thinking and moves to an exercise in doing. Just as frequently the order is reversed, but the two processes are always in tandem. The emphasis in a thematic series—and the emphasis throughout the problems in this chapter—is on process rather than product.

Any drawing problem has many possible solutions. Thematic drawing, since it is an open-ended series of pieces, provides a way to express more ideas or variations on an idea than is possible in a single work. Nothing can better illustrate the number of compositional and stylistic variations possible on a given subject than your own work with a set of thematic drawings. Since you will be using only one subject or idea throughout the series, you are free to attend more fully to matters of content.

A thematic series allows you to go into your work more deeply, with more involvement and greater concentration. Further, you will learn to work more independently, at your own pace.

Finally, the process of drawing thematically develops a commitment to your work and thereby a professional approach. And, like a professional, you will begin more and more to notice the thematic patterns in other artists' work.

296. Jim Dine. *Double Red Self-Portrait (The Green Lines)*. 1964.
Oil and collage on canvas,
7 × 10′ (2.13 × 3.05 m).
Seagram Collection, New York.

A first step toward developing thematic drawings is to look at the way artists have handled theme in their works. Some general thematic categories are *private themes,* chosen by individual artists; *group themes,* developed within a movement or school, such as Cubism or Impressionism; and *shared themes,* the same images or subjects used by different artists over a long period of time.

Private Themes

An example of private thematic development can be seen in works by Jim Dine. His bathrobe series (Figs. 296–298) shows the artist's use of an everyday object infused with energy and personal meaning, so much so that it is a type of self-portrait. Dine draws a bathrobe with no one wearing it, but he becomes a part of the drawing because he projects the feeling that he is *inside* the robe. In his series, Dine changes the treatment of the bathrobe by using different media, techniques, styles, and scales. He has used the robe in combination with other elements, both two- and three-dimensional, and he has treated the robe theme in drawings, prints, and paintings. The treatment has changed but the subject, or theme, has remained constant.

above left: 297. Jim Dine. *Red Bathrobe.* 1969. Lithograph, 4'5¹/₈" × 3'1¹/₂" (1.35 × .95 m). Courtesy Brooke Alexander, Inc., New York.

above right: 298. Jim Dine. *Charcoal Self-Portrait in a Cement Garden.* 1964. Charcoal and oil on canvas with five cement objects, 8'11¹/₄" × 3'9⁵/₈" × 2'3" (2.75 × 1.17 × .69 m). Allen Memorial Art Museum, Oberlin College, Ohio.

above: 299. Claes Oldenburg.
Small Monument for a London Street:
Fallen Hat (for Adlai Stevenson). 1967.
Pencil and watercolor,
23 × 32″ (58 × 81 cm).
Collection Kimiko and John Powers.

right: 300. Claes Oldenburg.
Proposed Colossal Monument:
Fan in Place of the Statue of Liberty,
Bedloe's Island. 1967.
Pencil, 26 × 40″ (66 × 102 cm).
Öffentliche Kunstsammlung, Basel.

below: 301. Claes Oldenburg.
Late Submission to the Chicago Tribune
Architectural Competition
of 1922—Clothespin, Version One. 1967.
Crayon, pencil, and watercolor;
22 × 23¼″ (56 × 59 cm).
Collection Philip Johnson.

Claes Oldenburg's monument series (Figs. 299–301)—imagined installations of gigantic everyday objects such as a fan, a hat, and a clothespin—is another example of private thematic development. In Oldenburg's work the emphasis is not on a polished, finished drawing but rather on an idea, a concept. The drawings are energetic, sometimes simple indications with just enough detail to convey the idea. Oldenburg chooses a specific geographical location and places on it an object that furnishes a humorous social commentary. The fan, for example, would guarantee residents of Lower Manhattan a constant breeze. We can only begin to imagine the scale and mass of a fan as large as the Statue of Liberty.

Private themes can also deal with abstract or nonobjective images. In Figure 302, Sam Gummelt's chevron motif is combined with negative space. The motif is then enlarged and used as an overall pattern made up only of positive shapes (Fig. 303).

left: 302. Sam Gummelt. *Hillsboro #11.* 1977.
Pastel and graphite, 32″ (81 cm) square.
Courtesy the artist.

below: 303. Sam Gummelt. *Untitled (Double White).* 1976.
Pastel and graphite, 30 × 40″ (76 × 102 cm).
Courtesy the artist.

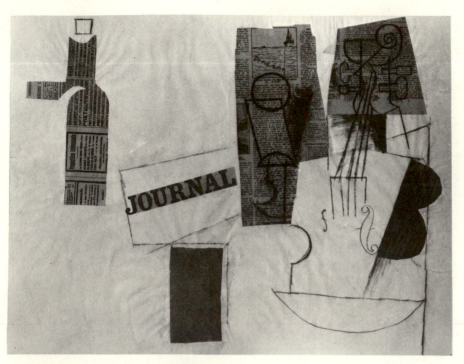

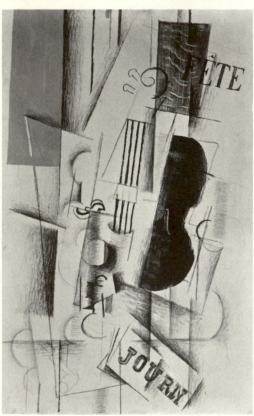

above: 304. Pablo Picasso. *Bottle, Glass and Violin.* 1912–13. Paper collage and charcoal, 18¹/₂ × 24³/₈" (47 × 62 cm). National Museum, Stockholm.

left: 305. Georges Braque. *Musical Forms.* 1913. Oil, pencil, and charcoal on canvas; 36¹/₄ × 23¹/₂" (92 × 60 cm). Philadelphia Museum of Art (Louise and Walter Arensberg Collection).

Group Themes

Members of the same schools and movements of art share common philosophical, formal, stylistic, and subject interests. Their common interests result in *group themes.* The Cubists illustrate the similarity of shared concerns most readily (Figs. 304, 305). Their use of ambiguous space through multiple, overlapping, simultaneous views of a single object, along with a combination of flat and textured shapes, is an identifying stylistic trademark. Collage elements—newspapers, wallpaper, and playing cards—as well as the images of guitars, wine bottles, and tables appear in the works of many Cubists.

Pop artists comprise a contemporary group with a preference for banal subjects. As the name suggests, these artists deal with *popular* images, taken from mass media, which are familiar to almost everyone in our culture. Not only do they choose commercial subjects such as the Coca-Cola bottle (Figs. 306, 307), but they also use commercial design techniques such as the repeated or jumbled image. In James Rosenquist's painting *F-111* (Fig. 308), images of an airplane, a hair dryer, and a plate of spaghetti are mixed with no logical relation of scale. For the Pop artists both subject and technique make a comment on American life and culture.

above: 306. Tom Wesselmann. *Still Life #50.* 1965.
Assemblage on wood;
diameter 39¹/₂″ (100 cm), depth 4″ (10 cm).
Courtesy Sidney Janis Gallery, New York.

right: 307. Andy Warhol. *Green Coca-Cola Bottles.* 1962.
Oil on canvas, 6′10¹/₄″ × 4′9″ (1.78 × 1.45 m).
Whitney Museum of American Art, New York
(gift of Friends of the Whitney Museum).

below: 308. James Rosenquist. *F-111,* detail. 1965.
Oil on canvas with aluminum,
entire work 10 × 86′ (3.05 × 26.21 m).
Courtesy Leo Castelli Gallery, New York.

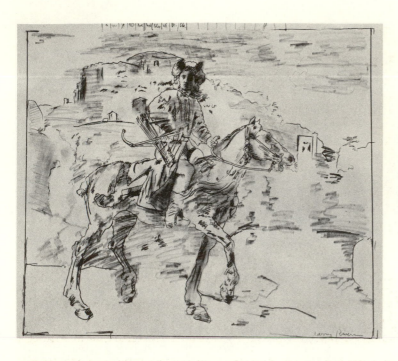

309. Larry Rivers. *Study for Rainbow Rembrandt.*
1977. Pencil, 29³/₄ × 41³/₄″ (76 × 106 cm).
Courtesy Robert Miller Gallery, New York.

Shared Themes

Examples of the third category, *shared themes,* come from art history. Artists frequently raid the works of their predecessors for sources of themes, even making pictures of other pictures.

Larry Rivers and Mel Ramos are only two among many who have taken subjects from earlier art and given them new meaning. Rivers' *Study for Rainbow Rembrandt* (Fig. 309), is a variation on Rembrandt's *The Polish Rider* (Fig. 310). In *I Like Olympia in Black Face* (Fig. 311) Rivers transforms Manet's *Olympia* (Fig. 312) into a mixed-media construction. Ramos' satirical handling of the same painting transposes the 19th-century figure into a 1970s centerfold (Fig. 313). Different techniques, styles, and materials have worked jolting transformations.

310. Rembrandt. *The Polish Rider.* 1655.
Oil on canvas, 3′10″ × 4′5¹/₈″ (1.17 × 1.35 m).
Frick Collection, New York (copyright).

190

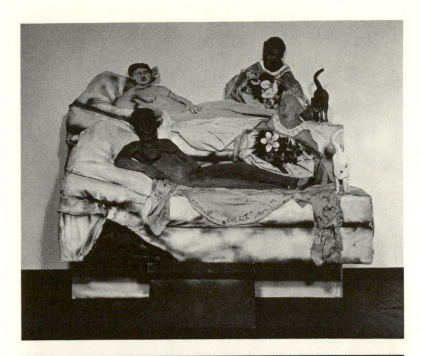

above right: 311. Larry Rivers. *I Like Olympia in Black Face.* 1970. Mixed media construction, 5'11" × 6'3⁵⁄₈" × 3'3" (1.82 × 1.94 × 1 m). Musée National d'Art Moderne, Paris.

right: 312. Edouard Manct. *Olympia.* 1863. Oil on canvas, 4'3¹⁄₄" × 6'2³⁄₄" (1.3 × 1.9 m). Louvre, Paris.

below: 313. Mel Ramos. *Manet's Olympia.* 1973. Oil on canvas, 4' × 5'10" (1.22 × 1.78 m). Courtesy Louis K. Meisel Gallery, New York.

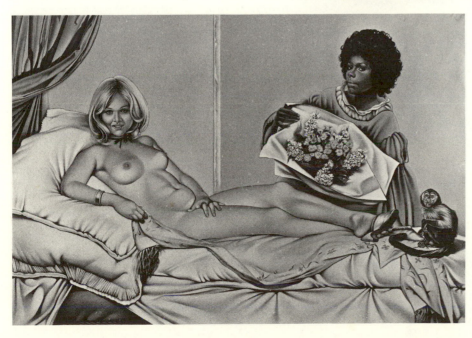

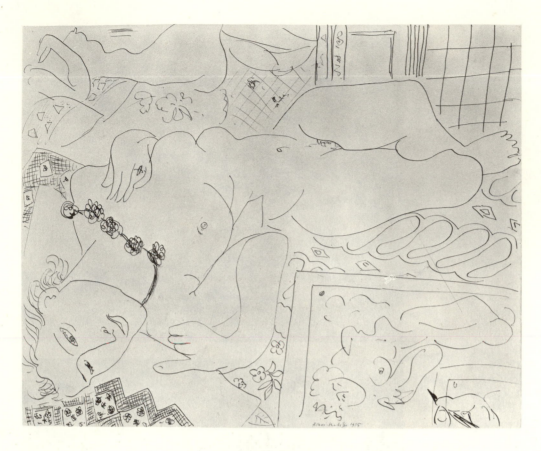

above: 314. Henri Matisse. *Nude in the Studio.* 1935.
Pen and ink, 17³/₄ × 22³/₈″ (46 × 57 cm).
Private collection, New York.

below: 315. Pablo Picasso. *4.2.67 V (Peintre Mousquetaire).* 1967.
Colored pencil, 19⁵/₈ × 25¹/₂″ (50 × 65 cm).
Courtesy Éditions Cercle d'Art, Paris.

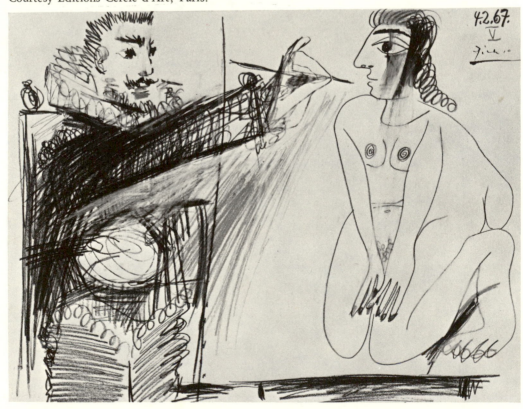

316. Jackson Pollock. *O'Connor/Thaw 3:606.*
c. 1939–42.
Black ink, 17³/₄ × 13⁵/₈″ (45 × 32 cm).
Collection Lee Krasner Pollock.

Shared themes include the very personal theme of the artist's own studio. A studio is the artist's contained world; it is a very private and personal space. Work using this subject matter frequently has an autobiographical overtone. Henri Matisse (Fig. 314), Pablo Picasso (Fig. 315), and Philip Pearlstein (see Fig. 147) are a few artists who have concentrated on this subject.

Some shared themes are so universal that knowledge of other art work is not necessary for the viewer to appreciate them. The appeal of such themes touches a wide audience with their general human concerns. The mother-and-child theme, for example, goes beyond artistic or even religious traditions in its universality.

Other fertile sources of thematic imagery shared by many artists are archetypal, mythological, and religious subjects. The archetypal bull, for example, has provided centuries of vital imagery for artists and writers alike. Jackson Pollock produced a series of sketches on the bull theme while under psychoanalysis (Fig. 316). He drew archetypal patterns and images from sources pulled from his unconscious.

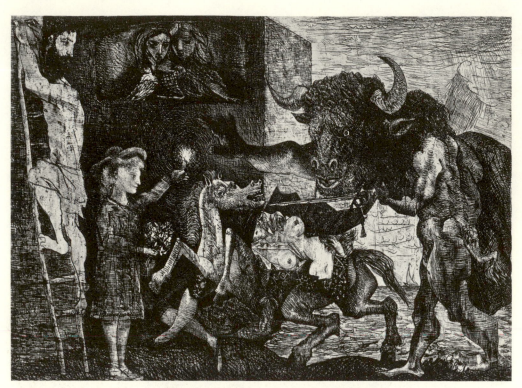

above: 317. Pablo Picasso. *Minotauromachia.* 1935.
Etching, $19^{1}/_{2} \times 27^{3}/_{8}''$ (50 × 70 cm).
Philadelphia Museum of Art (gift of Henry P. McIlhenny).

below: 318. Rico Lebrun. *Flagellation.* 1959.
Ink wash. Private collection.

Picasso, more in keeping with mythical traditions, used the ancient Greek bull legend of Theseus and the Minotaur in his *Minotauromachia* (Fig. 317). The bull in Picasso's print is represented both as destructive and life-sustaining; Picasso combined the traits of Theseus and the bull into one heroic being. Although the original myth has been altered, an awareness of it enhances our appreciation of Picasso's treatment. The deep psychological import of the Theseus-minotaur myth comes from its archetypal power, a creative wellspring found in many classic legends.

Religious themes have always provided emotional subject matter for artists. Rico Lebrun's drawing of the flagellation of Christ (Fig. 318) illustrates the continuing power of religious themes. A religious subject from another culture, *Priest of Shango, The Yoruba Thunder God* (Fig. 319), by the African artist Twins Seven Seven, shows the universality of myth and religion as constant sources of thematic imagery.

319. Twins Seven Seven.
Priest of Shango, The Yoruba Thunder God (Oshogbo).
1966. Pen and ink with gouache,
6 × 2′ (1.83 × .61 m).
Courtesy the artist.

Let us now look at some means of beginning a sustained series of thematically related works of your own. The first two problems deal with the development of a private theme—the first uses recognizable subject matter; the second deals with variations using a nonobjective image. The third problem is built on a painting from art history, an example of shared themes.

Problem 71 Thinking about transformations is a good way to begin some thematically related drawings. Choose an object that interests you, that is significant to you. The object might have a shape that is analogous to something else, as in Figures 320 and 321, where the shape similarities between an electric mixer and a fish are emphasized.

Begin by making a number of drawings that accurately depict the object. Experiment with both scale and viewpoint. After doing several of these analytical drawings you will be more familiar with the visual aspects of the object and a transformational shape will probably suggest itself to you. Your object might undergo a number of transformations, as in the brassiere drawings in Figures 322 to 324.

left: 320. Transformation. Student work. Vine charcoal.

below: 321. Transformation. Student work. Vine charcoal.

Use it as a
hammock
for 2 Frogs

above right: 322. Transformation.
Student work. Craypas.

right: 323. Transformation.
Student work. Craypas.

Use it as a
chip & Dip
Server!

EMXCRV

'LXXVIII

324. Transformation. Student work.
Photocopy and watercolor pencils.

In addition to analyzing the form of the object, you might also analyze its function. Imagine it under various conditions. For the three drawings of a faucet in Figures 325 to 327 the faucet itself was photocopied. The student then drew directly on the photocopy image, changing the condition and function of the faucet. The actual *shape* of the faucet remains constant; it is the *function* that has undergone transformation. Imaginary leaps and associations—the faucet becomes a spaceship and a tornado—will suggest themselves.

You might even think of your object as having human attributes. In the chair series in Figures 328 to 331 the torso merges with a chair, uniting and transforming both figure and chair. The chair has been given human characteristics; that is, it has been *anthropomorphized*.

above left: 325. Transformation. Student work. Photocopy with mixed media.

left: 326. Transformation. Student work. Photocopy with mixed media.

above: 327. Transformation. Student work. Photocopy with mixed media.

above: 328. Transformation.
Student work. Pastel.

left: 329. Transformation.
Student work. Pastel.

left: 330. Transformation.
Student work. Pastel.

above: 331. Transformation.
Student work. Pastel.

below: 332. Landscape transformation. Student work. Mixed media.

right: 333. Landscape transformation. Student work. Mixed media.

334. Landscape transformation. Student work. Mixed media.

The landscape transformations in Figures 332 to 334, the subject of which is the four elements—earth, air, fire, and water—might be viewed as visual storytelling. The language of these drawings is a set of privately developed symbols. Each drawing has a reference to weather; clouds, lightning, earth, and sky are repeated motifs.

In *Past, Present, Future* (Figs. 335–337) the student has chosen time as the connecting link in a self-portrait series, depicting himself as a child, a young man, and an old man. Self-portraiture is a familiar theme.

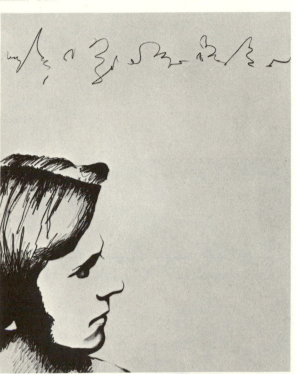

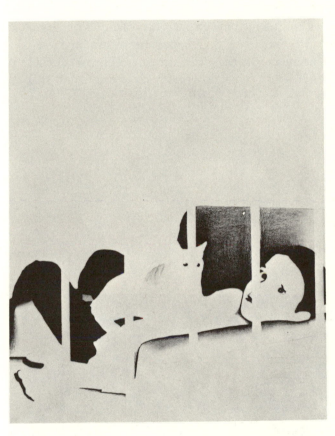

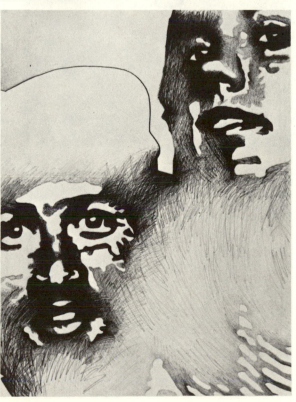

above: 335. Time transformation. Student work. Pencil.

above right: 336. Time transformation. Student work. Pencil.

right: 337. Time transformation. Student work. Pencil.

Problem 72 For this series of drawings you are to choose a single motif and develop it through variations of a form. Change the placement—the compositional, spatial arrangement—from drawing to drawing. Use abstract or nonobjective imagery rather than recognizable objects or figures.

In both Figures 338 and 339 the motif is a centralized image. The student creates a sense of space through the use of texture and value. The images in these graphite drawings seem to pulsate, at times floating forward out of the picture plane, sometimes folding back on themselves.

In Figures 340, 341, and 342, shapes resembling jigsaw pieces serve as the motif. The use of line, value, texture, and medium are the same in all three works. In the first drawing (Fig. 340) the shapes completely fill the picture plane. In the second drawing (Fig. 341) some of the shapes are eliminated, calling attention to placement. In the third drawing (Fig. 342) there is a shift in scale, creating tension between large and small shapes.

above: 338. Variation of a form. Student work. Graphite.

right: 339. Variation of a form. Student work. Graphite.

340. Variation of a form.
Student work. Colored pencil.

left: 341. Variation of a form.
Student work. Colored pencil.

below: 342. Variation of a form.
Student work. Colored pencil.

Drawings dealing with form need not lack in expressive content. Formal development does not rule out a subjective approach. The student drawings using pastel and turpentine (Figs. 343, 344) make a personal statement through the gestural marks. The boldness of the approach conveys expressionistic immediacy.

Problem 73 Choose as your subject a painting from art history. Make a series of at least six drawings that use the painting as a point of departure. You can approach your drawings through any of the methods discussed in this chapter. The painting can be altered and transformed stylistically. Think, for example, what Andy Warhol's *XIV Green Coca-Cola Bottles* (see Fig. 307) would look like if drawn expressionistically. You also can

left: 343. Form with expressive content. Student work. Pastel and turpentine.

below: 344. Form with expressive content. Student work. Pastel and turpentine.

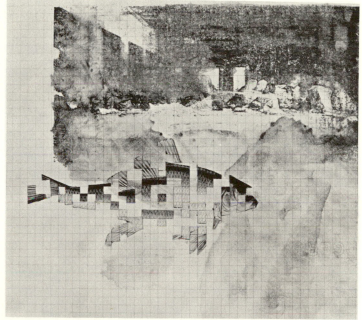

left: 345. Art history transformation.
Student work. Collage and photocopy.

below: 346. Art history transformation.
Student work. Collage and photocopy.

below: 347. Leonardo da Vinci. *The Last Supper*. 1495–98.
Fresco, 14′5″ × 28′1/4″ (4.39 × 8.54 m).
Santa Maria della Grazie, Milan.

make changes in the form or can use a contemporary compositional format. What would be the effect, for instance, of Manet's *Olympia* (see Fig. 312) reduced to flat shapes? You can even change the meaning, transforming a religious or mythological subject into a scientific or secular context.

The transformations shown in Figures 345 and 346 are based on Leonardo da Vinci's *The Last Supper* (Fig. 347). The subject does not change but the use of grids and 20th-century collage techniques gives the drawings a contemporary look.

Remember, it is necessary to find a theme that is important to you. Each drawing in your series will suggest new ideas for succeeding drawings. An artist must observe, distinguish, and relate. Do not ignore any of these three essential steps in developing your thematic work.

A Look at Art Today

Chapter Ten

348. Red Grooms. *Gertrude.* 1975.
Six-color lithograph, cut out,
mounted, and boxed in acrylic;
19¼ × 22 × 10½" (49 × 56 × 27 cm).
Courtesy Brooke Alexander, Inc., New York.

Drawing is not an isolated discipline; it is a vital part of all art production—painting, sculpture, design, and print-making. In the first chapter we looked at some of the functions of drawing. Because of the expansive and explosive trends in contemporary art, drawing has a wider, more active role than ever before. In this chapter we will broaden our outlook to include the wide range of contemporary art.

Artists are both makers and critics of art. Involvement with the art of others is essential for the practicing artist. The full range of art experience—both the making of art and the viewing of art—contribute to one's growth as a studio artist.

Just as looking at other artists' thematic work helped you to develop your thematic series, familiarity with the many directions art is taking today will help you relate your work to your own experiences and to the times. It is certainly not necessary, nor would it be possible, to be involved in as many art techniques as are mentioned in this chapter. An acquaintance with current trends, however, will increase your knowledge of art and provide a reservoir of techniques and points of view from which you can draw for your own purposes.

The diverse directions art has taken since the 1960s could be called *stylistic eclecticism.* This eclecticism is a result of the selection and mixing of various philosophies, styles, techniques, materials, and subjects. Today many styles and schools of art exist side by side; one style does not replace another in sequential order. Contemporary art includes both representational and non-representational work, realism and abstraction. Some artists use an expressionistic approach; others advocate a more objective, formal approach. Some work is sophisticated; some is naïve.

Contributing to the trend of stylistic eclecticism is a cross-over of categories. The distinctions between the visual arts are blurred, and the visual arts have merged with other arts. Today the artist borrows from all the arts. A second contributing factor is the artist's use of nontraditional materials. Technological ad-

vances have offered artists new sources of material, but artists have also developed new ways to use common materials. Along with the proliferation of categories and materials comes an expanded range of subjects and meanings from which to draw. Let us look more closely at these three characteristics of stylistic eclecticism.

Crossover of Categories

The blurring of categories in the visual arts has taken place in three areas. The visual arts have overlapped one another, have merged with other arts—drama, music, dance, and literature— and have been affected strongly by science and technology.

In earlier times the traditional separation of sculpture, painting, and drawing was more readily determined; today the demarcation lines are less precise. Red Grooms' three-dimensional lithograph *Gertrude* (Fig. 348) is both a print and a sculpture. Grooms' work is noted for its humorous subject matter as well as its playful drawing style. *Gertrude* could be a paper doll for adults.

Sculpture and painting are also blending to create another blurred category. Contemporary sculpture is frequently painted. Three-dimensional elements may jut out from the flat surface of a painting. The painting itself even may be dimensional. Alan Shields' tubular canvases are enormous structures; the viewer must walk around them, viewing all sides as though they were sculptures (Figs. 349, 350). The paintings are like giant playpens; we can imagine ourselves inside them.

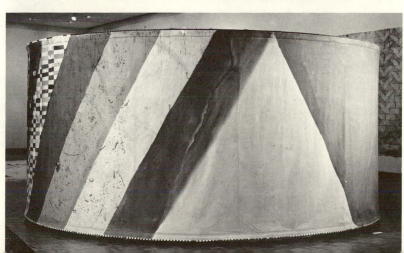

above right: 349. Alan Shields.
Everybody Knows Korolowitz.
1966–70.
Acrylic and thread on canvas;
height 7'6'' (2.29 m), diameter 16' (4.88 m).
Courtesy Paula Cooper Gallery, New York.

right: 350. Another view of Fig. 349.

New techniques in the field of photography have made the alteration and manipulation of the photograph itself a popular art form. Lucas Samaras distorts images of himself in his Polaroid *Photo-Transformations* (Fig. 351) by interfering with the process of the film's development. He mixes the photoemulsion pigments through heating, scratching, and scraping. While the pictures still are photographs, they more closely resemble paintings, and lend themselves to a very expressionistic approach.

Photographic imagery is widely used in painting. The Photorealists use actual photographs as their subjects. In their work they are interested in the way the camera "sees." Tom Blackwell's *Hi Standard's Harley* (Fig. 352) is an example of such an image. Blackwell, like many Photorealists, often retains the border of the photograph to show the source of the image.

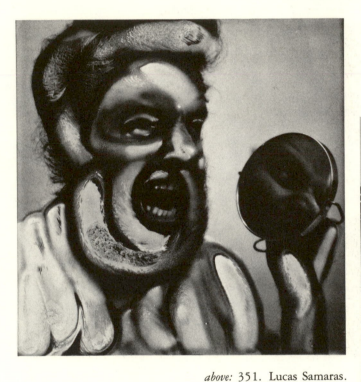

above: 351. Lucas Samaras.
Photo-Transformation 11/12/73. 1973.
SX-70 Polaroid, 3'' (7 cm) square.
Courtesy Pace Gallery, New York.

right: 352. Tom Blackwell.
Hi Standard's Harley. 1975.
Acrylic on panel, 22 × 15'' (56 × 38 cm).
Collection Louis and Susan Meisel, New York.

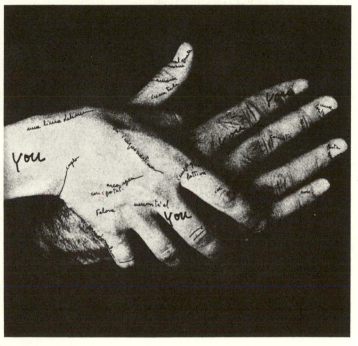

left: 353. Faith Ringgold. *Two Women*. 1973.
Serial performance piece with hat masks and props.
Courtesy the artist.

below: 354. Ketty La Rocca. *You, You*. 1974.
Photograph, 7 × 8½" (18 × 22 cm).

Art has always been connected with rituals, and ritualistic
performances combine art, music, and dance. Some of today's
performances are narrative; sometimes they are in an autobio-
graphical mode; and sometimes they make political and social
comment, as in the work of Faith Ringgold. In her serial per-
formance piece *Two Women* (Fig. 353), Ringgold works with her
daughters. The masks they wear are related to African portrait
masks, which reveal a person's essence rather than a physical
likeness. Her performance makes a statement on her role as a
black woman in today's society.

Out of performance art has come body art, in which the
body itself is drawn, painted on, or otherwise transformed. Ketty
La Rocca used her hands in *You, You* (Fig. 354) to present a
"pantomine made by language."

The relationship between the visual arts and literature is long-standing. Artists have always used imagery derived from literary sources. Their interest in the use of words manifests itself in a wide variety of forms. Some artists use words in a narrative context; some use the word as image; and some are involved in linguistics, the analysis of the way language works. Arakawa's drawing from *The Signified Or If . . .* (Fig. 355) is an example of the involvement with art and linguistics.

above: 355. Arakawa. Drawing from *The Signified Or If . . .* 1974–75. Colored pencil, 2′6″ × 6′8″ (.76 × 2.03 m). Courtesy the artist.

right: 356. Vernon Fisher. *Zeros.* 1976. Graphite on laminated paper, 24″ (61 cm) square. Courtesy the artist.

Vernon Fisher and William Wiley combine visual art with written words to produce narratives. Fisher overlays his story onto the image, actually incising the letters so that they "go into" the image (Fig. 356). Wiley writes a story in the border below the image (Fig. 357). His handwriting is compatible with the style of his drawing—both are highly personal and subjective. In Figure 358 the calligraphic imagery, sometimes purposely disguised so as to be illegible, evolved from the visual quality as well as the

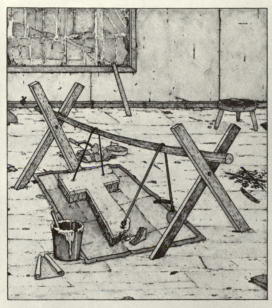

Initial Break Through
was made one afternoon when it was raining. starting from the middle of a name isn't always the best way, but it eased the pressure some. I thought something more might come of it. something I could see and devour.
Jim Balyeat said to no one day. "Maybe we aren't supposed to try and save it? Maybe we are supposed to use it up." I don't know any more about that than i do this.

wm. T. Wiley
1970

above: 357. William Wiley.
Initial Break-Through. 1970.
Watercolor and ink,
24 × 19" (61 × 48 cm).
Fort Worth Art Museum
(Benjamin J. Tillar Trust).

right: 358. Claudia Betti. *Shaman,*
from *Numinous Word Series.* 1977.
Mixed media,
24³/₄ × 34³/₄" (63 × 88 cm).
Courtesy the artist.

emotional content of the words. Edward Ruscha, on the other hand, divorces the meaning of the word from its semantic intent (Fig. 359); he uses the word itself as image. He does not intend the actual meaning of the word to be the meaning of the drawing. In Peter Blake's drawing *Grauman's Chinese Theater* (Fig. 360) words are used in a format that parallels familiar advertising techniques. Blake uses stenciled and commercially printed letters in making his "souvenir advertisement."

New Materials and New Uses of Materials

A second condition that has contributed to stylistic eclecticism in contemporary art has been the relationship between art and technology. The technological expansion of the 20th century has made a vast array of new materials available to the artist. Advances in plastics have made acrylic paint as popular as oil paint. The airbrush is as often in use today as the traditional painter's brush. James Rosenquist's enormous, 86-foot-long *F-111* (see Fig. 308) was painted with an airbrush. Softened edges and thinness of paint are clues to this technique.

Sculptors, too, have taken advantage of new materials. Eva Hesse is known for her use of fiberglass. Her interest in synthetics stems from their contradictory nature—they are both beautiful and ugly at the same time. Fiberglass furnishes structural strength while simultaneously looking delicately insubstantial. Hesse's expressionistic sculpture *Contingent* (Fig. 361) deals with both texture and light.

359. Edward Ruscha. *Chop.* 1967. Pencil, 13¼ × 21⅞" (34 × 56 cm). Fort Worth Art Museum.

left: 360. Peter Blake. *Grauman's Chinese Theater.*
1963. Watercolor and pencil, 13 × 10″ (33 × 25 cm).
Courtesy Waddington Galleries Ltd., London.

below: 361. Eva Hesse. *Contingent.* 1969.
Fiberglass and rubberized cheesecloth;
8 units, each 14 × 3′ (4.27 × .92 m).
Courtesy Droll-Kolbert Gallery, New York.

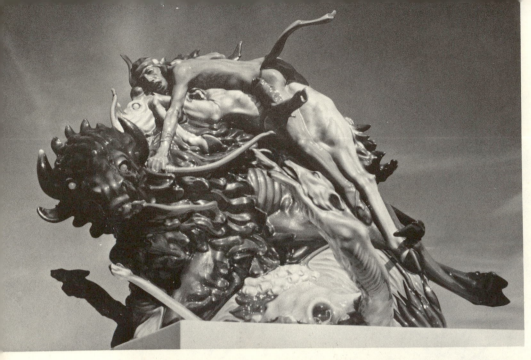

left: 362. Luís Jimenez. *Progress I.*
1963. Fiberglass with epoxy
coating, length 8' (2.44 m).
Collection Donald B. Anderson,
Roswell, N.M.

below: 363. Wallace Berman.
Untitled. 1964. Verifax collage,
4'1" × 3'10" (1.24 × 1.16 m).
Dallas Museum of Fine Arts
(purchase).

Fiberglass and epoxy offer a glistening surface for Luís Jimenez' sculpture *Progress I* (Fig. 362). Jimenez combines this new material with an image from Western art that has become a cliché. The "end of the trail" motif, aesthetically dead because it is so banal and sentimentalized, is given a new twist when seen in Jimenez' material. The figure is like a carnival souvenir except for its size. Jimenez intends the viewer to draw comparisons between sleazy, glazed, ceramic-and-plastic souvenir items and his sculpture. He makes a statement on exploitation and the devaluation of an art image as a commercial product.

Machines produced by 20th-century technology have been appropriated for artists' use. Generative processes of all kinds—computer printouts, holography, xerography, and video—are popular image makers. Copy machines, such as those made by Xerox, are easily available to everyone. Artists have taken advantage of this instant duplication method and have adopted it as a new medium. Wallace Berman has used a Verifax machine to make his gridded collage (Fig. 363). Commercial duplication methods, projections, blueprints, and X-rays have been appropriated by artists as new media.

Video, although not as readily available as commercial copy machines, is becoming increasingly important as a medium for the artist. Used for documentation and performance, video is concerned with time and motion and can be an art form in itself. The image in Figure 364 has been altered by a video synthesizer, which breaks up the image electronically. The short-lived image is then captured in a photograph.

364. Teel Sale. *Untitled.* 1978.
Video drawing using live model and synthesizer.
Courtesy the artist.

The partnership of art and technology is perhaps most dramatically seen in the work of Christo (Fig. 365). His elaborate constructions demand the most complex engineering to be executed. In order to carry out these plans, Christo must deal with volumes of information—about geographical, ecological, and even meteorological conditions. He has to have materials and machinery manufactured to his specifications. To hang the *Valley Curtain* he required a huge number of professional and volunteer laborers. Even documenting the installation required highly technical skills.

Earthworks and environmental installations such as Christo's involve the information networks of the day-to-day environment. Everything in the environment becomes the artist's material for these "ground systems." The artist relies heavily upon documentation, drawings, written descriptions, and photographs of the work in addition to scientific information concerning the site. In many cases, the actual piece is so ephemeral that the documentation is the only "lasting" product or evidence of its having been made. This is especially true in Michael Heizer's *Circular Surface Planar Displacement* (Fig. 366), in which the lines of the "drawing" are made on the earth by motorcycle wheels.

In addition to materials that are the result of technological advances, more common materials are frequently used. Bricks, sand, rope, rock, felt, and sticks are still basic materials. The German artist Joseph Beuys uses basic materials to convey an archetypal imagery in his work. He selects natural objects for their traditionally symbolic power, such as the "fast-running hare" which represents the fleeting passage of time in his performance piece *Eurasia* (Fig. 367).

365. Christo.
Valley Curtain (Project for Colorado). 1971.
Pencil, crayons, blueprint,
map, fabric, charcoal;
3 × 5′ (.91 × 1.52 m).
Private collection, New York.

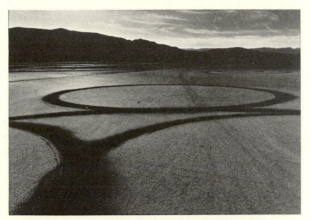

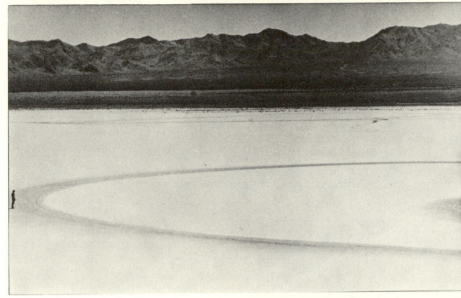

left: 366. Michael Heizer.
Three views of *Circular Surface
Planar Displacement.* 1971.
Earth construction,
Jean Dry Lake, Nev.;
400 × 800' (121.92 × 243.84 m).
Courtesy Sam Wagstaff.

below: 367. Joseph Beuys.
Eurasia, from *Siberian Symphony.* 1966.
Performance piece; media included
thermometer, dead hare, iron plate,
white powder, and paint.
Courtesy Galerie René Block,
West Berlin.

Found objects of all kinds have been used increasingly throughout this century. C. Kenneth Havis uses discards found in secondhand shops in Figure 368. The doll in this work is encrusted and punctured with a variety of discarded remnants and jewelry to become a 20th-century fetish.

The truth-to-the-medium dictum has been supported throughout this century. The refusal to conceal the process by which an art work is made is an honesty to the medium that is still in force today as seen in Larry Rivers' "unfinished" canvases (Fig. 369). The paintings show the process and directness by which they were made. The retention of canvas as canvas emphasizes the two-dimensionality of the surface and calls attention to the role of art as illusion.

But for every direction one artist takes, we can find another artist following a countertrend. In *Painted Bronze* (Fig. 370) Jasper Johns combines an actual beer can with a painted bronze can. Incorporating the actual machine-produced object along with the bronze cast sets up a series of circular questions about the role of art and about the imitative power of art.

The new materials, when added to an array of more traditional materials, give the contemporary artist wide options in creating a work of art. The poet Rimbaud's statement, "the earth is my table," can well serve as the artist's motto: An artist may use anything as possible material for art.

below: 368. C. Kenneth Havis. *Self-Portrait, or That Personal Object Belongs to Me.* 1977. Mixed media, height 16″ (31 cm). Courtesy the artist.

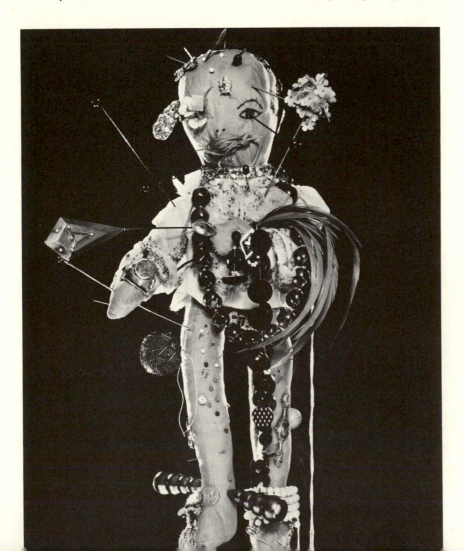

right: 369. Larry Rivers.
Parts of the Face (The Vocabulary Lesson).
1961. Oil on canvas,
29 1/2" (75 cm) square.
Tate Gallery, London.

below: 370. Jasper Johns.
Painted Bronze (Ale Cans). 1960.
Painted bronze,
5 1/2 × 8 × 4 3/4"
(14 × 20 × 12 cm).
Collection Dr. Peter Ludwig,
Aachen, W. Germany.

left: 371. Andy Warhol. *Colored Mona Lisa*. 1963.
Screenprint on canvas,
10′8″ × 6′10″ (3.25 × 2.08 m).
Courtesy Leo Castelli Gallery, New York.

below: 372. Sol LeWitt. *A 2 5 8*. 1968.
Baked enamel on steel,
1′7¼″ × 6′9″ × 2′8″ (.48 × 2.06 × .81 m).
Krannert Art Museum, University of Illinois
at Urbana-Champaign.

Contemporary Sources of Imagery

It is perhaps not surprising that in a technological age the medium itself becomes the message for many artists. In Andy Warhol's *Colored Mona Lisa* (Fig. 371) the silkscreen process itself is the subject. The technique—the process of reproducing an image many times—becomes more important than the image. Warhol takes an already-depleted image (the often-reproduced *Mona Lisa*) and makes the banality contribute to his intent to use the technique as subject. The effect is analogous to repeating a word over and over until it loses its sense and becomes just a sound. Repetition itself is a popular subject in contemporary art.

Serial art also deals with repetition. This type of work uses a geometric module, or unit of measurement, to which other units are proportioned. The modules undergo regulated changes, as in Sol LeWitt's work (Fig. 372). LeWitt's serial structure is a mental exercise for himself and for the viewer. The process itself is the subject of his work. *A 2 5 8* is composed of planes and cubes illustrating a geometric progression. The title refers to the cubes' locations on the gridded plane.

Although the modular changes in Vincent Falsetta's work are smaller than those in LeWitt's, Falsetta sets up a process—a predetermined formula—which he follows through in a series of works (Figs. 373, 374). This process is perhaps more apparent in

above: 373. Vincent Falsetta. *Texas 1.* 1978.
Acrylic on paper, 12″ (30 cm) square.
Courtesy the artist.

right: 374. Vincent Falsetta. *Texas 4.* 1978.
Acrylic on paper, 12″ (30 cm) square.
Courtesy the artist.

Brenda Miller's modular installation *Diagonal Alphabet* (Figs. 375, 376). Using a limited system, a diagonal crossing of the alphabet, she stamps the letters directly onto the wall, literally making the wall the picture plane. This type of installation, in which the walls, floor, or other space of the gallery or museum is altered, is much in evidence today. Process is the subject of LeWitt's, Falsetta's, and Miller's work.

A revolutionary trend in imagery that has emerged in the second half of this century is information as art. Marcel Duchamp is credited with the idea of replacing the actual art object with documentary information about it (Figs. 377, 378). This secondhand presentation of the art object through documentation has made possible the viewing of much art that would otherwise not be seen by a wide audience. Christo's *Valley Curtain* and Michael Heizer's earth construction (see Figs. 365, 366) are examples of this type of documentation.

Many secondhand subject sources, from mass-media models to old masters, are available to today's artists. In the chapter on

left: 375. Brenda Miller.
Diagonal Alphabet (26) Interior West, detail. 1975.
Rubber stamps with ink and pencil on wall;
8 panels, each 4'4'' (1.32 m) square.
Courtesy Sperone Westwater Fischer, Inc., New York.

below: 376. Installation view of *Diagonal Alphabet.*

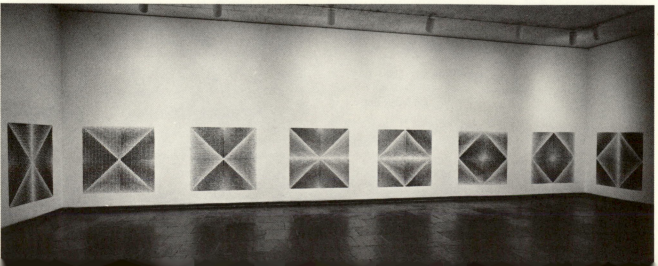

left: 377. Marcel Duchamp. *The Green Box.* 1934. Multiple edition of 300; mixed media; containing facsimiles of 93 documents. Private collection.

below: 378. Interior view of Fig. 377, Marcel Duchamp's *The Green Box,* showing enclosed documents.

thematic development we discussed several artists who use works by old masters as their source of imagery (see Figs. 309–313). Mass-media images taken from magazine and news photographs are also important in the work of Pop artists. Peter Phillips uses the movie star Marlon Brando and the logo of the Los Angeles Lakers basketball team in his drawing *Star Players* (Fig. 379). Images are jumbled, fragmented, and arranged in ways that imitate commercial design techniques.

379. Peter Phillips. *Star Players.* 1962.
Pencil, 23 × 18″ (58 × 46 cm).
Collection J. P. W. Cochrane, London.

Whatever choices the artist makes, imagery is exciting both for the meaning it can convey and for the formal way it can be composed. Images are added to, subtracted from, transformed, changed, destroyed, rebuilt. Artists use elements and materials in traditional and nontraditional ways. Some artists minimize content and emphasize form; others minimize formal considerations and emphasize idea. Contemporary art is eclectic, not only in the crossover of categories between the arts and in material sources, but in the number of subject possibilities as well.

Summary

Artists have freedom in choices of imagery, techniques, and materials. The whole world of sensations and experiences is open for investigation. The challenge is not only to the artist but to the viewer as well. Through art we find new associations, new ways of processing information, new questions about our perceptions. How do we see what we see? How do we know what we know?

Space and time are necessary requirements—time to make, time to view, time to digest, time to rethink and review. We are concerned not only with the visible or sensory but also with the knowable, thinkable aspects of art. Both artist and viewer are involved in the process. Art is a creative gift to all of us.

Practical Guides

Part IV

Materials

Guide A

The relationships among form, content, subject matter, materials, and techniques are the very basis for art, so it is essential that the beginning student develop a sensitivity to materials—to their possibilities and limitations. The problems in this text call for an array of drawing materials, some traditional, some nontraditional. The supplies discussed in this chapter cover all the materials needed to complete the problems in the book.

Paper

To list all the papers available to an artist would be impossible; the variety is endless. The importance of the surface on which you draw should not be minimized. The paper you choose, of course, affects the drawing.

Since the problems in the book require the use of a large amount of paper, and since the emphasis is on process rather than product, we do not recommend expensive papers for the beginning student. We have limited the papers to three or four types, all of them serviceable and inexpensive. Experimentation with papers, however, is encouraged—you may wish to treat yourself to better-quality paper occasionally.

Newsprint and *bond paper* are readily available, inexpensive, and practical. Both come in bulk form—in pads of 100 sheets. Buying paper in bulk is much more economical than purchasing single sheets. Bond paper, a smooth, middle-weight paper, is satisfactory for most media. Newsprint is good for warm-up exercises. Charcoal and other dry media can be used on newsprint; it is, however, too absorbent for wet media.

Ideally, *charcoal paper* is recommended for charcoal drawing, since the paper has a tooth, a raised texture, that collects and holds the powdery medium. Charcoal paper is more expensive than bond paper and is recommended only for a few problems, those in which extensive rubbing or tonal blending is emphasized.

A few sheets of black *construction paper* are a good investment. Using white media on black paper makes you more aware of line quality and of the reversal of values. A few pieces of toned charcoal paper would likewise furnish variety. Only the neutral tones of gray or tan are recommended.

We suggest all paper be at least 18 by 24 inches. If you draw on a smaller format, you can cut the paper to size.

An inexpensive way to buy paper is to purchase it in rolls. End rolls of newsprint can be bought from newspaper offices at a discount. Photographic backdrop paper is another inexpensive rolled paper. It comes in 36-foot lengths and 10-foot widths. The paper must be cut to size, but the savings may be worth the inconvenience. The advantage to buying rolls of paper is that you can make oversize drawings at minimal cost. Brown wrapping paper also comes in rolls and is a suitable surface, especially for gesture drawings.

Another inexpensive source of paper is scrap paper from printing companies. The quality of the paper varies as does the size and color, but it would be worthwhile to visit a local printing firm and see what is available.

The sketchbook pad is discussed in the Practical Guide to Keeping a Sketchbook. Size is optional. You should choose a size that feels comfortable to you, one that is easily portable, no larger than 11 by 14 inches.

Charcoal and Crayons

Charcoal is produced in three forms: vine charcoal, compressed charcoal, and charcoal pencil.

Vine charcoal, as its name indicates, is made from processed vine. It is the least permanent of the three forms. It is recommended for use in quick gestures since you can remove the marks with a chamois skin and reuse the paper. The highly correctable quality of vine charcoal makes it a good choice for use early in the drawing, when you are establishing the organizational pattern. If vine charcoal is used on charcoal paper for a longer, more permanent drawing, it must be carefully sprayed several times with fixative.

Compressed charcoal comes in stick form and a block shape. With compressed charcoal you can achieve a full value range rather easily. You can draw with both the broad side and the edge, easily creating both mass and line.

Charcoal pencil is a wooden pencil with a charcoal point. It can be sharpened and will produce a much finer, more incisive line than compressed charcoal.

Charcoal is easily smudged; it can be erased, blurred, or smeared with a chamois skin or kneaded eraser. All charcoal comes in soft, medium, and hard grades. We recommend soft charcoal for the problems in this book.

Conté crayons, too, can produce both line and tone. They come in soft, medium, and hard grades. Experiment to see which you prefer. Conté comes in both stick and pencil form. It has a clay base and is made of compressed pigments. Conté is available in four colors—white, black, sanguine, and sepia.

Water or turpentine will dissolve charcoal or conté if a wash effect is desired.

Another medium in stick and pencil form is the *lithographic crayon,* or *lithographic pencil.* Lithographic crayons have a grease base and are soluble in turpentine. They, too, can be smudged, smeared, and blurred and are an effective tool for establishing both line and tone. The line produced by a lithographic crayon or pencil is grainy; lithographic prints are readily identified by the grainy quality of the marks. (Lithographic crayons and pencils are specially made for drawing on lithographic stone, a type of limestone.) Lithographic crayons are produced in varying degrees of

softness. Again, you should experiment to find the degree of softness or hardness you prefer.

China markers, like lithographic pencils, have a grease base and are readily smudged. Their advantage is that they are manufactured in a wide variety of colors.

Pencils and Graphite Sticks

Pencils and graphite sticks come in varying degrees of hardness, from 9H, the hardest, to 7B, the softest. The harder the pencil, the lighter the line; conversely, the softer the pencil, the darker the tone. We recommend 2B, 4B, and 6B pencils and a soft graphite stick. Graphite sticks produce tonal quality easily and are a time-saver for establishing broad areas of value. Pencil and graphite marks can be smudged, smeared, erased, or dissolved by a turpentine wash.

Erasers

We do not suggest erasers as a correctional tool, but erasure can contribute to a drawing. There are three basic types of erasers. The *kneaded eraser* is pliable and can be kneaded like clay into a point or shape; it is self-cleaning when it has been kneaded. *Gum erasers* are soft and do not damage the paper. A *pink pencil eraser* is recommended for use with graphite pencils or sticks; it is more abrasive than the gum eraser. A white plastic eraser is less abrasive than the pink eraser and works well with graphite.

While a *chamois skin* is not technically an eraser, we include it here because it can be used to erase marks made by vine charcoal. It also can be used on charcoal and conté to lighten values or to blend tones. As its name indicates, it is made of leather. The chamois skin can be cleaned by washing it in warm soapy water.

Inks and Pens

Any good drawing ink is suitable for the problems in this book. Perhaps the most widely known is black *India ink.* It is waterproof and is used in wash drawings to build layers of value. We have recommended both black and sepia ink.

Pen points come in a wide range of sizes and shapes. Again, experimentation is the only way to find the ones which best suit you. We do recommend a crowquill pen, a very delicate pen that makes a fine line.

Felt-tip markers come with either felt or nylon tips. They are produced with both waterproof and water-soluble ink. We recommend the water-soluble ink, since the addition of water will create tone. Invest in both broad and fine tips. Discarded markers can be dipped in ink, so you can purchase different size tips and collect an array of sizes.

Paint and Brushes

A water-soluble *acrylic paint* is useful. You should buy tubes of white and black. You might wish to supplement these two tubes with some earth colors—for example, burnt umber, raw umber, or yellow ochre.

Brushes are important drawing tools. For the problems in this book you need a 1-inch and a 2-inch varnish brush, which you can purchase at the dime store; a number 8 nylon-bristle brush with a flat end; and a number 6 Japanese bamboo brush, an inexpensive reed-handled brush.

Other Materials

A small can or jar of *turpentine* should be kept in your supply box. Turpentine is a solvent that can be used with a number of media—charcoal, graphite, conté, and grease crayons.

Rubber cement and *white glue* are useful, especially when working on collage. Rubber cement is practical, since it does not set immediately and you can shift your collage pieces without damage to the paper. However, rubber cement discolors with age. White glue dries transparent, it is long lasting, and it does not discolor.

Sponges are convenient. They can be used to dampen paper, apply washes, and create interesting textures. They are also useful for cleaning up your work area.

Workable fixative protects against smearing and helps prevent powdery media from dusting off. Fixative comes in a spray can. It deposits uniform mist on the paper surface, and a light coating is sufficient. The term *workable* means that drawing can continue without interference from the hard surface left by some fixatives.

We strongly recommend the purchase of a *drawing board*. It should be made from Masonite and be large enough to accommodate the size of your paper. You can clip the drawing paper onto the board with large metal clips. The board will furnish a stable surface; it will keep paper unwrinkled and prevent it from falling off the easel.

Masking tape, gummed paper tape, a mat knife and blades, single-edge razor blades, scissors, a small piece of sandpaper (for keeping your pencil point sharp), and a metal container for water also should be kept in your supply box.

Nonart Implements

Throughout the text we recommend experimentation with different tools and media. This is not experimentation just for experimentation's sake. A new tool does not necessarily result in a good drawing. Frequently a new tool will help you break old habits; it will force you to use your hands differently or to approach the drawing from a different way than you might have

with more predictable and familiar drawing media. Sticks, vegetables (potatoes or carrots, for example), pieces of styrofoam, a piece of crushed paper, pipe cleaners, and cotton-tipped sticks are implements that can be found easily and used to good effect.

Keep your supply box well stocked. Add to it newly found materials and drawing tools. Keep alert to the assets and liabilities of the materials you use. Experiment and enjoy the development of your understanding of materials.

Warning: Since many materials used in the manufacture of art supplies are toxic, you should carefully read the labels and follow directions. Always work in a well-ventilated room.

Presentation

Guide B

The selection of drawings to represent your work is an important undertaking. Your portfolio should show a range of techniques and abilities. The four most important criteria to keep in mind are accuracy of observation, an understanding of the formal elements of drawing, media variety and exploration, and expressive content.

After you have chosen the pieces that best incorporate these considerations, your next concern is how to present them. The presentation must be portable and keep the works clean and whole, free from tears and bends. Since framing stands in the way of portability, we will not discuss that option.

Some possible ways of presenting your work are backing and covering with acetate, stitching in clear plastic envelopes, laminating, dry mounting, and matting. Each method of presentation has advantages.

Acetate

A widely used way of presenting work is to apply a firm backing to the drawing, then covering both drawing and backing with a layer of acetate—a clear thin plastic that holds the drawing and backing together. More importantly, the covering provides protection against scuffing, tearing, and soiling. (Matted drawings can also be covered with acetate.) Backing is a good option if a work is too large for matting or if the composition goes all the way to the edge and you cannot afford to lose any of the drawing behind a mat.

Another option is to attach the drawing with gummed linen tape to a larger piece of paper and cover it with acetate. The drawing then has a border of paper around it and can retain its edges. The drawing lies on top; it is loose, not pinned back by a mat. The size of the backing paper is an important consideration. The drawing might need a border of an inch; it might need one several inches wide. Experiment with border sizes before cutting the backing paper and attaching it to the drawing.

Paper comes in more varieties and neutral colors than does mat board. The choice of paper is important. The drawing and the paper it is done on should be compatible with the texture, weight, value, and color of the backing paper. Backing paper should not dominate the drawing.

A disadvantage to acetate as a protective cover is its shiny surface. This interferes with the texture of the drawing and with subtleties within the drawing.

Plastic Envelopes

If flexibility or the idea of looseness is important to the drawing, there is another simple means of presentation—stitching the drawing in an envelope of clear plastic. For a drawing of irregular shape—for example, one that does not have square corners—a

plastic envelope might be an appropriate choice. A plastic casing would allow a drawing done on fabric to retain its looseness and support the idea of flexibility.

A disadvantage to clear plastic is its watery appearance and highly reflective surface, which distorts the drawing. The greatest advantage to this method of presentation is that large drawings can be rolled, shipped, and stored easily.

Lamination

Lamination is midway in stiffness between drawing and a loosely stitched plastic envelope. You are familiar with laminated drivers' licenses and credit cards.

Laminating must be done commercially. It is inexpensive, but cost should not be the most important consideration. The means of presentation must be suited to the concept in the drawing. Laminating is a highly limiting way of presenting work—once sealed, the drawing cannot be reworked in any way.

Dry Mounting

If the likelihood of soiling and scuffing is minimal, you might want to *dry mount* the drawing. You do this in exactly the same way as you dry mount a photograph, sealing the drawing to a rigid backing and leaving the surface uncovered. Dry-mount tissue is placed between drawing and backing. Heat is then applied by means of an electric dry-mount press, or if done at home, by a cool iron. Dry-mount tissue comes in a variety of sizes; rolled tissue can be found for large drawings. This tissue must be the same size as the drawing. Wrinkling can occur, and since a drawing sealed to backing is not easily removed, extreme care should be taken in the process. Carefully read and follow the instructions on the dry-mount tissue package before you start.

Since dry mounting is done with heat, it is important that the media used in the drawing do not run or melt when they come in contact with heat. Greasy media such as china markers, lithographic sticks, or wax crayons should not be put under the dry press for mounting.

Matting

Matting is the most popular and traditional choice for presentation. The mat separates the drawing from the wall on which it is hung and provides an interval of rest before the eye reaches the drawing. Secondly, a mat gives the drawing room to "breathe." Like a rest in music, it offers a stop between the drawing and the environment; it allows for uncluttered viewing of the drawing.

For this reason mats should not call attention to themselves or they will detract from the drawing. A colored mat screams for attention and diminishes a drawing's impact. White or off-white

mats are recommended at this stage, especially since most of the problems in this book do not use color. An additional argument for white mats is that art is usually displayed on white or neutrally colored walls, and the mat furnishes a gradual transition between the wall and the drawing.

Instructions for Matting

The materials needed for matting are:

- a mat knife with a sharp blade
- all-rag mounting board
- gummed linen tape
- a 36-inch-long metal straightedge
- a pencil
- a gum or vinyl eraser
- a heavy piece of cardboard for cutting surface

Change or sharpen the blade in your knife often. A ragged edge is often the result of a dull blade. A continuous stroke will produce the cleanest edge. Mat blades should not be used for cutting more than one mat before being discarded. The expense of a blade is minimal in comparison with the cost of mat board, so be generous in your use of new, sharp blades.

Do not use illustration board or other kinds of board for your mat. Cheaper varieties of backing materials, being made from woodpulp, contain acid; they will harm a drawing by staining the fibers of the paper and making them brittle. Use white or off-white, all-rag mat board, sometimes called museum board, unless special circumstances dictate otherwise. A heavyweight, hot-pressed watercolor paper can be used as a substitute for rag board.

Masking tape, clear tape, gummed tape, and rubber cement will likewise discolor the paper and should be avoided. They will lose their adhesive quality within a year or so. Use gummed linen tape, because it is acid-free.

Work on a clean surface. Wash your hands before you begin.

1. Carefully measure the drawing to be matted. The edges of the mat's opening will overlap the drawing by ⅜ of an inch on all sides.

2. For an 18- by 24-inch drawing, the mat should have a 4-inch width on top and sides and a 5-inch width at the bottom. Note that the bottom border is slightly wider—up to 20 percent—than the top and sides.

3. On the front surface of the mat board mark lightly with a pencil the opening to be cut. You can erase later.

4. Place a straightedge on the mat just inside the penciled line toward the opening and cut. Hold down both ends of the straightedge. You may have to use your knee. Better still, enlist a

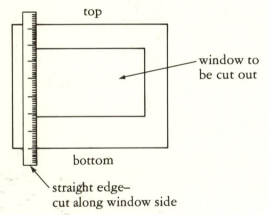

above: 380. Cutting mat board.

below: 381. Hinging the mat.

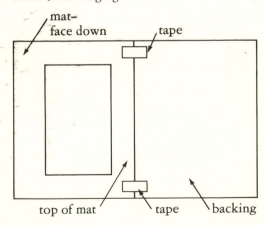

friend's help. If the blade slips, the error will be on the part that is to be discarded and can, therefore, be corrected. Cut the entire line in one continuous movement. Do not start and stop. Make several strokes, do not try to cut through completely on your first stroke (Fig. 380).

5. Cut a rigid backing ⅛ inch smaller on all sides than the mat.

6. Lay the mat face down and align the backing so that the two tops are adjoining. Cut four or five short pieces of linen tape, and at the top, hinge the backing to the mat (Figs. 381, 382).

7. Minor ragged edges of the mat can be corrected with fine sandpaper rubbed lightly along the edge of the cut surface.

8. Erase the pencil line and other smudges on the mat with a gum or vinyl eraser.

9. Hinge the drawing to the backing *at the top only*. This allows the paper to stretch and contract with changes in humidity (Fig. 383).

10. You may cover the matted drawing with acetate, which will protect both the drawing and mat. Place the backed, matted drawing face down on a sheet of acetate 2 inches wider on all sides than the mat. Cut 2-inch squares from each corner of the acetate (Fig. 384). Fold the acetate over, pulling lightly and evenly on all sides. Attach the acetate to the backing with tape.

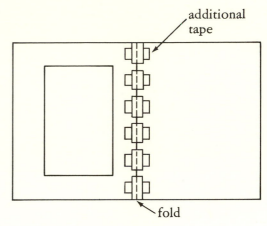

above: 382. Hinging the mat.

below: 383. Hinging drawing at the top.

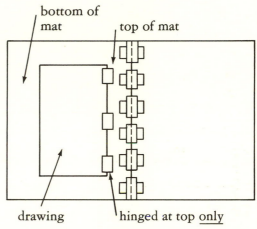

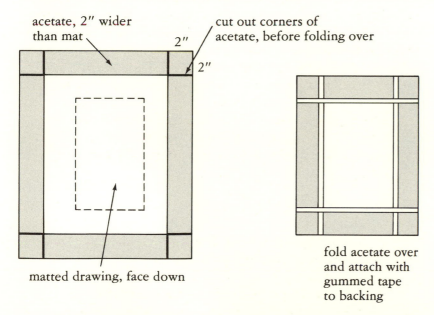

acetate, 2″ wider than mat

cut out corners of acetate, before folding over

2″

2″

matted drawing, face down

fold acetate over and attach with gummed tape to backing

384. Cutting acetate.

Summary: Selecting a Method of Presentation

In making your decision about what kind of presentation is suitable, you should first try to visualize the piece in a variety of ways. If you are attentive, the work itself will probably suggest an appropriate presentation. Matting is generally the safest. Stitch-

ing in plastic and lamination should be reserved for only those pieces that absolutely demand that type of presentation. Whatever your choice, remember that compatibility between drawing and method of presentation is essential.

If the manner of presentation is not clear to you, experiment with the piece. Place it in a discarded mat, or use some L-frames to crop the composition exactly right. Assess the drawing without a mat. Lay it on a larger piece of paper. Does the drawing go to the edge? Can you afford to lose half an inch on the borders? Is the idea of looseness or flexibility important to the drawing? Would a reflective covering detract from or enhance the drawing? What kind of surface and media are used in the drawing? What kind of backing would best complement the piece? What size mat or paper backing is the most appropriate? Does a cool white, a warm white, an off-white, a neutral, or a gray look best with the drawing? Does the size of the drawing present a problem?

The care and storage of individual drawings is another professional concern. Minimal good care is simple. You should spray-fix your drawings as soon as they are finished. Remove any smudges and store the drawings in a flat, rigid container slightly larger than the largest drawing. This ensures that the drawings will not become dog-eared, soiled, bent, or smudged. You should place a clean piece of paper between drawings so that the charcoal from one does not transfer onto the white of another.

Your attitude toward your work influences others' attitudes. A bad drawing can be improved by good presentation, while a good drawing can be destroyed by poor presentation. Each drawing does not have to be regarded as a precious monument, but general proper care and handling of your work is a good habit.

Keeping a Sketchbook

Guide C

Paul Klee has said that the way we perceive form is the way we perceive the world, and nowhere is this more strikingly visible than in a well-kept sketchbook. The sketchbook takes art out of the studio and brings it into daily life. By means of the sketchbook, actual experience is reintroduced into the making of art. This is a vital cycle, infusing your work with direct experience and at the same time continuing the acute observation that you have been using in the studio.

You are no doubt already aware of the indispensable role of the sketchbook in helping you solve formal problems encountered in the classroom. Keeping a sketchbook is an important extension of classroom activity.

The first consideration in choosing a sketchbook is that it be portable, a comfortable size to carry. Any materials are appropriate for a sketchbook, but crayons, water-soluble felt-tip markers, and pencils are some convenient media.

A sketchbook is an ideal place to juggle form, ideas, and materials. You can experiment freely with any or all of these aspects of art and have the record of your investigations for quick reference.

Any of the problems in the chapters on art elements is an appropriate stepping-off place for sketchbook development. You should try for continuity; force yourself to develop one idea through ten or fifteen pages. In Figures 385 to 389 the student chose an article of clothing as the subject of a number of sketchbook drawings. He began with a contour drawing of the shirt and then imagined the shirt as if it were hung, crumpled, starched, and hidden. Each drawing suggested new forms, new media.

below left: 385. Sketchbook page. Student work. Pencil.

below right: 386. Sketchbook page. Student work. Pencil and charcoal.

CRUMPLED

above: 387. Sketchbook page.
Student work. Pencil and charcoal.

right: 388. Sketchbook page.
Student work. Mixed media.

below: 389. Sketchbook page.
Student work. Ebony pencil.

STARCHED

HIDDEN

left: 390. Sketchbook page.
Student work. Mixed media.

below: 391. Sketchbook page.
Student work. Mixed media.

You should use your sketchbook daily. Though this may seem artificial and awkward in the beginning, you will soon develop a reliance on the sketchbook that will prove profitable.

The sketchbook is a practical place for self-instruction. It is a good testing ground for ideas and formal design concerns as well as for media experimentation. Sketchbook drawings are not meant to be final statements. They are directional signals that point to a new problem or suggest a new solution to an old problem.

For example, in Figures 390 to 393 the student began with fruit as a subject. The oval and round shapes are maintained through the series of drawings while scale, texture, placement, and media are juggled. In the first drawing (Fig. 390) the objects are placed in the center of the page. In the second drawing (Fig. 391) one of the objects has "fallen" out of the picture plane. In the third drawing (Fig. 392) the circular object is close to the edge. In the last drawing (Fig. 393) there is a transformation—the shapes become negative. The final drawing resembles a landscape with emphasis on the negative space.

left: 392. Sketchbook page. Student work. Mixed media.

below: 393. Sketchbook page. Student work. Mixed media.

It would be impossible for an artist to carry out every idea. The sketchbook offers a place to record both visual and verbal ideas for selection and extended development later. Claes Oldenburg's concern with verbal and visual analogies is apparent in his sketchbook *Notes in Hand.* In his drawing *Ketchup + Coke Too?* (Fig. 394) from this notebook Oldenburg equated ketchup, french fries, and Coke with the Pisa group—cathedral, tower, and baptistry. The equation is a verbal one noted along the sides of the drawing. Oldenburg makes suggestions for materials to be used if he ever decides to make this grouping into a sculpture. He uses a time-saving device of drawing over an advertisement.

394. Claes Oldenburg. *Ketchup + Coke Too?* from *Notes in Hand* by Claes Oldenburg (New York: E. P. Dutton, 1971). 1965. Ballpoint pen. Courtesy the artist.

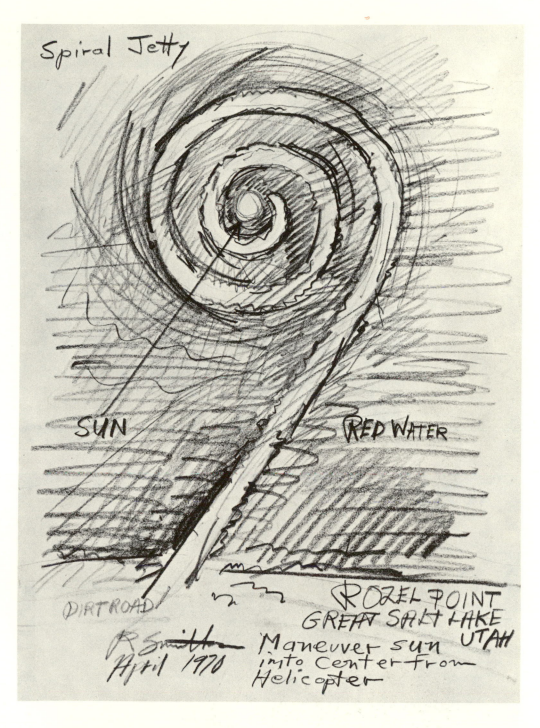

Sketchbook drawings are, in the long run, time-savers. Quickly conceived ideas are often the most valid ones. Having a place to jot down notations is important. Robert Smithson's *Spiral Jetty* (Fig. 395) is an example of a rapidly stated idea. His verbal notes are minimal; the drawing style is hasty. This is one of the preliminary sketches for a complex earthwork Smithson constructed on the Great Salt Lake in Utah. A more finished drawing made after his ideas had become more firmly established can be seen in Figure 15.

395. Robert Smithson.
The Spiral Jetty w/Sun. 1970.
Pencil, $11^{7}/_{8} \times 9''$ (30 × 23 cm).
Courtesy John Weber Gallery, New York.

above: 396. Sketchbook page. Student work. Photocopy and collage.

below: 397. Sketchbook page. Student work. Mixed media.

398. Sketchbook page.
Student work. Mixed media.

The sketchbook could function as both a verbal and visual journal. It is a place to record critical and personal comments on what you have read, seen, and experienced. For example a student made a photocopy of Rembrandt's *The Staalmeesters* (Fig. 396) and added a critical statement from an article concerning the work. A quote from the article, ". . . sometimes awkward, sometimes mere white patches. . . ," provides ideas for a series of sketchbook drawings. The student eventually turned the verbal statement itself into a drawing (Fig. 397). The verbal reference to the white patches became a literal basis for her third sketch, a collage using white shapes (Fig. 398).

The sketchbook serves as a repository, a memory bank for information and feelings that might escape if you do not jot them down. Keeping a written journal is a particularly important aspect of a sketchbook. Frequently a fleeting thought—either yours or someone else's—can trigger new responses when it is seen from a later vantage point.

399. Louise Nevelson.
For Dance Design. 1937.
Pencil, 9¼ × 17¼″ (23 × 44 cm).
Whitney Museum of American Art, New York
(gift of the artist).

While your approach in keeping a sketchbook is serious, playful improvisation should not be minimized. Louise Nevelson's playful attitude is obvious in *For Dance Design* (Fig. 399). Her serious interest in music, drama, and dance provided the impetus for the drawing. The fanciful figures relate to the geometric forms in her sculpture.

The main thing to remember about your sketchbook is that you are keeping it for yourself, not an instructor, even though you have been given assignments in it. You are the only one who benefits from a well-kept sketchbook. Looking back through a sketchbook can give you direction when you are stuck and provide a constant source of ideas for new work. When you use an idea from your sketchbook, you have the advantage of choosing an idea that has continuity to it—you have already done some thinking about that idea. A new viewpoint adds another dimension. Both *process* and *progress* are the rewards of dedication to keeping a sketchbook.

Summary: The Advantages of a Sketchbook

A sketchbook serves different functions. It is a personal tool that you can use in many ways. For example, in a sketchbook you can:

- acquaint yourself with new forms
- record drawings of an object through sustained observation
- introduce new imagery
- juggle the elements in a given composition
- record media experimentation

In addition to developing visual ideas, you can use your sketchbook to record verbal ideas and information. In it you can:

- write quotations that appeal to you
- keep an artist's diary
- keep a personal journal that records your daily interests, activities, and insights
- keep a source book or address book for materials
- attach clippings from other sources
- critically review other art work that you have seen
- make comments on what you have read and seen

Over the years your sketchbooks will form a valuable repository. Through these records you can trace your growth as an artist. You may see that you have a preference for certain ideas and relationships. The sketchbook will jolt your memory, reminding you of visual and verbal information you might otherwise have forgotten.

Remember the ground rules. Choose a sketchbook for its portability. Use it daily; set yourself a minimum number of fifteen pages a week. For each theme, develop no fewer than ten variations. Above all, remember that the sketchbook is a personal source, a chance to experiment. It is yours, and yours alone.

Breaking Artistic Blocks

Guide D

Generally, there are two times when artists are susceptible to artistic blocks: in an individual piece when they feel something is wrong and do not know what to do about it; and when they cannot begin to work at all. These are problems that all artists, even the most experienced, must face. They are common problems that you should move quickly to correct.

Correcting the Problem Drawing

What can you do with a drawing you cannot seem to complete? The initial step in the corrective process is to separate yourself, physically and mentally, from the drawing in order to look at it objectively. You, the artist/maker, become the critic/viewer. This transformation is essential in assessing your work. The original act of drawing was probably on the intuitive level; now you begin the process of critical analysis. You are going to learn to bring into consciousness what has been intuitively stated.

Turn away from your work for a few minutes. Occupy your mind with some simple task such as straightening equipment or sharpening pencils. Then pin the drawing on the wall, upside down or sideways. Have a mirror handy to view the drawing. The mirror's reversal of the image and the new perspective of placement will give you a new orientation so you can see the drawing with fresh eyes. This fresh viewpoint allows you to be more aware of the drawing's formal qualities regardless of the subject you have chosen.

When you can see how line, value, shape, volume, and texture are used, you are not so tied to the subject matter. Frequently the problem area will jump out at you. The drawing itself tells you what it needs. Be sensitive to the communication that now exists between you and your work. Before, *you* were in command of the drawing; now *it* is directing you to look at it in a new way. At this stage you are not required to pass judgment on the drawing. You simply need to ask yourself some nonjudgmental questions about the piece. The time for critical judgments comes later. What you need to discover now is strictly some *information* about the drawing.

Ask yourself these questions:

1. What is the subject being drawn?
2. Which media are used and on what surface?
3. How is the composition related to the page? Is it a small drawing on a large page? A large drawing on a small page? Is there a lot of negative space? Does the image fill the page? What kind of space is being used in the drawing?
4. What kind of shapes predominate? Amoeboid? Geometric? Do the shapes exist all in the positive space, all in the negative space, or in both? Are they large or small? Are they the same size? Are there repeated shapes? How have shapes been made? By line? By value? By a combination of these two? Where

is the greatest weight in the drawing? Are there volumes in the drawing? Do the shapes define planes or the sides of a form? Are the shapes flat or volumetric?

5. Can you divide value into three groups: lightest light, darkest dark, and mid-gray? How are these values distributed throughout the drawing? Is value used in the positive space only? In the negative space only? In both? Do the values cross over objects or shapes, or are they contained within the object or shape? Is value used to indicate a single light source or multiple light sources? Does value define planes? Does it define space? Does it define mass or weight? Is it used ambiguously?

6. What is the organizational line? Is it a curve, a diagonal, a horizontal, or a vertical? What type of line is used—contour, scribble, calligraphic? Where is line concentrated? Does it create mass? Does it create value? Does it define edges? Does it restate the shape of a value? Again, note the distribution of different types of line in the drawing; ignore the other elements.

7. Is invented, simulated, or actual texture used in the drawing? Are there repeated textures, or only one kind? Is the texture created by the tool the same throughout the drawing? Have you used more than one medium? If so, does each medium remain separate from the other media? Are they integrated?

This list of questions looks long and intimidating at first glance, but you can learn quickly to make these assessments—make them almost automatically, in fact. Of course, many of these questions may not apply to each specific piece, and you may think of other questions that will help you in making this first compilation of information about your drawing.

Critical Assessment

After letting the drawing speak to you and after having asked some nonjudgmental questions about it, you are ready to make a *critical assessment*. It is time to ask questions that pass judgments on the piece.

To communicate your ideas and feelings in a clearer way, you should know what statements you want to make. Does the drawing do what you meant it to do? Does it say something different—but perhaps *equally important*—from what you meant it to say? Is there a confusion or a contradiction between your intent and what the drawing actually says? There may be a conflict here because the drawing has been done on an intuitive level, while the meaning you are trying to verbalize is on a conscious level. Might the drawing have a better message than your original intended message?

Can you change or improve the form to help the meaning become clearer? Remember, form is the carrier of meaning. Separate the two functions of making and viewing. What is the message to you as viewer?

An important reminder: Go with your *feelings*. If you have any doubts about the drawing, wait until a solution strikes you. However, do not use this delay to avoid doing what you must to improve the drawing. Try something—even if the solution becomes a failure and the drawing is "ruined," you have sharpened your skills and provided yourself with new experiences on which to build other work. Nowhere but in art is it more true that you can profit by your mistakes. The fear of ruining what might be a good drawing can become a real block to later work. Be assertive, experiment; do not be afraid to fail. Taking risks is one of the excitements of art.

Problems in an individual piece tend to fall within these five categories:

- inconsistency of style, idea, or feeling
- failure to determine basic structure
- tendency to ignore negative space
- inability to develop value range and transitions
- failure to observe accurately

Inconsistency refers to the use of various styles, ideas, or feelings within a single work. A number of techniques and several types of line may be employed within a single drawing, but the techniques and elements must be compatible with each other and with the overall idea of the drawing. Frequently an artist will unintentionally use unrelated styles in the same drawing; this results in an inconsistency that can be disturbing to the viewer. For example, a figure drawing may begin in a loose and gestural manner, and seem to be going well. Suddenly, however, when details are stated, the artist feels insecure, panics, tightens up, and begins to conceptualize areas such as the face and hands. The style of the drawing changes—the free-flowing lines give way to a tighter, more constricted approach. As conceptualization takes the place of observation, the smooth, almost intuitive interrelationship of the elements is lost. The moment of panic is a signal for you to stop, look, analyze, and relax before continuing.

A frequent problem encountered in drawing is the *failure to determine basic structure*—to distinguish between major and minor themes. For example, dark geometric shapes may dominate a drawing, while light amoeboid shapes are subordinate. Although it is not necessary for every drawing to have a major and minor theme, in which some parts dominate and others are subordinate, it is important for the artist to consider such distinctions in the light of the subject and intent of a particular drawing. Details should overshadow the basic structure of a drawing only if the artist intends it. The organization of a drawing is not necessarily predetermined; however, at some point in its development, you should give consideration to the drawing's basic structure.

Human beings are object-oriented and have a *tendency to ignore negative space*. We focus our attention on objects. A problem

arises for the artist when the space around the object is ignored and becomes merely leftover space. It takes conscious effort to consider positive and negative space simultaneously. Sometimes it is necessary to train ourselves by first looking at and drawing the negative space. When we draw the negative space first, or when positive and negative space are dealt with simultaneously, there is an adjustment in both. In other words, the positive and negative shapes are altered to create interrelationships. There are times when only one object is drawn on an empty page. In these cases, the placement of the drawing on the page should be determined by the relationship of the negative space to the object.

One way to organize a drawing is by value distribution. Problems arise when students are *unable to develop value range and transitions.* For many students, developing a value range and gradual value transitions is difficult. The problem sometimes is a lack of ability to see value as differentiated from hue. At other times, it is failure to consider what range of value distribution is most appropriate for the idea of the drawing. Too wide a range can result in a confusing complexity or a fractured, spotty drawing. Using too few values can result in an uninteresting sameness.

The final problem, *failure to observe accurately,* involves lack of concentration on the subject and commitment to the drawing. If you are not interested in your subject, or if you are not committed to the drawing you are making, this will be apparent in the work.

Once you have pinpointed the problem area, think of three or more solutions. If you are still afraid of ruining the drawing, do three drawings exactly like the problem drawing and employ a different solution for each. This should lead to an entirely new series of drawings, triggering dozens of ideas.

The failure to deal with this first category of problems—being unable to correct an individual drawing—can lead to an even greater problem—not being able to get started at all.

Getting Started

There is a second type of artistic blockage, in some ways more serious than the first: the condition in which you cannot seem to get started at all. There are a number of possible solutions to this problem. You should spread out all the drawings you did over the period of a month and analyze them. It is likely that you are repeating yourself by using the same medium, employing the same scale, or using the same size paper. In other words, your work has become predictable.

When you break a habit and introduce change into the work, you will find that you are more interested in executing the drawing. The resulting piece reflects your new interest. A valid cure for being stuck is to adopt a playful attitude.

An artist, being sensitive to materials, responds to new materials, new media. This is a good time to come up with some

inventive, new, nonart drawing tools. Frequently you are under too much pressure—usually self-imposed—to produce "art," and you need to rid yourself of this stifling condition. Set yourself the task of producing one hundred drawings over a 48-hour period. Use any size paper, any medium, any approach—and before you get started, promise yourself to throw them all away. This will ease the pressure of producing a finished product and will furnish many new directions for even more drawings. It may also assist you to get over the feeling that every drawing is precious.

All techniques and judgments you have been learning are pushed back in your mind while your conscious self thinks of solutions to the directions. Your intuitive self, having been conditioned by some good solid drawing problems, has the resource of past drawing experience to fall back on. Art is constantly a play between what you already know and the introduction of something new, between old and new experience, the conscious and the intuitive, the objective and the subjective.

Art does not exist in a vacuum, and while it is true that art comes from art, more to the point is that art comes from everything. If you immerse yourself totally in doing, thinking, and seeing art, the wellsprings soon dry up and you run out of new ideas. Exhausting physical exercise is an excellent remedy, as is reading a good novel, scientific journals, or a weekly news magazine. A visit to a natural history museum, a science library, a construction site, a zoo, a cemetery, a concert, a political rally—these will all provide grist for the art mill sooner or later. Relax, "invite your soul." Contact with the physical world will result in fresh experiences from which to extract ideas, not just to improve your art but to sharpen your knowledge of yourself and your relation to the world.

Keep a journal—a visual one and verbal one—in which you place notes and sketches of ideas or quotes, of what occupies your mind. After a week reread the journal and see how you spend your time. How does the way you spend your time relate to your artistic block?

Lack of authentic experience is damning. Doing anything, just existing in our complex society, is risky. Art is especially risky. What do we as artists risk? We risk confronting things unknown to us; we risk failure. Making art is painful because the artist must constantly challenge old ideas and experiences. Out of this conflict comes the power that feeds the work.

An artistic block is not necessarily negative. It generally means that you are having growing pains. You are questioning yourself and are dissatisfied with your previous work. The blockage may be a sign of good things to come. It is probably an indication that you are ready to begin on a new level of commitment or concentration, or you may be ready to begin a new tack entirely. When you realize this, your fear—the fear of failure, which is what caused the artistic block in the first place—is reduced, converted, and put to use in constructive new work.

Glossary

Italicized terms within the definitions are themselves defined in the Glossary.

abstraction　An alteration of *forms,* derived from observation or experience, in such a way as to present essential rather than particular qualities.

achromatic　Relating to light and dark, the absence of *color,* as opposed to *chromatic* (relating to color).

actual texture　The *tactile* quality of a surface, including the mark made by a tool, the surface on which it is made, and any foreign material added to the surface. See also *inverted texture, simulated texture.*

aggressive line　An emphatically stated *line.*

ambiguous space　*Space* that is neither clearly flat nor clearly volumetric, containing a combination of both two- and three-dimensional elements.

amoeboid shape　See *organic shape.*

analytical line　A probing *line* that penetrates space, locating objects in relation to one another and to the space they occupy.

anthropomorphism　Ascribing human form or attributes to non-human forms.

arbitrary value　*Value* that does not necessarily conform to the actual appearance of an object; the use of value based on intuitive responses or the need to comply with compositional demands.

assemblage　A work of art composed of fragments of objects or *three-dimensional* materials originally intended for other purposes; the art of making such a work.

background　See *negative space.*

base line　The imaginary *line* on which an object or group of objects sits.

biomorphic shape　See *organic shape.*

blurred line　Smudged, erased, or destroyed line.

calligraphic line　Free-flowing *line* that resembles handwriting, making use of gradual and graceful transitions.

cast shadow　One of the six categories of *light.*

chiaroscuro Modeling, the gradual blending of light to dark to create a *three-dimensional* illusion.

chromatic Relating to *color,* as opposed to *achromatic* (relating to light and dark).

collage Any flat material, such as newspapers, cloth, or wallpaper, pasted on the *picture plane.*

color Visual assessment of the quality of light that is determined by its spectral composition.

composition The organization or arrangement of the *elements of art* in a given work.

conceptual drawing A drawing that in its essential *form* is conceived in the artist's mind, rather than derived from immediate visual stimuli.

constricted line A *crabbed,* angular, tense *line,* frequently aggressively stated.

content The subject matter of a work of art, including its emotional, intellectual, *symbolic,* thematic, and narrative connotations, which together give the work its total meaning.

contour line *Line* that delineates both the outside edge of an object and the edges of *planes,* as opposed to *outline,* which delineates only the outside edge of an object.

core of shadow One of the six categories of *light.*

crabbed line See *constricted line.*

cross-contour line *Line* that describes an object's horizontal or cross contours rather than its vertical contours. Cross-contour line emphasizes the volumetric aspects of an object.

directional line See *organizational line.*

elements of art The principal graphic and *plastic* devices by which an artist composes a physical work of art. The elements are: *color, line, shape, texture, value,* and *volume.*

empty space See *negative space.*

expressive Dealing with feelings and emotions, as opposed to *objective* and *subjective.*

eye level An imaginary horizontal *line* parallel to the viewer's eyes.

field See *negative space.*

figure/field See *positive shape.*

figure/ground See *positive shape.*

foreground/background See *positive shape.*

form In its broadest sense, the total structure of a work of art—that is, the relation of the *elements of art* and the distinctive character of the work. In a narrower sense, the *shape,* configuration, or substance of an object.

frottage A *textural* transfer technique; the process of making rubbings with graphite or crayon on paper laid over a textured surface.

fumage A *textural* technique that uses smoke as a medium.

geometric shape *Shape* created by mathematical laws and measurements, such as a circle or a square.

gestural approach A quick, all-encompassing statement of *forms.* In gesture the hand duplicates the movement of the eyes, quickly defining the subject's general characteristics—movement, weight, *shape,* tension, *scale,* and *proportion.* See *mass gesture, line gesture, mass and line gesture* and *sustained gesture.*

ground See *negative space.*

group theme Development of related works by members of the same schools and movements of art who share common philosophical, formal, stylistic, and subject interests.

highlight One of the six categories of *light.*

hue The characteristic of a *color* that causes it to be classified as red, green, blue, or another color.

icon A portrait or image that is an object of veneration (usually religious veneration).

illusionistic space In the graphic arts, a representation of *three-dimensional space.*

implied line A *line* that stops and starts again; the viewer's eye completes the movement the line suggests.

implied shape A suggested or incomplete *shape* that is "filled in" by the viewer.

incised line A *line* cut into a surface with a sharp implement.

indicative line See *organizational line.*

informational drawing A category of objective drawing, including diagrammatic, architectural, and mechanical drawing. Informational drawing clarifies concepts and ideas that may not be

actually visible, such as a chemist's drawings of molecular structure.

interspace See *negative space*.

invented texture An invented, nonrepresentational patterning that may derive from *actual texture* but does not imitate it. Invented texture may be highly stylized.

light In the graphic arts, the relationship of light and dark patterns on a *form,* determined by the actual appearance of an object and by the type and direction of light falling on it. There are six categories of light as it falls over a form: *highlight, light tone, shadow, core of shadow, reflected light,* and *cast shadow.*

light tone One of the six categories of *light.*

line A mark made by an implement as it is drawn across a surface. See also *aggressive, analytical, blurred, calligraphic, constricted, contour, crabbed, implied, lyrical, mechanical, organizational,* and *whimsical* line.

line gesture A type of gesture drawing that describes interior forms, utilizing *line* rather than *mass.* See *gestural approach.*

lyrical line A *subjective* line that is gracefully ornate and decorative.

mass In the graphic arts, the illusion of weight or density.

mass and line gesture A type of gesture drawing that combines broad marks with thick and thin lines. See *gestural approach.*

mass gesture A type of gesture drawing in which the drawing medium is used to make broad marks to create *mass* rather than line. See *gestural approach.*

mechanical line An *objective* line that maintains its width unvaryingly along its full length.

modeling The change from light to dark across a surface; a technique for creating spatial illusion.

negative space The *space* surrounding a *positive shape;* sometimes referred to as *ground, empty space, interspace, field,* or *void.*

nonobjective In the visual arts, work that intends no reference to concrete objects or persons, unlike *abstraction,* in which observed forms are sometimes altered to seem nonobjective.

objective Free from personal feelings; the emphasis is on the descriptive and factual rather than the *expressive* or *subjective.*

one-point perspective A system for depicting *three-dimensional* depth on a *two-dimensional* surface; dependent upon the illusion that all parallel lines that recede into space converge at a single point on the horizon, called the *vanishing point.*

organic shape Free-form, irregular *shape.* Also called *biomorphic* or *amoeboid shape.*

organizational line The *line* that provides the structure and basic organization for a drawing. Also called *indicative* or *directional line.*

outline *Line* that delineates only the outside edge of an object, unlike *contour line,* which also delineates the edges of *planes.*

papiers collé The French term for pasted paper; a technique consisting of pasting and gluing paper materials to the *picture plane.*

perspective A technique for giving an illusion of space to a flat surface.

pictorial space In the graphic arts, the illusion of space. It may be relatively flat or *two-dimensional,* illusionistically *three-dimensional,* or *ambiguous space.*

picture plane The *two-dimensional* surface on which the artist works.

planar analysis An approach in which *shape* functions as *plane,* as a component of *volume.*

plane A *two-dimensional,* continuous surface with only one direction. See also *picture plane.*

plastic In the graphic arts, the illusion of *three-dimensionality* in a *shape* or *mass.*

positive shape The *shape* of an object that serves as the subject for a drawing. The relationship between positive shape and *negative space* is sometimes called *figure/field, figure/ground, foreground/ background,* or *solid/void* relationship.

private theme Development by an individual artist of a personal, sustained, related series of works.

proportion Comparative relationship between parts of a whole and between the parts and the whole.

reflected light One of the six categories of *light.*

scale Size and weight relationships between *forms.*

scribbled line gesture A type of gesture drawing using a tight network of tangled *line.* See *gestural approach.*

shadow One of the six categories of *light*.

shallow space A relatively flat space; having height and width, but limited depth.

shape A *two-dimensional,* closed or implicitly closed configuration. The two categories of shape are *organic* and *geometric shape*.

shared theme Thematic work in which the same images or subjects are used by different artists over a long period of time.

simulated texture The imitation of the *tactile* quality of a surface; can range from a suggested imitation to a highly illusionistic duplication of the subject's texture. See also *actual texture* and *invented texture*.

simultaneity Multiple, overlapping views of an object.

solid/void See *positive shape*.

structural line *Line* that helps locate objects in relation to other objects and to the space they occupy. Structural lines follow the direction of the *planes* they locate.

stylistic eclecticism The use side by side of varying philosophies, styles, techniques, materials, and subjects.

subjective Emphasizing the artist's emotions or personal viewpoint rather than informational content; compare *objective*.

sustained gesture A type of gesture drawing that begins with a quick notation of the subject and extends into a longer analysis and correction. See *gestural approach*.

symbol A *form* or image that stands for something more than its obvious, immediate meaning.

tactile Having to do with the sense of touch. In the graphic arts, the representation of *texture*.

texture The *tactile* quality of a surface or its representation. The three basic types of texture are *actual, simulated,* and *invented texture*.

theme The development of a sustained series of works that are related by subject, that have an idea or image in common. See *private theme, group theme,* and *shared theme*.

three-dimensional Having height, width, and depth.

three-dimensional space In the graphic arts, the illusion of *volume* or volumetric space—that is, of space that has height, width, and depth.

trompe-l'oeil The French term for trick-the-eye illusionistic techniques. See also *simulated texture*.

two-dimensional Having height and width.

two-dimensional space Space that has height and width with little or no illusion of depth or *three-dimensional* space.

value The gradation of tone from light to dark, from white through gray to black.

value scale The gradual range from white through gray to black.

vanishing point In *one-point perspective,* the single spot on the horizon where all parallel lines converge.

void See *negative space.*

volume The quality of a *form* that has height, width, and depth; the representation of this quality. See also *mass.*

whimsical line A playful, *subjective* line with an intuitive, childlike quality.

Suggested Readings

Because the text is based on a contemporary approach to drawing, the Suggested Readings concentrate on modern art and modern artists.

Students may also find helpful such periodicals as *Art News, Art Forum, Artweek, Arts,* and *Art in America.*

Surveys and Criticism

Alloway, Lawrence. *American Pop Art.* New York: Macmillan, 1974.

Amaya, Mario. *Pop Art and After.* New York: Viking, 1965.

American Drawings 1963–1973. New York: Whitney Museum of American Art, 1973.

Arnason, H. H. *History of Modern Art.* New York: Abrams, 1968.

Ashton, Dore. *A Reading of Modern Art.* Cleveland: Press of Western Reserve University, 1969.

Battcock, Gregory. *Idea Art: A Critical Anthology.* New York: Dutton, 1973.

Battcock, Gregory. *The New Art: A Critical Anthology.* New York: Dutton, 1973.

Battcock, Gregory. *Super Realism.* New York: Dutton, 1975.

Beier, Ulli. *Contemporary Art in Africa.* New York: Praeger, 1968.

Cooper, Douglas. *The Cubist Epoch.* New York: Praeger, 1971.

Drawings: Recent Acquisitions. New York: Museum of Modern Art, 1967.

European Drawings. New York: Solomon R. Guggenheim Museum, 1966.

Geldzahler, Henry. *New York Painting and Sculpture: 1940–1970.* New York: Dutton, 1969.

Gottlieb, Carla. *Beyond Modern Art.* New York: Dutton, 1976.

Kuh, Katherine. *Break-up: The Core of Modern Art.* Greenwich, Conn.: New York Graphic Society, 1968.

Lipman, Jean, and Richard Marshall. *Art About Art.* New York: Dutton/Whitney Museum of American Art, 1968.

Lippard, Lucy. *From the Center.* New York: Dutton, 1976.

Lippard, Lucy. *Six Years: The Dematerialization of the Art Object from 1966 to 1972.* New York: Praeger, 1973.

Lucie-Smith, Edward. *Art Now.* New York: Morrow, 1977.

Meyer, Ursula. *Conceptual Art.* New York: Dutton, 1972.

100 European Drawings. Introduction by Jacob Bean. New York: Metropolitan Museum of Art, 1964.

Plagens, Peter. *Sunshine Muse.* New York: Praeger, 1974.

Rose, Barbara. *American Art Since 1900: A Critical History.* New York: Praeger, 1967.

Rosenberg, Harold. *The Anxious Object.* New York: Horizon Press, 1964.

Rosenberg, Harold. *The De-definition of Art.* New York: Collier Books, 1973.

Russell, John, and Suzi Gablik. *Pop Art Redefined.* New York: Praeger, 1969.

Sandler, Irving. *The New York School.* New York: Harper & Row, 1978.

Women Chose Women. New York Cultural Center. New York: Worldwide Books, 1973.

Works on Individual Artists

Francis Bacon
Francis Bacon: Recent Paintings, 1968–1974. New York: Metropolitan Museum of Art, 1975.

Leonard Baskin
Baskin: Sculpture, Drawings and Prints. New York: Braziller, 1970.

Romare Bearden
Romare Bearden: The Prevalence of Ritual. New York: Museum of Modern Art, 1971.

Joseph Beuys
Joseph Beuys: The Secret Block for a Secret Person in Ireland. Oxford: Museum of Modern Art, 1974.

Paul Cézanne
Chappeuis, Adrien. *The Drawings of Paul Cézanne.* Greenwich, Conn.: New York Graphic Society, 1973.

Judy Chicago
Chicago, Judy. *The Dinner Party.* Garden City, N.J.: Anchor, 1979.

Christo
Bourdon, David. *Christo.* New York: Abrams, 1972.
Christo: Valley Curtain, Rifle, Colorado. New York: Abrams, 1977.

Joseph Cornell
Waldman, Diane. *Joseph Cornell.* New York: Braziller, 1977.

Stuart Davis
Sweeney, James Johnson. *Stuart Davis.* New York: Museum of Modern Art, 1945.

Willem de Kooning
de Kooning: Drawings/Sculptures. New York: Dutton, 1974.

Jim Dine
Gordon, John. *Jim Dine.* New York: Praeger/Whitney Museum of American Art, 1970.

Jean Dubuffet
Drawings, Jean Dubuffet. New York: Museum of Modern Art, 1968.

Marcel Duchamp
Marcel Duchamp. New York: The Museum of Modern Art and Philadelphia Museum of Art, 1973.

Max Ernst
Ernst, Max. *Une Semaine de Bonté: A Surrealistic Novel in Collage.* New York: Dover, 1976.
Max Ernst: Inside the Sight. Houston: Institute for the Arts, Rice University, 1973.

Alberto Giacometti
Lust, Herbert C. *Giacometti: The Complete Graphics and 15 Drawings.* New York: Tudor, 1970.

Arshile Gorky
Seitz, William C. *Arshile Gorky: Paintings, Drawings, Studies.* New York: Arno Press, 1972.

Red Grooms
Tully, Judd. *Red Grooms and Ruckus Manhattan.* New York: Braziller, 1977.

George Grosz
Love Above All, and Other Drawings: 120 Works by George Grosz. New York: Dover, 1971.

David Hockney
Stangos, Nikos, ed. *David Hockney.* New York: Abrams, 1977.

Hans Hofmann
Seitz, William C. *Hans Hofmann.* New York: Arno Press, 1972.

Edward Hopper
Goodrich, Lloyd. *Edward Hopper.* New York: Abrams, 1971.

Robert Indiana
Robert Indiana. Philadelphia: Institute of Contemporary Art of the University of Pennsylvania, 1968.

Jasper Johns
Jasper Johns. Whitney Museum of American Art. New York: Abrams, 1974.
Kozloff, Max. *Jasper Johns.* New York: Abrams, 1972.

Ellsworth Kelly
Coplans, John. *Ellsworth Kelly.* New York: Abrams, 1972.

Paul Klee
Grohmann, Will. *The Drawings of Paul Klee.* New York: C. Valentin, 1944.

Käthe Kollwitz
Zigrosser, Carl. *Prints and Drawings of Käthe Kollwitz.* New York: Dover, 1951.

Rico Lebrun
Rico Lebrun: Drawings. Berkeley: University of California Press, 1968.

Fernand Léger
Green, Christopher. *Léger and the Avant Garde.* New Haven: Yale University Press, 1976.

Sol LeWitt
Sol LeWitt. New York: Museum of Modern Art, 1978.

Roy Lichtenstein
Waldman, Diane. *Roy Lichtenstein.* New York: Abrams, 1971.

Morris Louis
Fried, Michael. *Morris Louis*. New York: Abrams, 1970.

René Magritte
Miller, Richard. *Magritte: Ideas and Images*. New York: Abrams, 1977.

Henri Matisse
Cassou, Jean. *Paintings and Drawings of Matisse*. Paris: Braun and Cie. New York: Tudor, 1939.
Matisse as a Draughtsman. Greenwich, Conn.: New York Graphic Society/Baltimore Museum of Art, 1971.

Joan Miró
Penrose, Roland. *Miró*. New York: Abrams, 1969.

Henry Moore
Wilkinson, Alan G. *The Drawings of Henry Moore*. London: Tate Gallery Publications, 1977.

Louise Nevelson
Nevelson: Skygates and Collages. New York: Pace Gallery, 1974.

Robert Motherwell
Arnason, H. *Robert Motherwell*. New York: Abrams, 1977.

Georgia O'Keeffe
Georgia O'Keeffe. Los Angeles: Praeger (Worldwide Books), 1970.

Claes Oldenberg
Baro, Gene. *Claes Oldenberg: Prints and Drawings*. London: Chelsea House, 1969.
Haskell, Barbara. *Claes Oldenberg: Object into Monument*. Pasadena, Calif.: Pasadena Art Museum, 1971.
Oldenberg, Claes. *Notes in Hand*. New York: Dutton, 1971.

Pablo Picasso
Picasso: His Recent Drawings 1966–68. New York: Abrams, 1969.

Jackson Pollock
Friedman, B. H. *Jackson Pollock: Energy Made Visible*. New York: McGraw-Hill, 1972.

Robert Rauschenberg
Forge, Andrew. *Rauschenberg*. New York: Abrams, 1969.

Robert Rauschenberg. National Collection of Fine Arts. Washington, D.C.: Smithsonian Institution, 1976.

Larry Rivers
Hunter, Sam. *Larry Rivers*. New York: Abrams, 1969.

Lucas Samaras
Lucas Samaras: Photo Transformations. California State University, Long Beach; New York: Dutton, 1975.

Georges Seurat
Russell, John. *Seurat*. New York: Praeger, 1965.

Robert Smithson
Robert Smithson: Drawings. New York: The New York Cultural Center, 1974.

Ben Shahn
Morse, John D. *Ben Shahn*. New York: Praeger, 1967.

Saul Steinberg
Rosenberg, Harold. *Saul Steinberg*. New York: Knopf, 1978.

Yves Tanguy
Yves Tanguy. New York: Acquavella Galleries, 1974.

Wayne Thiebaud
Wayne Thiebaud Survey 1947–1976. Phoenix, Ariz.: Phoenix Art Museum, 1976.

Jean Tinguely
Hulten, K. G. Pontus. *Jean Tinguely: Meta*. Greenwich, Conn.: New York Graphic Society, 1975.

Andy Warhol
Coplans, John. *Andy Warhol*. Greenwich, Conn.: New York Graphic Society, 1970.

Tom Wesselmann
Tom Wesselmann: The Early Years/Collages 1959–62. Long Beach: California State University Art Galleries, 1974.

Andrew Wyeth
Andrew Wyeth: Dry Brush and Pencil Drawings. Cambridge, Mass.: Fogg Art Museum, 1968.
Two Worlds of Andrew Wyeth. New York: Metropolitan Museum of Art, 1976.

Index

Wright, Dimitri, *Untitled,* 50, Fig. 76

Wybrants, Sharon, *Self-Portrait as Superwoman,* 8, Fig. 8

Yamin, Alice, *Cocktail Series,* 22, Fig. 32

Yellow Violin, Dufy, 121, Fig. 208

Young Hare, Dürer, 69, Fig. 108

Zeros, Fisher, 213, Fig. 356

Zuccaro, Federigo, *Emperor Frederic Barbarossa before Pope Alexander III,* 44, Fig. 66

Photographic Sources

Brooke Alexander, Inc., New York, and Rudolph Burckhardt, New York (264); Alinari/Editorial Photocolor Archives, New York (178, 253, 347); Lee Angle, Fort Worth, Tex. (215); *Artforum,* New York, and Gianfranco Gorgoni, New York (366); Jacob Burckhardt, New York (259, 277, 297, 348); Rudolph Burckhardt, New York (232, 242); Barney Burstein, Boston (234); Pramuan Burusphat (33–60, 83–107, 119–131, 134–146, 154–163, 185–205, 207, 209–213, 218–219, 222–223, 227–229, 235, 246, 266–267, 272–273, 278–287, 290–295, 303, 320–346, 356, 358, 364, 373–374, 385–393, 397–398); Leo Castelli Gallery, New York (260, 299, 301, 370); Leo Castelli Gallery, New York, and Rudolph Burckhardt, New York (308); Geoffrey Clements, Staten Island, N.Y. (9, 74, 151, 249, 307, 377–378); Constance Lebrun Crown, Santa Barbara, Calif. (13, 30, 116, 318); Bevan Davies, New York (7, 289); Walter Dräyer, Zürich (173); André Emmerich Gallery, New York, and Ann Freedman, New York (256); Eeva-Inkeri, New York (3, 6, 147, 309, 365, 375); John A. Ferrari, New York (361); G. Franceschi, Mission Henri Lhote, Editions B. Arthaud, Paris (179); Robert L. Goodman, Jr. (302); Solomon R. Guggenheim Museum, New York (10, 27, 31, 233, 236, 275, 288, 360); Gundermann, Würzburg (252); Nancy Hoffman Gallery, New York, and Robert E. Mates and Paul Katz, New York (239); Sidney Janis Gallery, New York, and Oliver Baker Associates, Inc., New York (296); Sidney Janis Gallery, New York, and Eric Pollitzer, Hempstead, N.Y. (237); Kenneth Karp, New York (118, 132); Joseph Klima, Jr., Detroit (349); Margo Leavin Gallery, Los Angeles (64); Malcolm Lubliner, Los Angeles (22–24); Robet E. Mates and Paul Katz, New York (117); Peter Moore, New York, (114); Al Mozell, New York (351); Gerard Murrell, New York (352); Don Netzer, Denton, Tex. (368); Eric Pollitzer, Hempstead, N.Y. (166, 245, 247, 306, 371); Portland Art Association, Portland, Ore. (313); Nathan Rabin, New York (15, 206, 395); Service de Documentation Photographique de la Réunion des Musées Nationaux, Paris (311); Robin Smith Photography Ltd., Christchurch, N.Z. (80); J. M. Snyder (21); Bill J. Strehorn, Dallas, Tex. (164, 216, 363); Soichi Sunami, New York (19, 25); Eugene Victor Thaw, New York (316); Frank J. Thomas, Los Angeles (67); John Webb, Cheam, Eng. (63); Joel Peter Wilkin, New York (182).

Fig. 4 reprinted with permission of Macmillan Publishing Co., Inc., from *Creative and Mental Growth* 6th edition, by Viktor Lawenfeld and W. Lambert Brittain. Copyright © 1975, Macmillan Publishing Co., Inc. Works by Braque, Dubuffet, Duchamp, Giacometti: © A.D.A.G.P., Paris 1979. Works by Klee: © COSMOPRESS, Geneva/S.P.A.D.E.M., Paris. Works by de Chirico: © S.I.A.E., Rome/V.A.G.A., New York. Works by Dufy, Léger, Matisse, Picasso: © S.P.A.D.E.M., Paris/V.A.G.A., New York. Figs. 70, 166 © Leonard Baskin. Fig. 241 © Estate of Max Ernst. Fig. 250 © Audrey Flack. Figs. 13, 30, 116, 318 © Rico Lebrun. Figs. 22–24, 247 © Roy Lichtenstein. Fig. 236 © Robert Motherwell. Figs. 148, 242 © Robert Rauschenberg. Figs. 251, 308 © James Rosenquist. Fig. 169 © Estate of Ben Shahn. Figs. 307, 371 © Andy Warhol. Figs. 237, 306 © Tom Wesselmann. Permission granted by V.A.G.A., New York.